KLAUS
OTTMANN

THOUGHT
THROUGH
MY EYES

Writings on Art
1977 – 2005

SPRING PUBLICATIONS, INC.
PUTNAM, CONNECTICUT
2006

ART & KNOWLEDGE SERIES 2

Published by Spring Publications, Inc.
Putnam, Conn.
www.springpublications.com

Inquiries should be addressed to:
Spring Publications, Inc.
PO Box 230212
New York, N.Y. 10023

Distributed by The Continuum International Publishing Group
www.continuumbooks.com

Printed in Canada

Designed by white.room productions, New York

Library of Congress Cataloging-in-Publication Data

Ottmann, Klaus.
 Thought through my eyes : writings on art, 1977–2005 / Klaus Ottmann. — 1st ed.
 p. cm. — (Art & knowledge ; 2)
 Includes bibliographical references and index.
 ISBN-13: 978-0-88214-578-5 (pbk. original : alk. paper)
 ISBN-10: 0-88214-578-9 (pbk. original : alk. paper)
 1. Art, Modern—20th century. 2. Artists—Interviews. I. Title. II. Series.

N6490.O755 2006
700—dc22

 2006016342

∞ The paper used in this publication meets the minimum requirements
of the American National Standard for Information Sciences — Permanence of
Paper for Printed Library Materials, ANSI Z39.48-1992.

THOUGHT THROUGH MY EYES

CONTENTS

INTERVIEWS

Ineluctable modality of the visible: at least that if no more, thought through my eyes . . . Shut your eyes and see.
— James Joyce, 1922

PREFACE

In 1983, after having written journalistic pieces for a Berlin weekly as a student, I submitted my first critical art writing, unsolicited, to three leading art magazines: *Kunstforum International*, *Artforum*, and *Flash Art*. The essay, "Painting in an Age of Anxiety," a collage of criticism and poetry influenced by structuralist philosophy, was published in English translation in *Flash Art* in 1984, and almost a year later, it was reprinted in German in *Kunstforum*. Thus encouraged, I continued to contribute regularly to *Flash Art*, experimenting with the format of art criticism. Trained as both a philosopher and an art historian, I approached the "ineluctable modality of the visible" with my mind and my eyes. Rather than contributing to the fabrication of meaning, I chose to place art in the context of philosophy, literature, poetry, and science.

Wittgenstein often spoke of the impossibility of expressing the inexpressible, that which is beyond the limits of language. He called it "running against the boundaries of language." The pursuit of the extraordinary in art, which I examine in my book *The Genius Decision: The Extraordinary and the Postmodern Condition*, remains one of the most elusive quests of all. In the book I describe the creative act as an *active-passive* leap that the artist is impelled to make and the viewer is challenged to repeat. The artist and the viewer are pressed passively by the urgency of the nonrepresentable to be represented; but they are also prompted to make an active decision — a decision whose outcome can only be failure. One can only fail *better*, but one can never succeed. Thus the real challenge for critics and curators is not to provide the public with as much information as possible and an illusion of understanding, but to embrace the public's anguish and frustration and convey to it that art is about running against boundaries, about following the path of the artist toward the extraordinary by failing well.

Some of my earlier writings may seem eccentric in the use of quotations, but they are evidence of my lifelong interest in creative ideas originating from a wide range of disciplines. Many of the thoughts propounded in these writings became the basis for exhibitions, once my focus shifted from writing to curating. This volume contains a selection of essays, exhibition reviews, and conversations with artists spanning almost thirty years. I have made revisions to most of the previously published texts while preparing them for collection in this book, eliminating repetition and adding footnotes while preserving their original style.

I am grateful to Helena Kontova and Giancarlo Politi, the publishers of *Flash Art*, for having fostered my unconventional style of writing early on. I also want to acknowledge the numerous editors who over the years have published my writings, especially Paul Taylor, Barry Schwabsky, and Glenn Harper. But first and foremost my thanks go to my wife, Leslie Tonkonow, who has been guiding my life and work with her brilliant mind and kindred eye for almost twenty years.

Lastly, this book is dedicated to the memory of Colin de Land, Pat Hearn, Moira Dryer, Paul Taylor, James Lee Byars, and Pierre Restany. I miss their friendship and creative genius.

ESSAYS

TRANSFORMER SALOMÉ

I can't do anything else — I could not paint trees. I simply like my body and I think it's cool if others are turned on by it as well.
— Salomé

Thursday, August 25, 1977.
Berlin, Pestalozzistr. 106, shortly before 3 a.m.: Salomé is re-clining on a ruby-red pillow in a shop window laid out with pink satin. He is motionless, looking out to the street, wear-ing a black garter belt, nylon stockings, and a black mask over his eyes.

In front of him are assembled fetishistic objects: a pair of pink pumps and a dildo covered with red satin and stuffed with nylons. Salomé has been standing, sitting, or lying in various poses in this window of the Petersen Gallery for more than eight hours — each hour in a different pose; each pose is recorded with a Polaroid camera. It is a twenty-four-hour live performance.

In front of the gallery, friends and acquaintances meet with inquisitive passers-by. Cars stop to catch a glimpse of the spec-tacle, which appears curiously sacral. But only rarely is there serious interest. Most come by not to see but to be seen. There is much laughter. Nobody is outraged or offended.

Salomé, who studies at the Hochschule der Künste, is a "transformer" and painter who depicts himself on large canvases, in Polaroid photographs, and on video or film. To-night he will attempt to experience extreme psychological stress and physiological strain during a public performance. Salomé, like all self-performers, is interested in his own body. He knew from the outset that his homosexuality had to be at the center of his artistic work. For him, art is a means

This essay originally appeared in *INZEIT* 13 (September 1977).

to transcend the reality principle, and the alienation from feelings and desires it demands, and to fully experience his own body.

Live performance as art originated in the Happenings and the actionist art of the 1960s. With the "body works," which began to emerge around 1965, the body became the central subject for artists. Body language and transformative performance thematize the body as sexual identity. While body works emphasize demonstration and therapy, performance increasingly focuses on individual, subjective experience, which reduces the viewer to serving as a mirror for the artist.

As one of the most important art forms of the 1970s, performance is widely represented in the current *documenta* exhibition in Kassel. The best-known transformer in Kassel is Jürgen Klauke, a friend of Salomé's, who recently had a one-person exhibition at the Petersen Gallery. His works are not unlike Salomé's with respect to the elaboration of a sexual double identity, albeit with a stronger emphasis on the ritual character of transformation.

Performance is arguably the most radical form of art. It breaks with the traditional art industry in significant ways. Performance artists will not surrender their potential for continuing artistic development to art dealers or agents. Their works have no lasting value that would make them marketable.

For Salomé, no art is more communicative than a live performance, as it elicits immediate reactions from the public. After twelve hours of imparting, more or less successfully, his experience to the audience, Salomé aborted his performance due to physical exhaustion.

Art fights reification by making the petrified world speak, sing, perhaps dance.
— Herbert Marcuse, 1978

PAINTING IN AN AGE OF ANXIETY

I

To make visible that there is something which can be conceived and which can neither be seen nor made visible: this is what is at stake in modern painting. But how to make visible that there is something that cannot be seen? Kant himself shows the way when he names "formlessness, the absense of form," as a possible index to the unpresentable.
— Jean-François Lyotard, 1982

I paint the impossibility of painting . . .
I don't like talking. I don't like people talking to me.
Painting is silence.
— Bram van Velde, 1967

A bar in New York during World War II. The radio spreads war news and commercials. From outside one can hear the noises of the nearby El. Three men and one woman are sitting silently and alone in front of their memories, dreams, and anxieties. A scene as if it were depicted in a painting by Edward Hopper: frozen gestures of loneliness in a vacuum of anxiety. Thus begins W. H. Auden's "Age of Anxiety," written in New York in 1946.

Lies and lethargies police the world
In its periods of peace. What pain taught
Is soon forgotten; we celebrate
What ought to happen as if it were done,
Are blinded by our boasts. Then back they come,
The fears that we fear . . .
We are warm, our active universe is young; yet we shiver:
For athwart our thinking the threat looms, . . . of more deaths
And worse wars.[1]

This essay originally appeared in *Flash Art* 118 (Summer 1984).
1 W. H. Auden, "The Age of Anxiety," in *Collected Poems*, ed. Edward Mendelson (New York: Vintage International, 1991), p. 461.

Anxiety is the keyword of modern consciousness. (Martin Heidegger, 1926: "The basic condition of anxiety as a distinctive way in which Being is disclosed.")

The retreat into the subjectivity of the painted gesture, understood as a world-relevant one, in accordance with the new philosophy after 1945 in the art of Jackson Pollock, Willem de Kooning, and Mark Tobey, is the expression of revolt against a world that produces anxiety.

Suffering from the world as co-passion of the body in the painting gestures. Their traces on the canvas are stigmata of painting, sympathy. In gesture painting and graffiti happens the re-incorporation of the world.

In 1947 Mark Rothko painted his color fields, the absence of content and form.

In the nonrepresentation, the nonrepresentable becomes visible; in the withholding, the unspeakable becomes communicable.

The gesture, too, belongs to the nonrepresentable, the speechless, the nonlogical. It appears where ambivalence exists. In it, time is suspended; the repressed and hidden, present. The gesture is the language of *hysteria*, the resistance of the body against the order of reason.

Hans Jonas[2] has pointed out that there is a connection between modern existentialism and gnosis — both feelings of homelessness, desertedness, and desperation in ages of anxiety. Adopting a distinction given by Jonas, the two sides of art in ages of anxiety are as follows:

libertine	and	*ascetic*
mannerism		purism
violation of form		indifference
expressive		metaphysical

2 "Gnosticism and Modern Nihilism," *Social Research* 19 (1952): 430–52.

II

The postmodern would be that which, in the modern, puts forward the unpresentable in presentation itself; that which denies itself the solace of good forms, the consensus of a taste which would make it possible to share collectively the nostalgia for the unattainable; that which searches for new presentations, not in order to enjoy them but in order to impart a stronger sense of the unpresentable.
— Jean-François Lyotard, 1982

After Schubert's death his brother cut some of Schubert's scores into small pieces and gave such pieces, consisting of a few bars, to his favorite pupils.
— Ludwig Wittgenstein, 1931

Berlin/Rome/New York 1983. Paintings of bliss. Paintings that neither give satisfaction nor conform to the aesthetic taste but execute a cut into pleasure.

Paintings that bring their relation to the viewer to a crisis. Paintings of scandal.

Paintings that put themselves at stake. Mad paintings. Paintings that are not in their right mind.

Broken paintings. Opening the seam of lust. Unspeakable. Uncriticizable. The history of art presents itself as a history of bodies: the bodies of van Gogh, Gauguin, Delacroix, Manet.

Romantic paintings. Reintroducing the ideal of sexual duality, the expression in male and female categories.

Sexual paintings, insofar as they contain communication: between the sexes and between man and object or animal.

Postmodern paintings that leave the modern stance of egotistic chauvinism, the absence of a nomenclature of (sexual) difference, for the Romantic ideal of feminism.

The knife may be sharper and more analytic, but the axe has fullness, mass, and anthropomorphic connotations.
— Joseph Beuys, 1967

If one were only an Indian, instantly alert, and on a racing horse.
— Franz Kafka, 1913

THE NEGRO. Soon after his arrival in Tahiti, Paul Gauguin made an excursion into the forests of the island to cut rosewood. Afterward he wrote in his diary:

I struck out with joy. My hands became stained with blood in my wild rage, my intense joy of satiating within me, I know not what divine brutality. It was not the tree I was striking, it was not it which I sought to overcome . . . And here is what my axe seemed to say to me in cadence of its sounding blows:

> Strike down to the root the forest entire!
> Destroy all the forest of evil,
> Whose seeds were one sowed within thee by the breathings
> of death! . . .

Yes, wholly destroyed, finished, dead, is from now on the old civilization within me. I was reborn. Or rather another man, purer and stronger, came to life within me. This cruel attack was the supreme farewell to civilization, to evil . . . I was, indeed, a new man: from now on I was a true savage, a real Maori.[3]

That same year Gauguin painted a young native on the beach of Tahiti raising his axe to cut off the roots of civilization — like the Negro Manning in Soupault's *Le Nègre* who, "alive like red color, fast like a catastrophe," kills the prostitute Europe with his knife.

The Negro: at once threat and fascination, danger and temptation, destruction and salvation.

The mad man in Rainer Fetting's *Man and Axe* is staring surprised at his cut-off hand, posing artlessly with a gigantic blue

3 *Noa Noa: The Tahiti Journal of Paul Gauguin*, trans. O. F. Theis (San Francisco, Chronicle Books, 2005), pp. 46–48.

axe — Gauguin's axe. Gauguin in Tahiti. Fetting in New York. The artless artist after being cut off from European culture.

Enzo Cucchi's barbarian stamps over torn-off parts of bodies. Cannibalism and sacrifice. Tearing and consumption. The axe as sacrificial hatchet. The dismemberment of culture. The destruction of the form in its waste. The boundless squandering of art in the exuberance of form and color.

The painter of the future will be *such a colorist as has never yet been* ... Why did the greatest colorist of all, Eugène Delacroix, think it essential to go south and right to Africa? ... All true colorists must come to this, must admit that there is another kind of color than that of the North.
— Vincent van Gogh, 1888

Negroes, barbarians, red Indians in the paintings of Fetting, Salomé, Hervé di Rosa, Cucchi; in the movies of Herbert Achternbusch. Remy Blanchard's tigers, Joseph Beuys's coyotes, Fetting's wolves: animal bodies.

Negroes, barbarians, Indians: heroes of the Other, the excluded or colonized, the *nègritude*. Sacrifice and sacrificer in one. Bodies of revolt. Bodies of suppression.

I have just read a book, neither beautiful nor well written but moving, about the Marquesas Islands. It tells about the extermination of a whole native tribe: cannibals, insofar as they ate, let's say, one man a month. But what does it matter? ... These tattooed races, these Negroes, these Indians, all of them are disappearing, degenerating ... And those savages had been so gentle and so loving!
— Vincent van Gogh, 1888

Fetting is the savage, the Indian, van Gogh; Achternbusch is the Comanche, the Negro; Beuys is the shaman, the nomad.

The sexual act is in time what the tiger is in space.
— Georges Bataille, 1949

THE GARDEN OF LUSTS. In Hieronymus Bosch's *Garden of Earthly Delights* black women are wearing red cherries on their heads: bodies of lust, promises of endless pleasures.

In the paintings of Rainer Fetting and Salomé: naked male bodies under the shower, in front of mirrors, swimming among water lilies. Autoerotic games in the drawings of Francesco Clemente. Erotic bodies in the polychromy of lust. Erotic paintings painted with the whole body at stake.

In the polyphony of pleasures: variations, repetitions, dissonances. The enjoyment of sexual variety to the full in a state of innocence. The suspension of sin in the permanence of its repetition. The register of perversions. The offense against the sexual order. The endless violation.

The origin of war, sacrifice, and orgy is the same: it lies in the existence of prohibitions that oppose the liberty of murderous or sexual violence.
— Georges Bataille, 1957

Fetting, Clemente, Salomé: bodies of lust. Painting as sexuality, sexual gesture. Metamorphoses: male to female, animal to human. Living the difference. Bestiary of lusts. Human-animal hybrids, fabulous creatures, monsters: pig-woman (di Rosa), zebra-men (Salomé), unicorn (Blanchard).

But know also that in the *stercoribus humanis* there can be found various strange animals, which were derived from the sodomites . . . And know furthermore of the sperms of animals, which they often use instead of man's: from which then are born peculiar monsters . . . If such monsters stem from sodomitic order, then they are a sodomitic growth, neither human nor animal but by all means deformities.
— Paracelsus, 1567

Excursions into the nightmares of childhood, the fantasies of fever. The fall into the horror, into the monstrous, the unknown, uncanny.

Heaven and hell are one. Bosch placed the garden of delights between paradise and hell. The erotic that lives in the tension between innocence and sin. The pleasure of the horror. Madness. Exaggeration. The tearing of the symbol (Clemente). The labyrinth of lust.

Performance of co-passion: Salomé's body wrapped in barbed wire. Fetting's body on the cross. Beuys's bloody, beaten body. Bodies that are nonsacrifices.

Mother Superior: Doesn't it bother you to drink red wine? *Jesus/Waiter:* No, why? *Mother Superior:* It's your blood. *Jesus/Waiter:* My blood? Where did you get that idea?
— Herbert Achternbusch, 1982

White water which is pure is as inconceivable as clear milk.
— Phillip Otto Runge, 1806

MILK AND HONEY. The return to paradise where milk and honey flows:

Those who felt a desire for the white drink scraped the ground with their fingertips, and found gushes of milk, and from the ivied thyrsi dripped sweet streams of honey.[4]

But the paradisiacal unity of man, god, and nature is deceptive. It is always followed by the difference, the tearing, the *omophagia*, the Fall. The honey-giving thyrsus becomes a murderous weapon. The milk transforms itself into blood and sperm.

4 Euripides, *Bacchae*, trans. David Franklin (Cambridge: Cambridge University Press, 2000), p. 43.

You could see a woman pulling apart a young, full-uddered, bellowing heifer, with her bare hands, and others tearing fully grown cows to pieces.[5]

In the garden of delights, the unicorn, which dips its horn into the water of the fountain of life, is already watched by its murderers who are waiting behind the bushes. Wolfgang Laib's spread-out pollen: its unity is an illusion. The wind could disperse it. The milk, which is poured onto the marble and resembles white water, eventually coagulates.

Milkstones/bloodstones. The indifference that keeps the difference.

Fat and wax: materials of difference. Beuys's sculptures of difference. In his arm he carries the dead hare. His head is covered with honey and gold.

5 Ibid., p. 45.

EXILE AND POSTAVANT-GARDE

I

Reading in R. Wagner's autobiography I discover in his fate much of my own, although I was not exactly occupied with barricades. An emigration of 10–15 years nevertheless seems to be an organic component of every essential personality — despite Goethe and Jean Paul, among others — but even my old friend Goya had to get out in his old age.
— Max Beckmann, 1948

Every emigre intellectual, without any exception, is damaged.
— Theodor W. Adorno, 1944

EXILES. After arriving in Paris in the summer of 1921, Malcolm Cowley wrote about the newest generation of writers who, like him, left America for Europe:

As an organized body of opinion, the youngest generation in American letters does not exist. There is no group, but there are individuals. There are prevailing habits of thought . . . The writers of the newest generation show more respect, if not reverence, for the work of the past . . . The youngest writers not only prefer to read Shakespeare: they may even prefer Jonson, Webster and Marlowe, Racine and Molière. They are more interested in Swift and Defoe than in Samuel Butler.[1]

New York 1984. A new generation of exiles from Europe has emerged who takes a leading part in the art of the 1980s. Like the exiles of 1921 they could not be farther apart from the art that preceded them. They address themselves to the Italian Renaissance and German Expressionism rather than

This essay originally appeared as "Artists in Exile," in *Flash Art* 122 (April–May 1985).
1 Malcolm Cowley, *Exile's Return: A Literary Odyssey of the 1920s* (New York: Penguin Books, 1994), pp. 97–99.

to the American Pop art of the 1960s and the conceptual art of the 1970s. Their idea of modernity can be found in the paintings of Manet and Picasso rather than in the works of Rauschenberg and Johns.

They, too, are no organized group but individuals from different nationalities and cultures. They take exile in the history of art. They extensively, if not excessively, make use of a *bricolage* of art history. They are less interested in innovation and originality than in allusion and repetition. They are competing with Delacroix, Tintoretto, Manet, Van Gogh, and Picasso rather than with their contemporaries: the Italians Sandro Chia who evokes Picabian sentimentality and Roman mock-heroism, and Francesco Clemente who practices traditional Indian painting; the German Rainer Fetting who imitates van Gogh in New York; the Russians Komar and Melamid who combine Italian Renaissance with Socialist Realism.

Their exile is, in the first place, not political but deliberate, something they share with others who choose the *exile within:* the Italian Enzo Cucchi in Ancona and the German Anselm Kiefer in Hornbach.

Painter of Exile I: ANSELM KIEFER

The *total* destruction by fire, other than by shattering, tearing, etc., must have attracted man's attention.
— Ludwig Wittgenstein, 1931

But the commands of this truth-speaking god and his announcements of what *is* are in fact deceiving.
— G. W. F. Hegel, 1807

Paintings of function *(Veranstaltung)* — sacrificial function. *Nürnberg (Festspielwiese):* the scenery of Hitler's rallies of sacrifice, the deceptive discourse of war.

The charred wood and the traces of blood indicate the fraud, which since Prometheus has always accompanied the sacrifice.

The fraud that appears here with the introduction of the sacrifice — namely, that it would be something magnificent for the god to get the bones and the fat (that is, the jus) and something less for man to get the meat, although the meat is the only nutritious part — this fraud is now being repeated all the time . . . Whenever a sacrifice is performed, man stands there as acknowledged defrauder . . . The function appears as one in honor of the gods but is for the benefit of man.
— Klaus Heinrich, 1970

Paintings that tell of this fraud: paintings of *difference*. It was Prometheus who introduced the fraud of sacrifice, who also stole the fire from the gods to bring a civilization to man that is found upon fraud.

Malerei der Verbrannten Erde (Painting of Burnt Earth): branded paintings — branded with the mark of Cain, the fire of Prometheus.

Grab des Unbekannten Malers (Tomb of the Unknown Painter): painting as a topography of suffering. Paintings that remind us that painting after Dachau and Stalingrad can no longer be innocent.

Painter of Exile II: ENZO CUCCHI

As for Harar, there's neither a consulate, nor the post, nor roads; one arrives on camelback, and one lives exclusively with negroes. But all told, one is free, and the climate is good.
— Arthur Rimbaud, 1890

Vitebsk Harar: an installation in New York. An installation in exile.

Vitebsk and Harar. Two places of exile: the exile of Malevich and the exile of Rimbaud. Harar: place of transit for the

caravans on their way to Abyssinia and Shoa, place of the *other* Rimbaud, the explorer and merchant. Vitebsk: place of the silence of Malevich's "white."

The journey of the exile artist is an exchange of places: the exile of Malevich becomes the exile of Cucchi. The exile of Blake becomes the exile of Clemente. The exile of van Gogh becomes the exile of Fetting.

APPENDIX: BOOKS RIMBAUD REQUESTED TO BE SENT TO HIM IN ETHIOPIA

Handbook of the Carpenter
Manual of Metal Smelting
The Commander of Steamboats
Handbook of the Explorer
Dictionary of the Arabic Language
Mineralogy
Practical Handbook for Tracklayers
Tunnels and Underground Constructions
Manual of Waterpower for Town and Country
Industrial Chemistry
Yearbook of the Shipping Authority for 1882

Painter of Exile III: RAINER FETTING

What characterizes his works as a whole is its excess . . . of strength, of nervousness, its violence of expression. In his categorical affirmation of character of things, in his often daring simplification of forms, in his insolence in confronting the sun head-on, in the vehement passion of his drawing and color, even to the smallest details of his technique, a powerful figure is revealed . . . masculine, daring, very often brutal . . . yet sometimes ingeniously delicate.
— G.-Albert Aurier (writing about Vincent van Gogh), 1890

Van Gogh, the exile in the madness of his colors. In Rainer Fetting's paintings, he is rushing alongside the Berlin wall,

hunted by his burning sun. The wall that encloses the exiled past of a nation.

Die Rückkehr der Giganten (The Return of the Giants): van Gogh and Gauguin, the romantic and the modernist.

When Gauguin was in Arles, I once or twice allowed myself to be led astray into abstraction . . . At the time, I considered abstraction an attractive method. But that was delusion, dear friend, and one soon comes up against a brick wall.
— Vincent van Gogh (to Emile Bernard), 1889

Van Gogh in New York. Hastening past big American trucks, painting the sun over New Jersey on the broken piers along the Hudson river.

The New York Painter: tightrope walking between the Old and the New World.

Holzbilder (Wood Paintings): wooden barriers blocking the pleasure of the image. Broken boards barring the aesthetic reception, bringing back the primitive power of the image.

The union of paint and wood is deceptive: it is a union of difference.

II

This, my *Dionysian* world of eternally self-creating, eternally self-destroying . . . without goal, unless the joy of the circle is itself a goal; without will, unless a ring is of good will to always turn around itself, and only around itself, on its own old track: this world of *mine* — who is bright enough to behold it without wishing himself blindness? . . . And he who would be capable of doing this, would he not have to do even more? To betroth *himself* to the "ring of rings"? With the vow of the own *return*? With the ring of the eternal self-blessing, self-affirmation? With the will to wish again and once more? To wish back all things that have ever been?
— Friedrich Nietzsche, 1885

The *backward* movement is the unethical movement *par excellence* . . .
To go around in circles is senseless, purposeless.
— Otto Weininger, 1904

THE REVERSAL OF MODERNITY. In his exile in Sils-Maria, August 1881, Friedrich Nietzsche fulfilled his reversal of modernity: *Die Umwertung aller Werte* (The Revaluation of All Values), his radical enterprise to set the madness of Dionysus against the *logos* of Socrates/Christ.

After Kierkegaard's halfhearted attempt to introduce, with his journey to Berlin, the term of the repetition as a forward movement into modern philosophy, Nietzsche formed his teaching of the *Eternal Return of the Same* against the modernist dogma of the *Einsinnigkeit der Zeit* (the irreversibility of time):

May be that some centuries later one will judge that all of German philosophy has its real dignity in being a step-by-step regaining of antique soil, and that every claim for "originality" would sound petty and ridiculous.[2]

2 Friedrich Nietzsche, *Kritische Studienausgabe*, eds. Georgio Colli and Mazzino Montinari, vol. 11 (Munich: Deutscher Taschenbuch Verlag/ Walter de Gruyter, 1999), p. 678, par. 41[4] (my translation).

Nietzsche's recluse undertaken at the height of Modernism did not stop its rise, and three years after Nietzsche's death, the most violent thinker of modernity in the nineteenth century, the young Viennese philosopher Otto Weininger, wrote this against Nietzsche:

Kant's loneliest man does not dance and does not laugh; he does not bawl or and does not cheer: he feels no need to make noise because the universe is profoundly silent. He is not bound to a meaninglessness world "by chance"; rather his duty is to the meaning of the universe. Assenting to this loneliness is the "Dionysian" element in Kant.[3]

— before he shot himself, at the age of twenty-three, in the house where Beethoven had died seventy-six years earlier, the composer of modernity whom Weininger set against Nietzsche's Wagner:

The main motif of the "Appassionata" . . . is the greatest motif of the irreversible forward direction of time.[4]

3 Otto Weininger, *Geschlecht und Charakter* (Munich: Matthes & Seitz, 1980), p. 211 (my translation).
4 Otto Weininger, *Über die letzen Dinge* (Munich: Matthes & Seitz, 1980), pp. 118–19 (my translation).

III

In its old sense the verb "bricoler" applied to ball games and billiards, to hunting, shooting, and riding. It was however always used with reference to some extraneous movement: a ball rebounding, a dog straining, or a horse swerving from its direct course to avoid an obstacle. And in our time, the "bricoleur" is still someone who works with his hands and uses devious means compared to those of a craftsman . . . The "bricoleur" is adept at performing a large number of diverse tasks; but, unlike the engineer, he does not subordinate each of them to the availability of raw materials and tools conceived and procured for the purpose of the project. His universe of instruments is closed and the rules of his game are always to make do with "whatever is at hand," that is to say with a set of tools and materials which is always finite and which is also heterogeneous because what it contains bears no relation to the current project, or indeed to any particular project, but is the contingent result of all the occasions to maintain it with the remains of previous constructions or destructions.
— Claude Lévi-Strauss, 1962

EXILE AND BRICOLAGE. The universe of the bricoleur artist is closed because of his displacement. Cut off from his homeland, he lives on his portable collection of quotations and memories. His *library* is complete and discontinued.

His method is essentially ahistoric and devious. He finds his material in the history of his art only as far as it is part of his library.

When collecting, the decisive factor is that the object is dissociated from its original functions in order to enter the closest relationship possible to one of its kind. This relationship is the diametrical opposite of utility and stands under the peculiar category of completeness. What is the meaning of this "completeness"? It is the grandiose attempt to overcome the total irrationality of its mere presence by integrating it into a new, specially created historic system, the collection.
— Walter Benjamin, 1927–40

The result of bricolage is always a compilation of objects found, "driftworks" (Lyotard), like Piranesi's frontispiece to

his *Antichità Romane*, an assembly of styles from all times put together to form one gigantic antimodern architecture, revealing the *substructures of Modernism*, which that one denies — and therewith denies what is at the same time essential to it, what keeps it alive.

The intention of the bricoleur artist is more to adapt and rework that which has already been done than to continue the progressive forward movement of Modernism.

His idea of art is not defined by originality but by *displaceability*. His movement is circling and repetitive. His attitude towards the idea of progress is defined by a Promethean dialectic: that progress has always been both liberating and binding.

IV

In its nomad creativity, art in the 70s has found its own movement par excellence, the possibility of unlimited free transit inside all territories with open references in all directions . . . The *transavant-garde* means taking a nomad position, which respects no definitive engagement, which has no privileged ethic beyond that of obeying the dictates of a mental and material temperature synchronous to the instantaneity of the work.
— Achille Bonito Oliva, 1979

EXILE AND TRANSIT. Unlike the bricoleur/emigre artist, the nomadic artist of the *trans-avanguardia* (Oliva) does not have a library. He uses whatever comes his way without keeping anything longer than necessary.

He does not leave a home behind. A transient of territories and languages, he is always passing through. He is a "foreigner of some sort," like Henry James's European, who lives everywhere and does not know where he comes from.

Presence and place are essential modes of his being, while the past is of no significance to him who always asks: *Where am I?* He is a cosmopolite, a citizen of the world. His philosophy is essentially Stoic.

The emigre artist, on the other hand, will always be bound to the place from where he came. He is a citizen of two worlds. In his exile he will always be a stranger. He lives a life in difference, torn between his home and his exile.

He cares more about where he came from than where he is. His essential mode of being is the past. His philosophy is essentially Gnostic. In his art he follows a circular, labyrinthine path the center of which is his lost home.

THE SOLID AND THE FLUID –
BARTLETT, LAIB, KIEFER

I

The house shelters the unconscious.
— Gaston Bachelard, 1958

Houses, boats, pool — retaining memories of childhood. Images of prenatal protection and fluidity. Jennifer Bartlett's houses are not empty geometrical spaces but inhabited wombs sheltering the world of the unconscious.

The sea — primordial waters that bear under themselves the forgotten ground of life. Solid sheets of water, shattered in pieces in the pool that indicate a rape, the solidification of the fluid.

The fluids — milk, blood, sperm. The discourse of the fluid. Indefinite, unstable, illogical, evading the mathematics of the solid.

Houses, boats, pool — female bodies, the architecture of *feminitude*, disclosing the underworld of the male discourse of the solid.

This essay originally appeared in *Flash Art* 123 (Summer 1985).

II

The question is: is constructing a "transparent white body" like constructing a "regular biangle"?
— Ludwig Wittgenstein, 1951

Marble and milk — the solid and the fluid. The transformation of marble into milk. The liquefaction of the solid.

Wolfgang Laib's milkstones are reversing the solidification of art. The marble becomes transparent, formless, perishable.

The amalgamation of the incompatible, violating the principles of logic.

III

My body of Iran fallen prey to insurrection. My body of Russia fallen prey to oppression. My body of Afghanistan fallen prey to invasion. My body of rockets devastating the houses. My body of guns decimating the population.
— Jeanne Hyvrard, 1982

The Red Sea — sacrificial tub and battlefield. Blood and lead — the fluid of vengeance and the metal of war.

Anselm Kiefer's canvases are bodies of suffering. The body of Israel. The body of Egypt. The body of Germany.

The solidification of color — by extracting the lead from the paint, Kiefer makes visible that there is no indifference of color, that there is no innocence of art: the holocaust is immanent.

Pillar of cloud — pillar of lead, weapon of the revenging god.

Kiefer's lead, spattered on the canvas, reminds us that metal has to be liquefied to make weapons, that the solid, by denying the fluid, denies that which is essential to it.

ART AND MASQUERADE

I. The Inversion of the Ordinary

The manifest censorship imposed by the orthodox discourse, the official way of speaking and thinking the world, conceals another, more radical censorship: the overt opposition between "right" opinion and "left" or "wrong" opinion, which delimits *the universe of possible discourse,* be it legitimate or illegitimate, euphemistic or blasphemous, masks in its turn the fundamental opposition between the universe of things that can be stated, and hence thought, and the universe of that which is unsaid. The universe of discourse . . . is practically defined in relation to the necessarily unnoticed complementary class that is constituted by the universe of that which is undiscussed, unnamed.
— Pierre Bourdieu, 1977

The mask is the implement of comedy, the world *upside down.* In the comedy, the mask takes the place of Dionysus. Through it, the *absent* god is present, reminding the spectator that tragedy and comedy always appear together, that life and death are invertible. The mask has *content.*

In the *Bacchae* by Euripides, Dionysus is both sacrifice and sacrificer. The hunter (Pentheus) becomes the hunted; the hunted (Dionysus), the hunter.

The *omophagia,* the slaughtering of Pentheus, is preceded by *masquerade:*

Pentheus
Well, what clothes will you make me put on?
Dionysus
I will hang long hair from your head.
Pentheus
And the next item of my costume?

This essay originally appeared in *Art & Text* 19 (1985).

Dionysus
A dress down to your feet. And there will be a headband on your head.
Pentheus
Oh! And will you make wear anything else besides that?
Dionysus
A thyrsus in your hand, and a dappled fawnskin.[1]

— tragedy, by comedy:

Dionysus
But this curl has fallen out of place. It isn't where I fastened it under your headband.
Pentheus
I must have thrown it out of place when I was dancing as a bacchant inside the palace, shaking my head up and down.
Dionysus
Well, my job is to look after you, so I will put it back in place.
Keep your head still.
Pentheus
Here, you arrange it: I am in your hands now.
Dionysus
Your belt is loose, and the folds of your dress don't hang smoothly to your ankles.[2]

The place of the absent Dionysus is the *universe of the undiscussed, nonrepresented.* The mask brings the undiscussed into discussion, the nonrepresented into representation. By turning the world upside down, the known becomes unknown; the representational, nonrepresentational; the identical, different.

Inversion, negation, and masquerade are manners of creating the extraordinary out of the ordinary, means of representing the repressed, the unconscious, the *Other.*

1 Euripides, *Bacchae*, trans. David Franklin (Cambridge: Cambridge University Press, 2000), p. 51.
2 Ibid., p. 57.

An object painted on its head is suited for painting, because it is unsuited as an object.
— Georg Baselitz, 1981

He felt no fatigue, except sometimes it annoyed him that he could not walk on his head.
— Georg Büchner, 1835

In art that turns itself upside down (Baselitz) or disguises (Dokoupil), meaning becomes absent but not inexistent. It becomes *absent-present*, difference — the difference between the mask and that which it represents, between the *signifier* and the *signified*.

Baselitz is turning the world upside down, as though he put Stratton's inverting spectacles on the viewer, thus suspending the inversion of the retinal image.

Objects become nonobjects, transcend their objectivity: the viewer recognizes the image (tree, person, bottle) but not as he knows it.

Images are painted over, covered with other images. The surface itself becomes mask. Top becomes bottom; background, foreground, and vice versa.

In Dokoupil's "Theoretical Paintings," the images are distorted, exaggerated, almost unrecognizable — as if seen through a fun-house mirror. In his "Masks," abstract forms pose as masks, indicating that content *is* present in abstraction.

The styles he constantly invents become masks behind which the artist disappears.

II. Mask and Facade

Modern aesthetics is an aesthetics of the sublime, though a nostalgic one. It allows the unpresentable to be put forward only as the missing contents; but the form, because of its recognizable consistency, continues to offer the reader or viewer matter for solace and pleasure . . . The postmodern would be that which, in the modern, puts forward the unpresentable in presentation itself; that which denies itself the solace of good forms.
— Jean-François Lyotard, 1982

What need of prose, or verse, or sense . . . ? Or to make boards to speak! There is a task! Painting and carpentry are the soul of the masque. Pack with your peddling poetry to the stage, this is the money-got, mechanic age.
— Ben Jonson, 1611

A mask tells us more than a face.
— Oscar Wilde, 1889

Following Jean-François Lyotard ("A work can become modern only if it is first postmodern"), the postmodern would be that which *turns art into mask*; the modern, that which *turns mask into facade.*

The voidance of the mask, the transformation of the mask into facade, is reflected in the conflict between form (decor) and content (text) in the English court masque, between the architect (Inigo Jones) and the poet (Ben Jonson), which came about in the middle of the seventeenth century and ended with the victory of the architect and the text becoming *decor.* The triumph of the facade marked not only the beginning of the modern spectacle but the end of the Dionysian theater (not to return to the stage until Mozart and Da Ponte). Devoid of content, the mask became an empty play with itself.

The facading of courtly society went hand in hand with the detachment of man from nature. The mask had become the face; the masquerade (mask, peruke, and fan), *second nature.*

There is in the trivial things of life, in the daily changing of external things, a speed of movement that imposes upon the artist an equal speed of execution . . . His excessive love of visible, tangible things, in their most plastic form, inspires him with a certain dislike of those things that go to make up the intangible kingdom of the metaphysician.
— Charles Baudelaire, 1863

Painters of modern life: painters of facade. In Markus Lüpertz's paintings, which are executed in staccato-like brushstrokes and modernist speed, content becomes decor; style, manner.

Lüpertz resembles the modern dandy of Baudelaire who has a "burning desire to create a personal form of originality within the external limits of social convention," manipulating art to express his own highly individual standpoint: *Standbein/Spielbein* (Contrapposto) — Lüpertz's contribution to the *Zeitgeist* exhibition in Berlin, the standpoint/standing leg of modernist chauvinism.

Lüpertz's manner of repetition is not a Dionysian-Nietzschean affirmation of the invertibility of life and death, the affirmation of the negation, but rather a Baudelarian affirmation of modern life. The mask that appears on many of his canvases is not the mask of Dionysus but empty decor.

Taste is the most faithful seismograph of historical experience . . . Artists who disgust, shock, speakers of unmitigated cruelties, let themselves guide, in their idiosyncrasy, by taste . . . The tender shudder, the pathos of difference are only standardized masks of the cult of suppression.
— Theodor W. Adorno, 1944

David Salle's paintings do not redeem their pretension of postmodernity. The bricolage of quotations from Modernism becomes an end in itself, *pseudobricolage.*

The quotations remain facade, neglecting the existence of the undiscussed. Facadism as pseudopostmodernism.

III. Imitation and Sacrifice

The imitated object makes something appear which remained invisible, or if one prefers, unintelligible.
— Roland Barthes, 1963

A certain practice accompanies sacrifice . . . This practice is the representation that generally precedes sacrifice; it is the laboratory for, among other things, theater, poetry, song, dance — art. That the combat it mimes precedes the sacrificial slaying is less important than the fact that it *mimes*.
— Julia Kristeva, 1974

Through imitation, the invisible becomes visible; the absent, present. Through affirmation, emptiness becomes content; facade, mask. The inversion of modernity: the replenishment of the facade.

By copying modern art (Picasso, Pollock, Warhol, Schnabel), Mike Bidlo reverses the transformation of the mask into facade that took place in modern art. By virtually turning the theory of the postmodern upside down, he demonstrates that a work that had first been postmodern, then became modern, can become postmodern again.

O Lamb of God unspotted,
There slaughtered on the cross,
Serene and ever patient,
Though scorned and cruelly tortured.
— J.S. Bach, 1727

The sacrifice is at home in the essence of the event through which Being claims man for the truth of Being.
— Martin Heidegger, 1943

The artist, like the actor on the stage of a Greek tragedy, is the imitator of Dionysus. In every performance of his art, he repeats anew the truth of sacrifice. His self-portraits imitate Christ/Dionysus. They are masks of Dionysus.

The artist: both sacrificing priest and sacrifice. Anselm Kiefer imitates on his canvases the sacrifice of war. Painting as topographic mimesis of suffering: *Unternehmen Seelöwe* (Operation Sea Lion); *Waterloo, Waterloo, Et la terre tremble encore; Nürnberg.*

The artist as substitutional sacrifice: *Grab des Unbekannten Malers* (Tomb of the Unknown Painter).

Salomé and Luciano Castelli imitate suffering at the risk of their own bodies: exposed to violence in the streets, in the exhibition hall, on the canvas. In Rainer Fetting's *Kreuzigung* (Crucifixion), it is his body that is nailed to the cross.

The body of the artist becomes the body of Dionysus, Christ. Performance of imitation, co-suffering.

IV. Mask and Exile

The world is everything that is the Fall.[3]
— Ludwig Wittgenstein, 1922

Homeland is the state of being escaped.
— Max Horkheimer and Theodor W. Adorno, 1944

The world upside down, the masquerade, is always the result of a *displacement after the catastrophe.*

The world upside down is the world *after.* In *Mad Max Beyond Thunderdome* (1985), the postsociety is one of inverted order: the underworld becomes the upper world; the least valuable (pig shit), the most valuable (fuel).

The displacement *(Verschiebung)* is of the kind Freud called, in *The Interpretation of Dreams,* an "exchange of linguistic expression": the exchange between the universe of the discourse and the universe of the undiscussed, the *off-discourse.*

In art, the catastrophe takes place in the aesthetic subject. The masquerade of the aesthetic object is the *exile* of the aesthetic subject.

The process of displacement is a process of sacrifice: exile *is* sacrifice.

Adorno's *Minima Moralia* shows the emigre intellectual in his *damaged* state ("Every emigre intellectual, without any exception, is damaged."[4]) as a perceiver of crises and disasters invisible to others.

3 The opening sentence of Wittgenstein's *Tractatus Logico-Philosophicus* ("Die Welt ist alles, was der Fall ist") is usually translated into English as "The world is everything that is the case," which omits the double meaning of the German *Fall* as "case" and "Fall (of man)."
4 Theodor W. Adorno, *Gesammelte Schriften,* vol. 4, ed. Rolf Tiedemann (Frankfurt am Main: Suhrkamp Verlag, 1997), p. 35.

Like the emigre intellectual, the emigre artist endlessly repeats the original holocaust in his art. For the emigre artist there can no longer be innocence, pleasure in art. Art becomes *art after.*

The masks in the self-portraits of Felix Nussbaum, painted during an eleven-year long exile that ended in Auschwitz, indicate the sacrifice of the artist. The holocaust does not end exile but precedes it.

THE WORLD ACCORDING TO ...
BYARS, BEUYS, DOKOUPIL

I. BYARS

Golden is a surface colour.
— Ludwig Wittgenstein (1951)

Gold and money have their origin in the sacrificial cult. In Greece a common monetary unit is the *obolos*, originally the skewer on which each participant of a sacrificial feast put the part of the meat that is allotted to him. In Egypt the seals that were used to mark the sacrificial animals depicted a kneeling man who was bound to a pale with a knife pointing to his throat — the original sacrifice. The seals represent the idea of the sacrificial substitution, which became the base of the monetary system. The oldest coins symbolize sacrificial animals or implements, like the axe or the tripod, which they depict. The pictorial representation has always been connected to sacrifice, and since Prometheus the sacrifice has been accompanied by fraud:[1] the *profit* (only an inferior part is for the gods), which leads to the accumulation of capital and the beginnings of trade and exchange.

The sacrificial context of art is still present in the Renaissance when, in the connection of art and money, painting undergoes a second substitution and becomes a commodity. In Fra Angelico's *The Martyrdom of Saints Cosmas and Damian*, the beheaded halos are like gold coins attached to the heads of the saints who were called "enemies of money" because

This essay originally appeared in *Flash Art* 125 (December 1985–January 1986).

[1] In *Theogony* 636–560, Hesiod describes how Prometheus introduced fraud into the sacrifice by wrapping bones in fat and offering them to the gods.

they practiced medicine without charging fees. The scene contains both original sacrifice (the decapitation) and substitutional sacrifice (the offertory).

Postmodern art uses gold to emphasize the sacrificial context of representation, which modern art denies, and reveals its fraudulent character, the gilding. James Lee Byars's *Halo* is golden only on the outside — the inside is made of brass.

II. BEUYS

The world picture does not change from an earlier medieval one to a modern one, but rather the fact that the world becomes picture at all is what distinguishes the essence of the modern age.
— Martin Heidegger, 1938

In modern art, the world becomes representation, substitution, money. It is built upon the fraud while, at the same time, it denies the sacrificial context of art. In postmodern art, the representation becomes again the original sacrifice, a sacrifice without fraud, without accumulation.

Money becomes honey; gold, rust; accumulation, bloodstream. But the postcapitalist world of Joseph Beuys is not an innocent world. Its bandaged wounds are still visible. It is the world after sacrifice.

III. DOKOUPIL

Childhood images, images which a child could make, images which a poet tells us that a child has made are, for us, manifestations of the permanent childhood.
— Gaston Bachelard, 1960

The postmodern world is characterized by recentralization. In a universe that has no limits, everywhere is the center. The earth becomes again the center of the universe. The globe becomes an icon of the postmodern age.

The postmodern artist views the world every time for the first time. His world is the world of the first time, the original world. He paints every time for the first time. Every canvas is the first canvas; every sacrifice, the original sacrifice. The world without the fraud. The postmodern artist is the permanent child. He is what Bachelard calls a "dreamer of childhoods." Everything around him is young: the globe, the canvas, the lamb.

Jiri Georg Dokoupil's paintings are allegories of the permanent childhood, the *Americanism* of postmodern art.

WHO PAINTS ABSTRACTLY?

Think? Abstractly? — *Sauve qui peut!* Everyone for himself! Already I hear a traitor, bought by the enemy, cry out these words, denouncing this essay because it will plainly deal with metaphysics. For *metaphysics* is the word, no less than *abstract*, and almost *thinking* as well, from which everyone runs away as from someone who has caught the plague.
— G. W. F. Hegel, 1807

Abstraction today is no longer that of the map, the double, the mirror, or the concept.
— Jean Baudrillard, 1981

I. *Away*/Blinky Palermo

There are born travelers among men; those are the *exotics*.
— Victor Segalen, 1908

The geography: Düsseldorf, Palermo, New York, Male, Sri Lanka. Surroundings. Landscapes. Spaces.

Spaces between forms, colors, surfaces. Interspaces, gaps, breaks.

The fragmentation of space, in which the invisible becomes visible; the nonrepresentable, representable.

The postmodern artist is a *traveler*, inundated by the outside world, who, in this overreceptive and overstimulated condition, creates an aesthetic *state of exception* in which the senses become more irritable and more susceptible to the nonrepresentable.

This essay originally appeared in *Flash Art* 126 (February–March 1986).

II. *The Mirror Stage*/Melissa Miller

The mirror stage is a drama whose internal thrust is precipitated from insufficiency to anticipation — and which manufactures for the subject caught up in the lure of spatial identification a succession of phantasies that extends from a fragmented body-image to a form of its totality that I shall call "orthopedic" — and lastly, to the assumption of the armor of an alienating identity.
— Jacques Lacan, 1949

Identifications, disguises, masquerades. Wolf and deer, baboon and leopard, rabbit and fox. The hunter becomes the hunted; the prey, the predator.

The postmodern condition. The world of original aggression and anxiety. The world without identity. The *infantile* world.

The postmodern condition corresponds to the phases in the mirror stage of the infant that, according to Lacan, precede the forming of the identity: the "fragmented body" and "transitivism."

That everybody present knows what thinking is and what is abstract is presupposed in good society, and we certainly are in good society, the question is merely *who* thinks abstractly.
— G. W. F. Hegel, 1807

I believe that there is some point in stressing the relation existing between the dimension of space and a subjective tension, which in the malaise of civilization intersects with that of anxiety.
— Jacques Lacan, 1948

In the utmost abstraction and in the utmost figuration the question is no longer one of figuration or nonfiguration. Both figurative and nonfigurative painting on an existential scale are expressions of the artists being thrown into the postmodern condition in an *age of anxiety*.

Fragmentation and transitivism open painting to the nonrepresentable, to the original aggression and anxiety.

MANNERISM ANTIMANNERISM

I. The End of the Avant-Garde

We cannot expect the avant-garde of the past, present and future to obey the same logic, assume the same forms. For instance, the new avant-garde need not have a historical consciousness, express recognizable values, or endorse radical politics. It need not shock, surprise, protest. The new avant-garde may not be an "avant-garde" at all: simply an agent of yet invisible change.
— Ihab Hassan, 1984

In an amazing acceleration, the generations precipitate themselves. A work can become modern only if it is first postmodern. Postmodernism thus understood is not modernism at its end but in the nascent state, and this state is constant.
— Jean-François Lyotard, 1982

The appropriative mannerism in current art comprises, in opposition to preceding forms of mannerism, an inherent *antimannerist* style. Just as mannerism tends to return to a position that preceded Modernism, the antimannerist style shows a preferred sympathy toward Modernism, toward Pop and minimal art. Both mannerism and antimannerism are just different forms of postmodernism.

Although it is true of the postmodern that it precedes the modern, both may appear simultaneously or even become identical. Within the postmodern pastiche we can distinguish a mannerist postmodernism (Ellen Carey, Jack Goldstein), a baroque postmodernism (Tim Maul), a romanticist postmodernism (Richard Hambleton), an expressionist postmodernism (Jed Jackson), and even a "modernist" postmodernism (Jeff Koons, Mike Bidlo, John Dogg). They all share

This essay originally appeared in *Flash Art* 131 (December 1986–January 1987).

mannerist as well as antimannerist elements, which means that each artist belongs to at least one other category.

We must do away with all *explanation,* and description alone must take its place.
— Ludwig Wittgenstein, 1945–49

Space is not in the subject nor is the world in space. Space is rather "in" the world in so far as space has been disclosed by that Being-in-the-world which is constitutive for Being (*Dasein*). Space is not to be found in the subject, nor does the subject observe the world "as if" that world were in a space; but the subject (*Dasein*), if well understood ontologically, is spatial.
— Martin Heidegger, 1927

The mannerists share a tendency to superficiality in the sense that the problem of three-dimensional space vanishes without reducing art to purely flat surfaces. The superimposed geometrical patterns in Ellen Carey's photographs counteract against spatiality by uniting the bodies with the space that surrounds them. John Dogg's tires suspend the spatiality of his Judd-like boxes, the empty shape becomes container; the spatiality, surface. The same is true of the vinyl covers in regard to the tire. In each case, the artistic effort is directed toward the suspension or reduction of spatiality.

The romanticists are obsessed with *necrophilia,* the unfulfillable desire to represent the nonrepresentable, as in Richard Hambleton's spheric paintings, the linking of the visible with the invisible; the representable with the nonrepresentable.

The modernists differ from their predecessors in their perfunctory affirmation and playful and childlike simulation of the modern. Mike Bidlo's simulations of modern art not only eliminate the concept of originality and do away with the authority of Modernism by its imitation but also turn the theory of the postmodern upside down by changing modern back into postmodern. He upsets by negating the uniqueness of artworks and artistic creation.

II. The Future of Art

The painter dragged a pile of unframed canvases from under the bed; they were so thickly covered with dust that when he blew some of it from the topmost, K. was almost blinded and choked by the cloud that flew up. "Wild Nature, a heathscape," said the painter, handing K. the picture. It showed two stunted trees standing far apart from each other in darkish grass. In the background was a many-hued sunset. "Fine," said K., "I'll buy it." K.'s curtness had been unthinking and so he was glad when the painter, instead of being offended, lifted another canvas from the floor. "Here's the companion picture," he said. It might be intended as a companion picture, but there was not the slightest difference that one could see between it and the other, here were the two trees, here the grass, and there the sunset. "They're fine prospects," he said. "I'll buy both of them and hang them up in my office." "You seem to like the subject," said the painter, fishing out a third canvas. "By a lucky chance I have another of these studies here." But it was not merely a similar study, it was simply the same wild heathscape again.
— Franz Kafka, 1925

Under European aspects things looked as follows: in all industrial products from the Middle Ages up to the beginning of the nineteenth century the development of technology went on much slower than the development of art. Art could take time to play around the technical methods in manifold ways. The change of things, which began around 1800, dictated to the art the speed, and the more breathtaking the speed became, the more the dominion of fashion spread to all areas. Finally it reached today's state of affairs: the possibility of art not having the time to tune into the technological process is within sight. The advertisement is the cunning with which the dream forces itself upon the industry.
— Walter Benjamin, 1927–40

Simulation art upsets and causes ignorance because it negates the concept of artistic creation that has been the foundation of modern art since the nineteenth century: the artist as the ingenious creator of original artworks that bear his or her unique signature and are produced in a historical effort

to continue the progressive development of art that has to do with breakthroughs that resemble the series of discoveries in nineteenth-century science.

Simulation art is neither a standstill nor a temporary crisis of creativity on account of a lack of originality. Instead it does away with the modernist conception of a continuing avant-garde. For the first time there is an art that leaves the positions of nineteenth-century art theory behind and keeps step with today's simulative technoscience, moving in a circular or spiral motion rather than in a rectilinear progression and mixing itself with advertisement, television and video, which today have almost exclusively taken up the task of visual representation.

Simulation art replaces shock with assimilation; originality with simulation. It has no need to transform advertisement and consumer goods into art: art *is* advertisement, consumer goods, and vice versa.

Tim Maul's photographs of corporate office interiors and Jeff Koons's simulations of advertisements are anticipations of a new *baroque* "corporate" art that will make the institutions of gallery, museums, and collector obsolete: *art as simulation of reproductions without originals,* in magazines and on billboards, noncollectable because of its nonunique, reproductive character.

ROSEMARIE TROCKEL

I

On the old problem: "What is German?" — Recapitulate in your mind the real achievements of philosophical thinking that one owes to the Germans. Is there any legitimate sense in which one might give credit for these achievements to the whole race? May we say that they are at the same time the products of "the German soul," or at least symptoms of that . . . ? Or should the opposite be the truth? Might they be just as individual, just as much exceptions from the spirit of the race as was, for example, Goethe's paganism with a good conscience? . . . In short, were the German philosophers really — philosophical Germans? . . . Yes, without any doubt . . . We Germans are Hegelians even if there had never been any Hegel, insofar as we (unlike all Latins) instinctively attribute a deeper meaning and greater value to becoming and development than to what "is"; we hardly believe in the justification of the concept of "being" — and also insofar as we are not inclined to concede that our human logic is logic as such or the only kind of logic (we would rather persuade ourselves that it is merely a special case and perhaps one of the oddest and most stupid cases).
— Friedrich Nietzsche, 1882

Who in his heart doubts either that the facts of feminine clothiering are there all the time or that the feminine fiction, stranger than the facts, is there also at the same time, only a little to the rere? Or that one may be separated from the other? Or that both may be contemplated simultaneously? Or that each may be taken up in turn and considered apart from the other?
— James Joyce, 1939

The art of Rosemarie Trockel is vigorous, subversive, postmodern, sensitive, German, disquieting, feminine, autonomous, surprising, masculine, poetic, obtrusive, modern, decorative, deconstructive. It gives a postmodern edge to modern

This essay originally appeared in *Flash Art* 134 (May 1987).

art and a modern edge to postmodern art. It refuses any superficial definition and classification. Her knitted paintings bearing stripes or logos and her sculptures that seem like hybrids of the works of Jeff Koons and Joseph Beuys bring her close to the current neominimal/neomodernist art, but only to deconstruct it; to represent that which is excluded from it, the nonvisible, the nonrepresented. But the knitted paintings are not only a deconstruction of masculinist representation; they are also a takeoff on the cloth simulacrum of early feminist art. The "new pure wool" logo in her paintings represents at the same time the program of masculinist modernism and the sphere of female activity that is excluded from it. It also plays with the implication of a promise of quality: art that bears a quality seal.

Trockel's work is about exclusion, but it does not exclude itself from the current discourse of representation. The logos and the patterns taken from knitting books and magazines are as much metaphors of simulation as Richard Prince's jokes or the contact papers in Vicky Alexander's work. Like Jeff Koons's work, Trockel's art is a comment on consumerism. But she never falls into the modernist trap, into mere fascination with the representable facade. Instead she undertakes a deconstructive dialogue with modern art, a dialogue between the represented and the nonrepresentable.

II

Here, in the very limited domain in which we are studying images, we should have to resolve the contradictions of the shell, which at times is so rough outside and so soft, so pearly, in its intimacy.
— Gaston Bachelard, 1958

According to the masculinist universe of the represented, the feminine does not exist. It becomes the nonrepresented, the nonrepresentable — a remainder like Kant's *Ding an sich*. As such it continues to exist in the exiles of dreams madness, and hysteria. While the modernist painting is essentially facade and denies the existence of the nonrepresented, Trockel's work attempts to represent the nonrepresentable. It interrupts the communication with the represented for the communication with the nonrepresentable, the noncommunication.

One of her recent sculptures consists of an arrangement of bronze seashells suspended within a glass vitrine. Again the materials used successfully carry on a dialogue of *feminitude* with (neo)modern art. The glass vitrine corresponds to Jeff Koons's aquariums and the naturally polished inside of the shells to the high-polished stainless steel of his recent objects. The shell as primal image of femininity, symbol of birth and rebirth, replaces the floating basketballs, symbol of the male world of sports, and their implication of equilibrium. The vitrine recalls the *cave* that in our matriarchal past contained the secrets of birth and death. Secrets of which only the women knew. For the men the cave became the nonrepresentable.

It is the same cave that with Plato, in a process of reversal, became the birthplace of (masculinist) philosophy, a philosophy whose concern since then has always been the negation of the nonrepresentable. Its truth, therefore, had to originate in the light, in a process of enlightenment, as against the darkness of the cave. But the early philosophers still received their truth from women, and the cave has always appeared, in one form or another, in masculinist representation

BERLIN: A PLACE FOR PAINTING

The British rock star David Bowie, in a period of personal and artistic depression, moved from Los Angeles to West Berlin in 1976, drawn by the city's tradition of decadence, its never-ending nightlife (Berlin is the only place in Europe without legal closing times), transvestite bars, cabarets, and theaters — and especially the city's fast pace. "One never knows how long it's going to remain there. One fancies that it's going very fast. That's why I was attracted to the city," he said. The singer often left his apartment, located in Schöneberg, a district with a large Turkish population, to visit the art galleries around town, and he began to paint portraits and scenes from his neighborhood almost every day.

Berlin has always been a place for painting. The exhibition *BERLINART 1961–1987*, opening on June 4 at the Museum of Modern Art in New York and then traveling to the San Francisco Museum of Modern Art, is concurrent with Berlin's 750th anniversary. The show focuses on a city whose artists have always been first and foremost painters. They remained significantly unaffected by Pop, minimal, or conceptual art, movements more ideologically oriented and less concerned with the primacy of paint, the flow of color from brush to canvas.

Geographically, politically, and economically isolated and artificially sustained through generous government subsidies, Berlin has become a cultural island. After the war, while such West German cities as Düsseldorf and Cologne looked toward the avant-garde in Paris and later New York, Berlin pursued its own romanticist and expressionist tradition, invoking artists like Caspar David Friedrich and Ernst Ludwig Kirchner. The cultural insularity released forces

This essay originally appeared in *Harper's Bazaar* (June 1987).

that achieved their intensity from both a reference to that tradition and an unshakable faith in the force of painted expression.

The exhibition spans three generations of continuous painting, starting with the historic turn to figurative work at the beginning of the 1960s by artists Georg Baselitz, Bernd Koberling, and Markus Lüpertz. This move coincided with the erection in 1961 of the Berlin Wall by the East German government, a structure that not only physically separated the city but also became a brutal presence.

In the 1960s, Berlin was not the liberal and commercially busy center it is today. When paintings by Baselitz were exhibited for the first time in 1963, the local tabloids reported that they contained pornography. Lines formed in front of the gallery, but the public left disappointed after seeing two works that showed frail and morbid nude male figures. Yet the paintings were confiscated as "obscene" by the authorities. Baselitz and his art dealers were each fined $200.

Baselitz, today best known for his notorious practice of painting recognizable images upside down, came to West Berlin in 1957, after being thrown out of the art academy in East Berlin because of his "social immaturity." He was born Hans-Georg Kern in 1938 and adopted the name Baselitz based on his place of birth, Deutschbaselitz in Saxony. But neither the obligatory Socialist Realism of East Germany nor the nonfigurative Western abstraction offered the young painter the possibility of formulating an existential expression of life through painting.

Baselitz, along with Lüpertz, Karl Horst Hödicke, Koberling, and A.R. Penck, belongs to a generation of artists that no longer bear the guilt for the crimes of Nazi Germany or feel the need to avoid dealing with the recent past. Even portraying the figure had become a rebellious act in a country where abstract painters had held all the important posts in art schools since 1945. In Berlin, this struggle for identity

also responded to the "Americanization" of West Germany's political, economic, and cultural life.

Lüpertz best personifies the position of this new generation after 1960 — the artist as a heroic outsider who creates his own laws and turns away from society. One of the most glittering stars of the Berlin art scene, he is a true Baudelairian dandy who loves beautiful women and fast cars. In 1962, he arrived in Berlin, where he invented a half-abstract figure, which he termed a "dithyrambe." This served as a metaphor for his drunken artistic feelings.

In 1977, a group of young artists established a cooperative gallery in a factory building close to the Berlin Wall, in the heart of Kreuzberg. The Galerie am Moritzplatz was founded by painters Rainer Fetting, Salomé, Helmut Middendorf, and Bernd Zimmer. It became the birthplace of Heftige Malerei (Vehement Painting), so called because of the "wild" style of the four "Moritzboys," characterized by rapidly executed brushstrokes and bright colors.

New Wave and Punk music formed the background to this younger generation. Punk music halls, like the SO 36 in Kreuzberg, not only inspired Fetting and Middendorf but also became the scene of painting. In the late 1970s, Fetting, Middendorf, and Zimmer worked together or alone on the walls of the SO 36.

In his first show at the Moritzplatz gallery in 1977, Fetting (who today lives and works mostly in New York) exhibited large depictions of the Berlin Wall and buildings in Kreuzberg. Salomé was then not only a painter but also a performance artist. He once sat for twelve hours on a pink satin sheet in the window of a gallery, remaining motionless except for a change of position every hour. He wore only a black garter belt, black nylons, and a black mask. Lined up in front of him were various fetish objects. As with his performances, in his paintings he was obsessed then with homosexuality, transvestism, and fetishism.

Berlin's nightlife is the main theme of Middendorf's work, while Zimmer, originally from a rural part of southern Germany, fills his large canvases with fields, meadows, and cow heads. Artists' cooperatives had existed in Berlin since the 1960s, but never before did one achieve the fame of the Moritzplatz gallery.

Heftige Malerei soon became perhaps the most internationally celebrated German art movement since the Expressionism of the 1920s. In 1980, two prominent Swiss art dealers were the first to buy large quantities of their works. At the same time, the exhibition *A New Spirit in Painting* at the Royal Academy in London placed canvases by Lüpertz, Hödicke, and Fetting next to those by Pablo Picasso, Francis Bacon, and Willem de Kooning. Exhibitions in London and New York soon followed.

The development of Berlin as a center of new art reached its climax in 1982 with *Zeitgeist*, an exhibition of 237 paintings and sculptures by 45 international artists. They included Julian Schnabel, David Salle, and Andy Warhol from the U.S.; Sandro Chia, Enzo Cucchi, and Francesco Clemente from Italy; and from Germany, Baselitz, Koberling, Lüpertz, Hödicke, Salomé, and Fetting. It was made possible through a subsidy of $600,000 from the city of Berlin and took place in a bomb-scarred, partially restored former decorative arts museum. Dramatically located adjacent to the Berlin Wall and the former Gestapo headquarters, the space was filled largely with neoexpressionist painting and sculpture.

The exhibition was criticized for its "blatant sexual bias," since of the 45 artists only one was a woman, the American Susan Rothenberg. This criticism could be extended to the local art scene as well. Berlin art has always been "boy art." Although there are women painters in Germany today — among them, Elvira Bach and Ina Barfuss — at its core, neoexpressionist painting has remained a "male" affair. As a consequence, women artists have excelled mostly in the less commercial areas of video, performance, conceptual art, and film.

Many American artists have been drawn to Berlin, among them, Keith Haring, Jonathan Borofsky, and Richard Hambleton, all of whom have joined the numerous unknown "artists" who have covered the Berlin Wall with graffiti. During a 1985 visit, Hambleton — best known for his black "shadow men," which he painted on buildings all over the U.S. and Europe — was commissioned by the city to do a mural on the Wall.

Inspired by Berlin's most prestigious modern art acquisition, Barnett Newman's *Who's Afraid of Red, Yellow, and Blue?* at the National Gallery, Hambleton painted a 150-foot segment of the Wall with black paint, leaving only a three-inch unpainted stripe in the middle. He added twelve-inch stripes of red and yellow on either side of the black field and called the work *Who's Afraid of Red, Yellow, and Black?*, alluding to the identical national colors of both Germanies.

Hambleton's direct involvement with the Wall is emblematic of others' reactions to its overwhelming presence, and to Berlin's unique status as a divided capital, an island of the West in the East. Nowhere else have artists responded so strongly to the political and economic situation of a city.

In addition to the city's painters, writers (Günther Grass, Peter Schneider), filmmakers (Volker Schlöndorff, Margarete von Trotta, Robert von Ackeren, Ulrike Ottinger), and musicians (Iggy Pop, Nina Hagen, David Bowie) have all contributed to the formation of this unique microcosm of cultural density. Their art is existentially connected with Berlin. As a result, art, especially painting, has become both a prime export commodity and the "trademark" of contemporary Berlin.

THE SPECTACLE OF CHAOS

Attractors are geometric forms that characterize long-term behavior in the state space. Roughly speaking, an attractor is what the behavior of a system settles down to, or is attracted to . . . The key to understanding chaotic behavior lies in understanding a simple stretching and folding operation, which takes place in the state space. Exponential divergence is a local feature: because attractors have finite size, two orbits on a chaotic attractor cannot diverge exponentially forever. Consequently the attractor must fold over onto itself. Although orbits diverge and follow increasingly different paths, they eventually must pass close to one another again. The orbits on a chaotic attractor are shuffled by this process, much as a deck of cards is shuffled by a dealer. The randomness of the chaotic orbits is the result of the shuffling process. The process of stretching and folding happens repeatedly, creating folds within folds ad infinitum. A chaotic attractor is, in other words, a fractal: an object that reveals more detail as it is increasingly magnified . . . Since nearby points in nonchaotic systems stay close as they evolve in time, a measurement provides a certain amount of information that is preserved with time . . . The stretching and folding operation of a chaotic attractor systematically removes the initial information and replaces it with new information: the stretch makes small-scale uncertainties larger, the fold brings widely separated trajectories together and erases large-scale information. Thus chaotic attractors act as a kind of pump bringing microscopic fluctuations up to a macroscopic expression. There is simply no causal connection between past and future.
— *Scientific American,* December 1986

The art to be discussed here centers on the spectacle of its appearance or ontological presence, the spectacle of *chaos*. It refers to a chaotic rather than historical process and, like chaotic fractals, it is self-referential and self-reproducing. Unlike the first generation of simulation artists, e.g., Peter Halley, Jeff Koons, and Sherrie Levine, who refer extensively to Modernism, the works of Calvin Brown, Tom Brazelton,

This essay originally appeared in *Flash Art* 135 (Summer 1987).

David Wilson, James Welling, and Eve Andrée Laramée are neither neomodern nor postmodern but beyond Modernism, *neoteric*. As in chaotic systems, there is no connection between past and future.

Calvin Brown's paintings privilege the artificiality of the *ornament*, the purely geometrical ordering of elements by identity and difference. Color is an elementary device for creating classes of motifs that are alike in one respect and different in another. Fluorescent paint is paired with aluminum paint, and both are in turn contrasted with black enamel. Brown is not concerned with the psychological effects of Op art abstraction but rather with self-reference, self-reproduction, and the sovereignty of the signifier.

Recent scientific studies of chaotic systems have discovered that "simple deterministic systems with only a few elements can generate random behavior ... There is order in chaos: underlying chaotic behavior there are elegant geometric forms that create randomness."[1] There is order in chaos, and chaos in order. Translated into the sphere of representation, this discovery gives way to the assumption that self-referential art is always a chaotic system, which can take on either a chaotic or a geometrical form, depending on the direction of the chaotic attractor.

Let us imagine a white surface with irregular black spots. We now say: whatever kind of picture these make I can always get as near as I like to its description, if I cover the surface with a sufficiently fine square network and now say of every square that it is white or black. In this way I shall have brought the description of the surface to a unified form ... That a picture like that instanced above can be described by a network of a given form asserts *nothing* about the picture (For this holds of every picture of this kind). But *this* does characterize the picture, the fact, namely, that it can be *completely* described by a *definite* fineness.
— Ludwig Wittgenstein, 1922

1 J.P. Crutchfield, J.D. Farmer, N.H. Packard, and R.S. Shaw, "Chaos," *Scientific American* 255 (December 1986): 46–57.

The Mandelbrot set broods in silent complexity at the center of a vast two-dimensional sheet of numbers called the complex plane. When a certain operation is applied repeatedly to the numbers, the ones outside the set flee to infinity. The numbers inside remain to drift or dance about. Close to the boundary minutely choreographed wanderings mark the onset of the instability. Here is an infinite regress of detail that astonishes us with its variety, its complexity and its strange beauty.
— *Scientific American*, August 1985

James Wellling's black-and-white paintings of Mandelbrot sets cannot be completely described by Wittgenstein's method quoted above because of the infinite complexity that distinguishes fractals like the Mandelbrot set, a computer-generated image of a relatively simple mathematical equation of chaotic attractors, named for its discoverer, Benoît Mandelbrot. Zoomed in on any part of the set at any magnification, it always reveals a reproduction of itself. As the zoom continues, the same image reappears ad infinitum.

In *The Poetics of Space*, Gaston Bachelard describes the difference between the scientific and the imaginative look through the magnifying glass. The scientist "has already seen what he observes in the microscope and, paradoxically, one might say that he never sees anything for the first time ... When we have forgotten all our habits of scientific objectivity, we look for the *images of the first time*. If we were to consult psychological documents in the history of science ... we should find that the first microscopic observations were legends about small objects, and when the object was endowed with life, legends of life."[2] Like Mandelbrot's fractals, David Wilson's paintings within paintings offer such a miniscule look into the world of the first time. They unfold a microcosm of infinite complexity and regress of detail, leading the viewer more and more deeply inside while he or she is discovering *interior* beauty.

2 Gaston Bachelard, *The Poetics of Space*, trans. Maria Jolas (Boston: Beacon Press, 1969), p. 156.

Distance, too, creates miniatures at all points on the horizon, and the dreamer, faced with these spectacles of distant nature, picks out these miniatures as so many nests of solitude in which he dreams of living . . . Distance disperses nothing but, on the contrary, composes a miniature of a country in which we should like to live.
— Gaston Bachelard, 1958

Tom Brazelton's viscous surfaces open inner spaces to a distant nature, but the spaces are based on chaos leaving the viewer and his or her desire alienated.

David Wilson's imaginative miniatures, Tom Brazelton's poured paintings, Eve Laramée's installations involving water, salt, copper, and other chemically active materials, and even Sigmar Polke's recent silver-oxide paintings depicting decorative loops taken from sixteenth-century woodcuts by Albrecht Dürer seem to celebrate the tangle of chaos and order that is peculiar to fractals.

The findings on fractals and, recently, on unstable solidifying crystals such as snowflakes are leading to a new understanding of the repetition of form involved in pattern and ornament. The electronic microscope reveals that snowflakes are not exactly symmetrical and that their tips or "dendrites" become unstable or chaotic as they grow downward and produce sub-branches.

Our contemporary understanding of the words "ornament" and "decoration" still connote the discriminations of Modernism defining ornament as something *applied* to function and structure. In art that makes decor its content, ornament becomes function; order, chaos.

PHOTOMANNERISMS

1

A proper understanding of mannerism can be obtained only if it is regarded as the product of tension between classicism and anticlassicism, naturalism and formalism, rationalism and irrationalism, sensualism and spiritualism, traditionalism and innovation, conventionalism and revolt against conformalism; for its essence lies in this tension, this union of apparently irreconcilable opposites.
— Arnold Hauser, 1965

2

This is "photographic ecstasy": certain photographs can take you outside of yourself, when they are associated with a loss, an emptiness.
— Roland Barthes, 1980

3

Throughout the history of art, postmodernism and mannerism have been engaged in the same discourse of representation, sharing the same stylistic concepts — from chaos, ambiguity, paradox, multi-functioning, inverted spatial effects, superimposition, layering, projection, infinite depth that becomes pure superficiality, and other complexities and contradictions, to the inclusion of the vernacular, the anonymous, and elements of our ordinary life or popular culture. These concepts signify representation in crisis, the *failure* of representation.

This essay originally appeared in *Flash Art* 137 (November–December 1987).

4

From the very beginning, existentialism defined itself as a philosophy of ambiguity. It was by affirming the irreducible character of ambiguity that Kierke-gaard opposed himself to Hegel, and it is by ambiguity that, in our own generation, Sartre, in *Being and Nothingness*, fundamentally defined man, that being whose being is not to be, that subjectivity which realizes itself only as a presence in the world, that engaged freedom, that surging of the for-oneself which is immediately given for others.
— Simone de Beauvoir, 1947

5

From its very beginnings, mannerism has defined itself as existentialism. It centers on the ambiguity of human existence assuming the existential anti-thesis *failure/success*. Peter Hopkins's photographs, floating inside overpowering frame constructions, are engaged in a permanent existential struggle between failure and success.

6

Mannerism, however, though there was no recurrence or direct continuation of it after its end in the seventeenth century, survived as an undercurrent in the history of western art . . . Mannerist trends have repeatedly appeared since the baroque and the rococo, and particularly since the end of international classicism, and they are most manifest in times of stylistic revolution associated with spiritual crises as acute as that of the transition from classicism to romanticism or from naturalism to postimpressionism.
— Arnold Hauser, 1965

7

The essence of postmodernism lies in its mannerism. Postmodernism has to be seen as being part of a series of mannerisms recurring in the history of art. The link between postmodernism and mannerism was first established by Robert Venturi in 1966: "The desire for a complex architecture, with its attendant contradictions, is not only a reaction to banality or prettiness of current architecture. It is an attitude common in the mannerist periods: the sixteenth century in Italy or the Hellenistic period in Classical art, and is also a continuous strain seen in such diverse architects as Michelangelo, Palladio, Borromini... and recently Le Corbusier, Aalto, Kahn, and others."[1]

According to Jean-François Lyotard's paradox, it can be said that the postmodern precedes and induces the modern, as far as it constitutes a form of mannerism, while, at the same time, it succeeds the modern, as far as it constitutes an anticlassicism and antiformalism.

8

The consonance of the High Renaissance
Is present, though distorted by the mirror.
What is novel is the extreme care in rendering
The velleities of the rounded reflecting surface
(It is the first mirror portrait),
So that you could be fooled for a moment
Before you realize the reflection
Isn't yours. You feel then like one of those
Hoffmann characters who have been deprived
Of a reflection except that the whole of me
Is seen to be supplanted by the strict
Otherness of the painter in his
Other room.
— John Ashbery, 1975

1 Robert Venturi, *Complexity and Contradiction in Architecture* (New York: The Museum of Modern Art, 1966), p. 19.

9

Mannerism is not so much a symptom and product of alienation, that is to say, an art that has become soulless, extroverted, and shallow, as an expression of the unrest, anxiety, and bewilderment generated by the process of alienation of the individual from society and the reification of the whole cultural process.
— Arnold Hauser, 1965

10

Being the direct descendant of the sixteenth-century Mannerist convex mirror (Parmigianino's *Self-Portrait from a Convex Mirror* marks the beginning of late Renaissance mannerism), photography is the mannerist art form par excellence.

Like Parmigianino's self-portrait, the photograph corresponds to the *mirror stage* of art, the mannerist experience of "alienated identity" and "fragmented body-image," as described by Lacan: "The mirror stage is a drama whose internal thrust is precipitated from insufficiency to anticipation — and which manufactures for the subject ... a succession of phantasies that extends from a fragmented body-image ... to the assumption of the armor of an alienating identity."[2] The photograph substitutes the mirror, the reflection of the Self, for the experience of the *Other.*

2 Jacques Lacan, 1949, "The Mirror Stage as Formative of the Function of the I," in *Écrit: A Selection*, trans. Alan Sheridan (New York and London: W. W. Norton, 1977), p. 4 (translation modified).

11

This otherness, this
"Not-being-us" is all there is to look at
In the mirror, though no one can say
How it came to be this way. A ship
Flying unknown colors has entered the harbor.
You are allowing extraneous matters
To break up your day, cloud the focus
Of the crystal ball.
— John Ashbery, 1975

12

The Greek myth of Narcissus is directly concerned with a fact of human experience, as the word *Narcissus* indicates. It is from the Greek word *narcosis*, or numbness. The youth Narcissus mistook his own reflection in the water for another person. This extension of himself by mirror numbed his perceptions until he became the servomechanism of his own extended or replaced image. The nymph Echo tried to win his love with fragments of his own speech, but in vain. He was numb. He had adapted to his extension of himself and had become a closed system.
— Marshall McLuhan, 1964

13

The predominance of the gilded frame is due, perhaps to the fact that metallic paint is the material that gives off the most reflection. A reflection is that note of color, of light, which contains no form in and of itself, but which is pure, shapeless color. We do not attribute the *reflections* of a metallic or glazed object to the object itself, as we do its surface color. The reflection is neither the reflecting object nor whatever may be reflected in it. Instead, it lies somewhere in-between those things, a specter without substance.
— Ortega y Gasset, 1921

14

In Mac Adams's photographs, personal and political reality is reflected as simulated cinematic stagings in the highly polished surfaces of household objects. They represent the mirror stage in its most intense state, while Helen Chadwick's work refuses to accept the alienation of the mirror stage by withdrawing itself into the closed, self-referential world of narcissism, in which the Other only exists in the form of the Self.

In Dan Devine's sculptures, the mannerist experience of alienation is eluded by the use of self-similar and self-referential materials such as formica and mirror glass. The materialized space of his sculptures thus becomes *materialized self-reflection.*

A different kind of self-reflection is taking place in the Polaroids of Marina Abramović and Ulay where objects and human figures are reduced to shadows of themselves.

15

So I am inclined to distinguish between essential and inessential rules in a game too. The game, one might say, has not only rules but also a *joke.*[3]
— Ludwig Wittgenstein, 1945–49

3 G.E.M. Anscombe translates this sentence somewhat incorrectly as: "So I am inclined to distinguish between the essential and the inessential in a game too. The game, one would like to say, has not only rules but also a *point.*" Ludwig Wittgenstein, *Philosophical Investigations* (New York, Macmillan, 1953), par. 564.

16

Tim Maul is not a photographer. He is a comic who works with a camera. His photographs of unpopulated office interiors and domestic situations become *jokes* because of their familiarity and insignificance. Like jokes, they keep getting retold. Here Maul meets with another nonphotographer, Richard Prince, who, in his recent work, takes the appropriative status of the joke literally.

What makes the images in Maul's photographs seem so interesting is the fact that they have already been seen before. Like the scenes in Jean-Luc Godard's films, they just play with the familiar, the given.

17

Looking at photograph of a world situation in an illusionistic space, be it deep or shallow, involves the perceiver, paradoxically, in two simultaneous activities which seem to be at odds with each other.
— Hollis Frampton, 1979

18

Superimposition (Ellen Carey, Paul Laster), juxtaposition (John Lamka, Robert Mapplethorpe), projection (Richard Baim, Krzystof Wodiczko), pointillism (Ellen Brooks), repetition and fragmentation (Andy Warhol, Doug and Mike Starn) play on the *photographic paradox* that Barthes describes as "the co-existence of two messages, the one without a code (the photographic analogue), the other with a code (the 'art,' or the treatment, or the 'writing,' or the rhetoric, of the photograph)."[4]

4 "The Photographic Message," in Roland Barthes, *Image, Music, Text*, trans. Stephen Heath (New York: Hill and Wang, 1977), p. 19.

The works of John Lamka, Ellen Carey, and James Welling combine the mannerist mirror stage with the self-similarity and self-reproduction of fractal geometry evoking the medieval idea of the autogeneous representation of Christ. Josef Ramaseder's paintings on thermal paper refer in similar manner to the postmodern allegory of *art painting itself.*

<div style="text-align:center">19</div>

From the beginning of the Renaissance to the end of impressionism, the aim of pictorial representation was the reduction of sensual experience to its visual elements, the rendering of purely optical impressions and of nothing more than what the eye could take in at a single moment and at a single glance; in other words, the exclusion from the picture of everything merely known but not seen, or seen at a different moment of time from that represented. Mannerism was the only phase of development in which the continuity of this process was interrupted.
— Arnold Hauser, 1965

<div style="text-align:center">20</div>

An hour is not merely an hour, it is a vase filled with perfumes, sounds, projects, and climates. What we call reality is a relation between those sensations and those memories which simultaneously encircle us . . . that unique relation which the writer must discover in order that he may link two different states of being together.
— Marcel Proust, 1927

The photographs of Doug and Mike Starn (who come as close to Proust's synthesis of two different states of being as one can get) focus on the instability of memory and the ambiguity of history. Their narcissistic memory calls to mind the mnemonic twins described by Oliver Sacks, who, among other skills, could recall political and personal details of any day in their life from about their fourth year on, "including the painful or poignant anguish of childhood, the contempt, the jeers, the mortifications they endured . . . without the least hint of any personal infliction or emotion. Here, clearly, one is dealing with memories that seem of a 'documentary' kind, in which there is no personal reference, no personal relation, no living center whatever. It might be said that personal involvement, emotion, has been edited out of these memories, in the sort of defensive way one may observe in obsessive or schizoid types . . . But it could be said, equally, and indeed more plausible, that memories of this kind never *had* any personal character, for this indeed is a cardinal characteristic of eidetic memory such as this."[5]

5 Oliver Sacks, *The Man Who Mistook His Wife for a Hat and Other Clinical Tales* (New York: Harper & Row, 1987), p. 198.

NEUSTEIN'S LAW

I

You give the law for each man into his own hand.
— *Sheviit*

I was looking for the future and the past social catastrophe in the geology,
in the reversion of the deepness of which the striated spaces testify, the re-
liefs out of salt and stone, the canyons into which the fossil river descends,
the abyss of immemorial slowness, the erosion and the geology, up to the
verticality of the megapoles.
— Jean Baudrillard, 1986

According to an old Hebrew tradition there is not one law
but six hundred thousand laws or faces of the law (as many
as there were people standing before Mount Sinai to receive
the Torah).

Looking at Joshua Neustein's work one is tempted to say
that there is not one border but six hundred thousand bor-
ders. (Law and border have always been close together in the
Torah Commentaries.[1]) Like Richard Hambleton who left his
"markings," black-painted silhouettes of himself, on build-
ings all over the U.S. and Europe, Neustein has been obsessed
with borders. From his early performances (involving a dog
urinating alongside several borders in Europe and Israel and
thereby setting its own natural borderline against the po-
litical border) to his recent map paintings, political bound-
aries are being removed and replaced with boundaries of a
different order.

This essay originally appeared in *Joshua Neustein,* exhibition catalog
(New York: Exit Art, 1987).
1 "Be deliberate in judgement; and raise up many disciple; and make a
fence for the Torah." (*Magen Avot* 1:1)

His maps with superimposed pieces of glass replace the political-geographical order of the map with the self-contained order of Piet Mondrian's abstract grids. Other maps, like *Horizon Line on Map of Europe* and *Device over Eastern Seaboard of U.S.*, having partly brushed and polished pieces of steel shelving and other found objects attached to them, seem like relics of a lost world that are zoomed out of a deterritorialized geography devoid of political borders and therefore life. The world according to Neustein has become an abstract or cubist structure, transforming political history into art history.

II

Unlike perspective, the grid does not map the space of a room or a land-scape or a group of figures onto the surface of a painting. Indeed, if it maps anything, it maps the surface of the painting itself. It is a transfer in which nothing changes place.
— Rosalind Krauss, 1978

The problem of expression is staked out by Kafka not in an abstract and universal fashion but in relation to those literatures that are considered minor, for example, the Jewish literature of Warsaw and Prague. A minor literature doesn't come from a minor language; it is rather that which a minority constructs within a major language . . . The three characteristics of minor literature are the deterritorialization of language, the connection of the individual to a political immediacy, and the collective assemblage of enunciation.
— Gilles Deleuze and Félix Guattari, 1975

The grid is the display of the ultimate deterritorialization. It maps the deterritorialized world. Neustein's work is in a permanent state of deterritorialization and reterritorialization. Deterritorialized from his birth (Neustein was born in Danzig, then a German enclave in Poland), the course of his life and work has been defined by displacement, or rather displaceability. The bricolage of found objects is a characteristic of the deterritorialized artist. Because of his displacement, he makes do with whatever is at hand. He finds his material in the history of art only insofar as it is part of his library, which is a complete and closed system.

In their book on Kafka, Deleuze and Guattari speak of a "minor literature" — the use of a major language within which the displaced artist remains a stranger, subverting it from within. Like Kafka's writing, Neustein's art is deterritorial, political, and collective (it has an "active solidarity in spite of skepticism" with art history).

STURTEVANT'S PARADOX

After the quantum of energy has already gone through the doubly slit screen, a last-instant free choice on our part — we have found — gives at will a double-slit-interference record or a one-slit-beam count. Does this result mean that present choice influences past dynamics, in contravention of every formulation of causality? Or does it mean, calculate pedantically and don't ask questions? Neither; the lesson presents itself rather as this, that the past has no existence except as it is recorded in the present. It has no sense to speak of what the quantum of electromagnetic energy was doing except as it is observed or calculable from what is observed. More generally, we would seem forced to say that no phenomenon is a phenomenon until — by observation, or some proper combination of theory and observation — it is an observed phenomenon. The universe does not "exist, out there," independent of all acts of observation. Instead, it is in some strange sense a participatory universe.
— John Archibald Wheeler, 1978

The basic element of quantum theory is the double-slit experiment. An electron gun emits electrons toward a thin metal plate with two holes in it. Beyond the plate is a wall with a detector of some kind that counts the electrons that pass through the holes. The result presents itself in the form of a paradox: each electron either goes through the first hole or it goes through the second hole (behaving like a particle) if we determine which hole is passed by blocking one of the holes during the experiment. But each electron goes through both holes at once (behaving like a wave) if both holes stay open during the experiment, making it impossible for an observer to determine which hole is passed by each electron.

In Wheeler's variation of the classical double-slit experiment, the observer decides whether the electron has gone

This essay originally appeared in *Sturtevant 1987*, exhibition catalog (New York: Stux Gallery, 1987).

through one hole alone or through both at once *after* the electron has already accomplished its travel. The decision thus has an unavoidable effect on the already past history of the electron.

For more than twenty years, Sturtevant has made work by other artists, such as Claes Oldenburg, Marcel Duchamp, Roy Lichtenstein, Jasper Johns, and Keith Haring. She has persistently pointed out that her paintings are not copies and that the work has to be seen on her own terms. The particle-wave-paradox of quantum theory seems to replay itself in her work. *Device Circle* is either a Johns (1959) or a Sturtevant (1987), but it is never both. As quantum theory teaches us, the past only exists as it is recorded in the present. Here the foundation of quantum theory meets with the foundation of simulation theory: "The real is not only what can be reproduced, but that which is always already reproduced."[1]

Device Circle exists only as it is created by Jasper Johns or as it is created by Sturtevant. Just as the electron is brought into being step by step by the experiments that the observer chooses to make, so the paintings and sculptures by Johns, Warhol, or Haring are brought into being step by step by Sturtevant as a phenomenon in the sense that they are pure Sturtevants. They prove the truth of simulationism, which states that the reproduction is the original.

1 Jean Baudrillard, *Simulations*, trans. Paul Foss, et. al. (New York: Semiotext(e), 1983), p. 146.

THE ART OF THE DEAL

I

Greed is good . . . greed is right.
— Gordon Gekko in the movie *Wall Street,* 1987

A constant sameness governs the relationship to the past as well. What is new about the phase of mass culture compared with the late liberal stage is the exclusion of the new. The machine rotates on the same spot. While already determining the consumption it excludes the untried as a risk. The movie-makers distrust any manuscript which is not reassuringly backed by a best seller. Yet for this very reason there is never-ending talk of ideas, novelty, and surprise, of what is all to familiar but has never existed.
— Max Horkheimer and Theodor W. Adorno, 1944

Enter West Broadway. Enter the age of greed. Midway in Oliver Stone's movie *Wall Street,* the fictive corporate raider Gordon Gecko delivers a speech to the shareholders that ends in a celebration of greed: "The point is, ladies and gentlemen, greed is good. Greed works, greed is right. Greed clarifies, cuts through, and captures the essence of the evolutionary spirit. Greed in all its forms, greed for life, money, love, knowledge, has marked the upward surge of mankind — and greed, mark my words, will save not only Teldar Paper but that other malfunctioning corporation called the U.S.A."

In the present state of the arts in America, enlightenment has been replaced by ignorance, the discourse of authenticity by the economics of the New Conformity, and the anxiety of creation by the administration of success.

The promise of the New that governs the economical logic of the art market is a false promise. It is the recycling

This essay originally appeared in *Flash Art* 140 (May–June 1988).

of the New that secures the continuity of sameness that the Collector desires. Like children who watch the same movies over and over again, the Collector buys what he or she has already seen. The discourse of sameness employs the notion of the New while simultaneously antiquating it:

If consciousness-by-default generates, here, the destiny of the past, then, perhaps, consciousness-after-culture determines the primordial future. From moment to moment, we heap dirt upon our eyes, and experience the luxury of darkness when we sleep. Perhaps this is where the antique future and the new past collide — and, perhaps, it is this collision that describes, in general, a Postmodern metaphysics of time.
— Tricia Collins and Richard Milazzo, 1987

The sustenance of sameness makes the constant flow of money possible and is a basic element in the administration of permanent success.

West Broadway and Wall Street function similarly: "The essence of Wall Street is an exchange across time — transactions between the past and the future. Old money, the surplus accumulated from past ventures, is lent to those who need it for future enterprises. For all the daunting complexities of financial markets, what Wall Street does is as simple as that. It is the intermediary, the meeting place where past and future agree on terms and the money changes hands."[1]

Like Wall Street, the Gallery is an intermediary between the past and the future, old and new art, the place where the powers of art meet and money changes hands.

1 William Greider, "Annals of Finance: The Price of Money," *The New Yorker* (November 9, 1987), pp. 72–78.

II

The question of who owned financial wealth — or who did not — was the buried fault line of American politics . . . In the nature of things, government might choose to enhance the economic prospects for the many or to safeguard the accumulated wealth held by the few; frequently, the two purposes were irreconcilable. The Federal Reserve served as mediating agent in this enduring conflict. On occasion, it assumed the power of independent arbiter, deciding on its own whom the government would favor, and enforcing its decision through its control of money and interest rates.
— William Greider, 1987

The Artist is obliged to listen to two powers: the desire of the Collector for sameness and the demands for difference from the Critic. The need for negotiation between these two powers created the Critic-Turned-Curator/Advisor who works for either the Collector or the Artist and his gallery, respectively, assisting inconspicuous galleries and sophomoric artists in gaining instant fame and success. The Curator/Advisor brings about the conciliation of both demands by means of a conceptual cunning that, dressed in a vocabulary of meaninglessness that neutralizes critical discourse, presents difference as sameness and sameness as difference.

If "The New Capital" show addressed . . . the issue of abstract capital and, at that time, its relations to the new commodity discourse in art, then "The New Poverty" in art today, in contradiction, addresses the issues of abstract poverty as it manifests itself in primary forms, linked as they are to the dark primacy of origins, of Nature, to originality as source of homelessness, to the actualities of desire, and to the embarrassed temporalities of lived experience . . . From radical consumption to the new impoverishment.
— Tricia Collins and Richard Milazzo, 1988

The "impoverishment" is that of the East Village, the place where difference and authenticity once excelled; the "homelessness," that of the Artist after abandoning difference for sameness.

There are reports that several of the area's more prominent galleries are contemplating relocation to Soho, with talk of space being looked at in this or that large building, of leases nearly signed . . . It is clear that these moves are necessary if the young East Village galleries are to stay competitive with the blue-chip Soho dealers who are trying, with considerable success, to lure their best artists away.
— Roberta Smith, May 1, 1987

Rather, it was Soho that had to stay competitive with the success of difference. The curtailment of the East Village, orchestrated largely by the galleries and investors of Soho, and the subsequent exodus of its artists and galleries are now followed by an accelerated recycling of the Familiar in Soho's new galleries, in the form of repetitive group shows, while its old galleries turn the former difference of their New Stars into the Recurrence of the Same.

The Curator/Advisor constitutes for the Collector an artificial variety and selection of the New while working hand-in-hand with the Critic on the *Gleichschaltung* of the critical discourse:

Jeff Koons: A gravely ironic salute to sports and nautical gear . . . An arduous and rewarding show.
— Gary Indiana, May 28, 1985

Untitled Group Show: A well integrated mixture of terrific new art: paintings by Ross Bleckner, Meyer Vaisman, and Steven Parrino. . . and an assemblage of hash pipes by Haim Steinbach. This show crackles with lunar satire and disruptive prescience.
— Gary Indiana, June 11, 1985

There are five completely different paintings, all 20-by-16-inch slabs of cut plywood, each with a differently grained, moiré-looking pattern. Where a leaf-shaped knot occurs, by chance, in the surface of the wood, Levine has applied a thin layer of gold paint . . . But even though they look familiar, no one has quite done these pictures before. Levine is addressing, or rather creating, a fictional art history; having already excerpted real art history and in some ways inverted it, Levine is now inserting fakes in the form of originals.
— Gary Indiana, December 3, 1985

Formica is kaput. Art objects crafted from Formica are no longer considered attractive or interesting. Indeed, they are no longer considered art objects.

Consumer critique sculpture has gotten too big for its britches. What began as a stimulating and clever practice has become an absurd and probably meretricious excuse for the undertalented to go shopping on other people's money.

Ciao, knotty pine. The elegant look of natural wood, and the not-so-elegant look of imitation wood, may spice up that basement rec room but they do less than nothing for an art gallery, either in picture form or as ambient surface.
— Gary Indiana, July 28, 1987

If you happen to go all gaga over sculpture assembled from supermarket or souvenir items dipped in bronze, chances are you will find Robert Gober's recent work somewhat lacking in the aesthetic splendor you have learned to cherish in a box of Tide . . . I'm personally inclined to place more importance on what's rare and hard-won than what's ubiquitous and factory-assembled.
— Gary Indiana, October 27, 1987

III

There it was, the Rome, the Paris, the London of the twentieth century, the city of ambition, the dense magnetic rock, the irresistible destination of all those who insist on being where things are happening — and he was among the victors! He lived on Park Avenue, the street of dreams! He worked on Wall Street, fifty floors up, for the legendary Pierce & Pierce, overlooking the world! He was at the wheel of a $48,000 roadster with one of the most beautiful women in New York — no Comp. Lit. scholar, perhaps, but gorgeous — beside him! A frisky young animal! He was of that breed whose natural destiny it was . . . to have what they wanted!
— Tom Wolfe, 1987

Is it a coincidence that Tom Wolfe, author of *The Painted Word,* just published a novel about Wall Street? Today Wolfe's thesis that theory precedes art seems truer than ever, only with one significant difference: theory has been replaced by a simulation of theory that has led to the commodification of European thought turning Baudrillard and Foucault into a slick prospectus for the Same.

The "impoverishment" is also that of the American mind. The increasing ignorance within the American public, especially in regard to the adoption of European art and a general lack of knowledge of the past, works in favor of a logic in which the New and the Same become identical.

Annette Lemieux. See? I told you . . . I hope she remembers once she's rich and famous that I was the one who put her there.
— Gary Indiana, April 28, 1987

THE GAZE OF ORPHEUS AND
THE DELIRIUM OF COMMUNICATION —
LYDIA DONA, ASHLEY BICKERTON, THOMAS LOCHER

I

Inspiration means the ruin of Orpheus and the certainty of his ruin, and it does not promise the success of the work as compensation, any more than in the work it affirms Orpheus's ideal triumph or Eurydice's survival. The work is just as compromised by inspiration as Orpheus is threatened by it . . . This is also why it protects itself by saying to Orpheus: "You will only be able to keep me if you do not look at *her*." But this forbidden act is precisely the one Orpheus must perform in order to take the work beyond what guarantees it, and which he can perform only by forgetting the work, carried away by a desire coming out of the night and bound to the night as its origin. In this respect, the work is lost . . . The work is everything to Orpheus, everything except that desired gaze in which the work is lost, so that it is also only in this gaze that the work can go beyond itself, unite with its origin and establish itself in impossibility.
— Maurice Blanchot, 1955

Painting has become lost in the gaze of Orpheus. Like Orpheus's desire, it can only establish itself in *impossibility*. Production has been replaced by seduction, the strategy of which is to cancel production and history and focus on the empty center of desire.

Aggregative transformations (Lydia Dona), solipsistic desiring-machines (Ashley Bickerton), and infinite possibilities of substitution (Thomas Locher): while Dona describes the reciprocal seduction of systems and Locher focuses on their exchangeability, Bickerton defines the empty space of seduction — the interstitial emptiness of desiring systems.

This essay originally appeared in *Flash Art* 143 (November–December 1988).

II

It might be said that, of the two directions in *physics* — the molar direction that goes toward the large numbers and the mass phenomena, and the molecular direction that on the contrary penetrates into singularities, their interactions and connections at a distance or between different orders — the paranoic has chosen the first: he practices macrophysics. And it could be said that by contrast the schizo goes in the other direction, that of microphysics, of molecules insofar as they no longer obey the statistical laws: waves and corpuscles, flows and partial objects that are no longer dependent upon the large numbers; infinitesimal lines of escape . . . The paranoic and the schizoid investments are like two opposite poles of unconscious libidinal investment, one of which subordinates desiring-production to the formation of sovereignty and to the gregarious aggregate that results from it, while the other brings about the inverse subordination, overthrows the established power, and subjects the gregarious aggregate to the molecular multiplicities of the production of desire. And if it is true that delirium is coextensive with the social field, these two poles are found to coexist in every case of delirium, and fragments of schizoid revolutionary investment are found to coincide with blocks of paranoic reactionary investment. The oscillation between the two poles is a constituent aspect of the delirium.
— Gilles Deleuze and Félix Guattari, 1972

Modern painting has always manifested itself in either a geometrical abstraction that continues the discourse of simplicity since Johann Joachim Winckelmann's *Thoughts on the Imitation of Greek Works in Painting and Sculpture* or in an impressionistic abstraction that recedes into the molecular unconscious. The former constitutes the molar or *paranoic* state of art; the latter, its microlytic or *schizophrenic* state.

The empty discourse of seduction cancels the *schizo-paranoic* process of production and antiproduction. In it painting becomes a body without organs, without image, unproductive, that serves as a surface for the recording of impossibility. It is in a state of *delirium*: the imageless communication.

III

We no longer take part in the drama of alienation, but are in the ecstasy of communication. And this ecstasy is obscene. Obscene is that which eliminates the gaze, the image and every representation. Obscenity is not confined to sexuality, because today there is a pornography of information and communication . . . It is no longer the obscenity of the hidden, the repressed, the obscure, but that of the visible, the all-too-visible, the more-visible-than-visible; it is the obscenity of that which no longer contains a secret and is entirely soluble in information and communication.
— Jean Baudrillard, 1983

Face to face with the obscene, the "pornography of information and communication," painting is engaged in the delirium of communication. The delirious communication of Orpheus, founder and destroyer of civilization. The delirious communication of synonymy (Locher), the delirious communication of commodity (Bickerton), the delirious communication of social, technical, and organic bodies (Dona).

THE REINVENTION OF PAINTING

In the third period of antiquity . . . the (classical) striving for manufacturing a mechanical causality between single phenomena had not only suffered loss from esteem, but had gone even as far as bringing the separate forms against each other in mutual isolation. But by that was not at all meant a return to primitive incoherence, rather, being no longer satisfied with a certain mechanical connection between the single forms, a different kind of connection — magic — was put in its place which has found its expression throughout the late pagan and early Christian world, in Neoplatonism, and in the syncretist cults as well as in the conceptions of the early Christian church.
— Alois Riegl, 1901

I read, among many similar examples, of a rain king in Africa, to whom the people appeal for rain *when the rain season comes*. But surely that means that they do not actually think that he can make rain, otherwise they would do it in the dry periods in which the land is "a parched and arid desert." Because if one assumes that these people once appointed a rain king out of stupidity, then it is surely clear that they had the experience that the rain starts in March beforehand, and therefore they would have let the rain king operate during the rest of the year . . . The nonsense here is that Frazer represents it as if these people had a totally wrong (even mad) idea of the way of nature whereas they only possess a strange interpretation of the phenomena. That is, their knowledge of nature, if written down, would not differ *fundamentally* from ours. Only their *magic* is different.
— Ludwig Wittgenstein, 1931

Now that postmodernism is being consumed by the same discourse that consumed modernism and art has become too sophisticated and self-conscious, there is a need for new strategies that make it possible to escape the postmodern trap and, at the same time, reverse the decision that art has reached its end, which has been wandering through art history like a ghost since Hegel's *Lectures on Aesthetics*.

This essay originally appeared in *Arts* (January 1989).

If art has to start over again, it has to do so through primitivism or amateurism (that is no longer defined within the postmodern practice of appropriation) — and in painting rather than sculpture or photography.

Ever since Hegel's statement that "we no longer have an absolute need to bring a content to presentation in the form of art," painting has been presumed dead or alive equally as many times. Yet, despite the recent drift to "conceptualism" in art, there are reasons to confirm Heidegger's believe, in his epilogue to *The Origin of the Work of Art*, that "the decision on Hegel's dictum has not yet been taken."

Today new strategies in painting are articulated by various artists. While some, like Zvi Goldstein, Lydia Dona, and Ashley Bickerton, have decided to complete the project of Modernism by transforming the syntax of painting into a new conceptual consciousness, others are looking in the opposite direction and, attracted by their crudity and austerity, are becoming engaged with primitive or naive images, folk art, or religious spiritualism.

In the Bodleian library in Oxford Jacques Derrida discovers the reversibility of cause and effect: Plato *before* Socrates. A postcard with a depiction of Plato dictating to Socrates, a reproduction from a thirteenth-century fortune-telling book, overturns the history of philosophy from Socrates to Heidegger.[1] Starting out from this subversion of what is generally understood as an irreversible sequence — Socrates–Plato–Paulus–Nietzsche–Freud–Heidegger — Derrida subsequently rehearses philosophy to likewise place himself *before* Heidegger, Freud, and Socrates.

Like Derrida, these artists have developed strategies of authenticity by way of such a reversibility of time and cause and effect, outflanking modernism and postmodernism by placing themselves *outside* or *before* history.

[1] Jacques Derrida, *The Post Card: From Socrates to Freud and Beyond*, trans. Alan Bass (Chicago: The University of Chicago Press, 1987), p. 9.

A murderer is brought to the place of execution. For the common people he is nothing but a murderer. Some ladies may note that he is a strong, handsome, interesting fellow. The others find this comment outrageous: What, a murderer handsome? How can one think so badly and call a murderer handsome; you must not be much better than him! . . . To think abstractly is to see in the murderer nothing but this abstract, that he is a murderer, and by way of this simple quality eradicate all other human qualities in him.
— G. W. F. Hegel, 1807

Germaine Brooks's paintings imply such a complicity with the abstract. Yet it comes from *the world of the simple*, a world that has never been seduced by the abstract, that is vivid and detailed, yet simple. We enter a unique and unexplored universe of imagination and "meaningless" particularities that is built upon the ambiguity of the concrete.

Tony Bevan's paintings share with Brooks an "abstract" fascination with particularities, which finds its expression in the titles of their works, giving prominence to seemingly unimportant accessories: *Green Buttons* (Brooks); *Black Table* (Bevan) — the replacing of one pictorial order with another, or as Wittgenstein would say, of one magic with another.

In Joe Andoe's paintings a psychologically complex, Kierkegaardian self is paired with religious iconography; a minimalist painting style, with the naiveté of devotional pictures, which bestows upon the images an eternal truth that transcends their Christian symbolism.

Is there such a thing as a "natural history of colours" and to what extent is it analogous to a natural history of plants?
— Ludwig Wittgenstein, 1951

Cary Smith's "abstract" panels refer more to American folk art than to the geometrical abstractions of much recent art — reflecting on their surface the original aggression, anxiety, and spirituality of early America. Paradoxically, the hidden, underlying grey primer seems to intensify the colors and patterns on the surface, or maybe, recalling one of Wittgenstein's

remarks on color, it is the grey that becomes intensified and "illuminated" from the outside in. ("Everything grey *looks* as though it is being illuminated.") The colors, though not "pure," regain a naive original purity that constitutes a "*natural history* of colours."[2]

Holt Quentel's paintings have given up the order of causality for a fatalistic order that reverses cause and effect. In each fragment of her work she replays the history of art, from Giotto to Schnabel, by overtaking it in a backward motion. She escapes the fatality of simulation by overwinding it an extra turn that puts her at the beginning of time. Her images become primeval symbols, images for the first time. The crudity of her paintings, the ripping and tearing, spells out a disdain for the empty sophistication of many of her peers.

2 Ludwig Wittgenstein, 1951, *Remarks on Colour*, trans. Linda L. McAlister and Margarete Schättle (Berkeley, Calif.: University of California Press, 1978), pars. III-224, III-135.

ROTRAUT, UECKER, KLEIN

When Günther Uecker came to Düsseldorf in 1955, he arrived to find an artistic climate that was dominated by the gloomy visions of Informel painting. Its urban-existentialist expressionism, which reflected the collective moral and physical breakdown of Germany after the war, seemed alien to Uecker's own ideas, which were born out of his rural beginnings on the Baltic Sea in East Germany.

Uecker was concerned with defining a spiritual position in a world of destroyed ideas and with translating the free and open structures that accompanied his childhood in Mecklenburg — the abstract simplicity and plainness of its landscape and rustic rituals — and the utopian spiritualism of artists like Kasimir Malevich and Wassily Kandinsky, into a basis for his own art.

Uecker's structuralist approach to painting was influenced largely by the Polish artist and Malevich student Wladyslaw Strzeminski, whose concept of unified structure did away with pictorial hierarchies and designated color as the unifying element. These concerns were shared by the ZERO group formed around Heinz Mack and Otto Piene, whose spiritual mentors were Lucio Fontana, Jean Tinguely, and Yves Klein, and which Uecker joined in 1961, subsequently becoming its leading protagonist.

For Uecker, ZERO was "from the start an open domain of possibilities, and we speculated with the visionary form of purity, beauty, and stillness . . . This was perhaps also a very silent and at the same time very loud protest against Expressionism, against an expression-oriented society." ·

This essay originally appeared in *Rotraut, Uecker, Klein,* exhibition catalog (Middletown, Conn.: Ezra and Cecile Zilkha Gallery, 1989).

The ZERO group, with its optimistic vision — like the Capitalist Realism of Gerhard Richter and Konrad Lueg (aka Konrad Fischer), which was more in concordance with the German economic miracle and the idealistic spirit of the Kennedy era — became the first internationally successful art movement to come out of Germany after the war.

Uecker found in Yves Klein *le monochrome* a brother-in-spirit who later would become his brother-in-law. Uecker's sister, Rotraut, who followed her brother to Düsseldorf in 1956, met Yves Klein in Nice two years later at the house of the artist Arman. She subsequently became Klein's assistant, model, wife, and the mother of their only son who was born three months after Klein's death in 1962. The critic Pierre Restany (who forms with Arman, Jean-Pierre Mirouze, and Claude Pascal the International Klein Bureau, which is authorized by the artist to create works of art in his name) poetically describes the extraordinary relationship that existed between Rotraut and Klein as an "osmosis between the sensibility of two beings":

[It] developed naturally, for their meeting occurred at a precise level of shared premonition and shared wonderment at the discovery of the world beyond the ordinary, of the ubiquity of cosmic energy. Living together with Yves Klein, at the heart of his work, entailed participation and total immersion in the monochrome adventure — a task as arduous as it was fascinating . . . Rotraut retained only the fascination, only the reflection of her own instinctive feeling. And it was in fact less through a process of osmosis and more by virtue of a catalytic event that Yves and Rotraut came together. She emerged from it in 1962 in the same way as she had entered into it in 1958, like a sensitive little animal keenly aware of the deep-seated vibrations of the earth and the sky.[1]

1 In André Verdet, *Rotraut*, exhibition catalog (Knocke-Zoute: Guy Pieters Gallery, 2003).

After Klein's death, Rotraut continued to produce work that was touched by his spirit but was distinctly her own. For instance, her *Vols de sensibilité* (1960–63) presaged early American appropriationists Sturtevant and Richard Pettibone by "stealing" the works of Rubens and other Great Masters. But they were "thefts" of the soul rather than the imagery of each work.

The playful contours and colors of the mysterious shapes, which first appeared in Rotraut's paintings, and more recently as ceramic reliefs and freestanding double-sided sculptures, have been likened to Matisse's paper cut-outs; yet, in Rotraut's work, form is not primarily line and color; it is an energetic process, or reflex, guided by an unconscious logic; a force that, like a flock of bats flying closely together yet never colliding, brings into play the texture of the universe as the sum of her body's movements. It is the parallelism of the mind and the body that mirror each other, yet cannot be reduced to effect and cause. Thus Rotraut's art is imbued with the miraculous. In fact, Rotraut' experiences or "lives" her working process as a miracle — she likens it to giving birth, the creation of new life — and she invites the viewer to "relive" this miracle.

Each of these shapes is created in a single moment, a fraction of a second, during which she releases liquid plaster from a bottle through a quick motion of her hand and body. After falling into shape, the material instantly hardens. This singular moment creates the foundation for the conscious choices that transform the produced forms into sculptures or paintings. Rotraut's shapes, in their precognizant origin, are symbols of the "collective unconsciousness," of that cosmic abundance — spiritual gifts of original joy and well-being, which Rotraut shares happily with anyone who momentarily enters her time and space. With every shape and color, Rotraut's art, guided by the intuitive power of her body and the conscious affirmation of her mind, is a celebration of life.

Both Uecker and Rotraut approach the blank canvas as a farmer primes his field for planting. The furrows drawn by the plough and the sweeping motion of the farmer's arm as he sows his seeds translate into textures and painterly gestures in the work. For Uecker, the nail that has become his signature signifies this approach to the canvas as a working field.

While this exhibition can only provide glimpses into the vast creative accomplishments of each artist, it is the first time that an exhibition has been dedicated entirely to the related spiritual project embodied in the works of all three.

THE NEW SPIRITUAL

The ironic figure of speech cancels itself, however, for the speaker presupposes his listeners understand him, hence through a negation of the immediate phenomenon the essence remains identical with the phenomenon... It is like a riddle and its solution possessed simultaneously . . . For irony everything becomes nothingness, but nothingness may be taken in several ways. The speculative nothingness is that which at every moment is vanishing for concretion, since it is itself the demand for the concrete, its *nisus formativus*. The mystical nothingness is a nothingness for representation, a nothingness which yet is as full of content as the silence of the night is eloquent for one who has ears to hear. Finally, the ironic nothingness is that deathly stillness in which irony returns to "haunt and jest."
— Søren Kierkegaard, 1841

I am wide / awake. The mind / is listening.
— William Carlos Williams, 1954

Restore my feet for me.
Restore my legs for me.
Restore my body for me.
Restore my mind for me.
— Navajo prayer

Does art need repose? Is art consumed too fast to be meaningful? Does art need a new paradigm?

To meet the demand of industrious critics, curators, and collectors, art schools in Europe and America have become breeding grounds for "instant" artists. The idealism of the seventies has been superseded by a decade of cynicism and irony that abandoned the notion of meaning in art.

Wherever the value of the word deteriorated, turning meaning into a cheap weapon and an easy coin, the intrinsic meaning of silence was also lost.

This essay originally appeared in *Arts* (October 1989).

We, indeed, live in a period of alarming inflation of the word, and nothing is more symptomatic of it than our aversion to silence and quietude that amounts to phobia . . . One of the reasons why modern man, generally speaking, avoids the silence of solitude and meditation with such circum-spection, is that he fears to face the emptiness of the world . . . But to the [American] Indian there was no such thing as emptiness in the world. There was no object around him that was not alive with spirit, and earth and tree and stone and the wide scope of the heaven were tenanted with numberless supernaturals and the wandering souls of the dead. And it was only in the solitude of remote places and in the sheltering silence of the night that the voices of these spirits might be heard.
— Margot Astrov, 1946

There is a need for an art of silence, an art that leaves, in Kierkegaard's words, "the ironic nothingness" for a "mystical nothingness" rooted in terrains of silence that make us listen to the innerness of our being, relate the myths of creation, and place us within the original purity and sincerity of the beginning of all things. A silence that restores art to the world by restoring its meaning.

Humankind has to be granted a principle that is outside and above the world . . . But this supernatural principle is no longer in its primeval purity but attached to another, lesser one. This other one has itself been brought into being and therefore is by nature nescient and dark; and darkened is necessarily also the higher one with which it is connected. In it reposes the memory of all things, of their original relations, their becoming, their meaning. But this primordial archetype of things sleeps in the soul as a darkened and forgotten, though not fully extinguished image. Perhaps it would never awake again if in its darkness itself would not lie the premo-nition and the longing of knowledge.
— F. W. J. von Schelling, 1811–15

The artists gathered here do not represent a new trend in art. Rather, they suggest a paradigm shift from a formalistic, self-referential, cynical art towards a more ecological, more femi-nist, more bodily, more process-oriented art that reinvents humanity within these terms. Their art carries glimpses of

abandoned meaning, of the silence, that "mystical nothing-ness," in which the voices of meaning can still be heard.

With its acknowledgment that any fundamental truth about the universe would always be hidden, the Copenhagen interpretation of quantum theory has brought the spiritual back into science. Quantum physics has inadvertently reha-bilitated the Thomistic dogma of the inability of the human mind to ever gain cognizance of the substance of God. In fact, as Richard Feynman has said, "it contains the *only* mystery."

Only a new, ecological spirituality that abandons anthro-pocentrism and is in reverence of our environment and all its inhabitants can bridge the gap between religion and sci-ence, a gap that has tragic consequences for the well-being of our planet.

At first almost everything looks hollow to us.
— Ernst Bloch, 1918

In Anish Kapoor's new work the sexual desires that were evoked by the seductive, yet intangible surfaces of his earlier objects are replaced with a desire for religion that is awakened by the primal sacred hollowness of the stone that is tactile, yet whose inside can only be accessed from within a spiritual experience.

Rotraut's paintings are cosmic *reveries*, spiritual gifts of original happiness and well-being that remind us that not only is inspiration bestowed upon an artist as she works, but that it is given to the world by the artist as a continu-ous donation. In each of her paintings Rotraut gives away pieces of her spiritual home: the sky of Yves Klein and the sun of the American Southwest.

Barbara Bloom is engaged in a phenomenology of appari-tions, in securing clues of the immaterial, of information that is at once remembered and imagined. Usually recorded in photographs, these clues relocate the meaning of evidence. Just as quantum theory has introduced the imaginary into physics, Bloom introduces the *uncertainty principle* into art.

Like Bloom, Georges Rousse is involved in securing clues. His photographs invent a *spiritualist* history of art, conjuring the spirits of great artists in sites they once inhabited: Vincent van Gogh's hospital in Arles, the Villa Medici, the bare walls of the Jeu de Paume — abandoned places of art that are filled with the silent voices of forlorn inspiration.

The process of civilizing European society during the seventeenth century was only possible by way of a rationalization and abstraction at the expense of the human body — the Cartesian separation of mind and body into existentially distinct substances. The dissociation, disciplining, and instrumentalizing of the human body formed a precondition for the onset of capitalism.

Since Descartes, the human body has been harnessed into a controlled structure of taboos and prohibitions and made by way of a series of measures of repression into an object of modern medicine where it is described and referred to only in terms of its deficiencies. The body is allowed to speak only through its diseases. The sanatorium, like that in Thomas Mann's *Magic Mountain*, becomes the place where the bodies and their organs converse.

The treatment of illness is reduced in modern medicine to a treatment of the body. It separates the patient from the disease, disregarding the unity of mind and body, essential for a (w)holistic healing.

Kiki Smith's work is to be understood as a different type of discourse of the body, one where the body and its organs and fluids talk not through disease and death but through life, reunited with the mind, as a needful aesthetic power. Her work confronts the classical beauty of the (exterior) human body with the vital beauty of its guts. It reminds us that by dissociating ourselves from body and nature we dissociate ourselves from life, and it brings to mind Marx's notion of a metabolism with nature: we can only live in an exchange of what we are not, the air we breathe, the food we eat, the water we drink.

THE FRACTALIST ACTIVITY

I conceived and developed a new geometry of nature and implemented its use in a number of diverse fields. It described many of the irregular and fragmented patterns around us, and leads to full-fledged theories, by identifying a family of shapes I call *fractals*. The most useful fractals involve *chance* and both their regularities and their irregularities are statistical. Also, the shapes described here tend to be scaling, implying that the degree of their irregularity and/or fragmentation is identical at all scales. The concept of *fractal* (Hausdorff) *dimension* plays a central role in this work . . . I coined *fractal* from the Latin adjective *fractus*. The corresponding Latin verb *frangere* means "to break": to create irregular fragments. It is therefore sensible — and how appropriate for our needs! — that, in addition to "fragmented" (as in *fraction* or *refraction*), *fractus* should also mean "irregular," both meanings being preserved in *fragment*.
— Benoît B. Mandelbrot, 1982

I believe fractal analysis should be extended beyond the physical and geo-metrical framework where it was born, and applied to the description of some border-line states of psyche and socius.
— Félix Guattari, 1987

Fractal geometry, which is based on relatively simple recur-sive algorithms, can be traced back to mathematicians of the late nineteenth and early twentieth centuries (Weierstrass, Cantor, Peano, Hausdorff). But it was the polish-born French mathematician Benoît B. Mandelbrot, formerly of the École Polytechnique, who, at the IBM's Thomas J. Watson Research Center, discovered the "beauty of fractals." Traditional Euclidian geometry was limited to the description of regular and scale-bound objects whereas fractal geometry is devoted to *scaling* objects with many scales of length, like mountains, coastlines, or fractured surfaces. A scaling object does not have a scale that characterizes it. Its scales depend entirely

This essay originally appeared in *artpress* 144 (February 1990).

upon the viewing point of the beholder. From an airplane at a height of ten thousand meters, only very large features of a coastline below might be visible. At a height of about ten meters, details only a few centimeters in length might be recognizable. And looking through a microscope, fractions of a millimeter might be detectable. Unlike Euclidian dimensionality, which is expressed in whole numbers, *fractal dimension* is expressed in fractions.

Scaling symmetry is only one feature of fractals. *Self-similarity* is another: each part of the whole resembles the whole, each part of each part resembles each part, and so on. Zoomed in at any part of a fractal at any magnification, it always reveals a reproduction of itself. As the zoom continues, the same images reappear ad infinitum. Mandelbrot's definition of fractals does not include self-similarity, since linear objects, such as a field of dots, can also possess self-similarity. Nonlinear fractals, like the Mandelbrot set, actually contain only limited, local self-similarity, which is richer and therefore more interesting than linear self-similarity; the fractal becomes less self-similar but *more* complex with increasingly finer scale.

The third component of fractals is *randomness* or chaos. In chaos theory, "strange attractors" — geometric forms of order within chaos to which long-term behavior of a chaotic system is attracted — are fractals.

What is fractal art? It is neither a new artistic style nor even a movement but, by analogy with Roland Barthes's definition of structuralism,[1] it is essentially an *activity*. We might speak of a fractalist activity as we once spoke of a surrealist or a structuralist activity, both of which may well have produced the first experiences of fractalization. Like the surrealist and the structuralist activity, fractalism is an

1 Roland Barthes, 1963, "The Structuralist Activity," in *The Structuralists: From Marx to Lévi-Strauss*, eds. Richard T. and Fernande M. De George, trans. Richard Howard (Garden City, N.Y.: Doubleday, 1972)., pp. 148–54.

activity of *simulation* — simulation of randomness (automatism) and meaning (structure). The fractalist artist is both a mirror of the psychological and social state of society, and an interface. He or she no longer concerns himself or herself with the mere manufacturing of objects but with the experience of fractalization.

With the neutralization of the subject, today's mass media and computer age switches from a geometric to a fractal state. The merging of cultural and economical practice — of art that, as well as our daily life, simulates advertisement and mass media, and vice versa — into the same type of discourse and the disappearance of the signified, already anticipated by Wittgenstein,[2] leads to the dissolution of the traditional concept of art. Art becomes a self-referential and self-reproducing system, a system that represents or refers to itself by designating itself or elements of itself within the system of its own symbolism. It is a consequence of representational power — as the mathematician Kurt Gödel has shown — that systems become increasingly self-referential the more their complexity increases. Advertisement and media have become the mediated forms of all social relations. The same is true of art that refers to self-referential systems of representation like the mass media (television, advertising, music videos) or science.

Watch for the presence of any one of the three attributes of fractals (scaling, self-similarity, and randomness) to determine whether the fractalist vision is constituted. It is constituted retrospectively in Leonardo da Vinci's drawings of water turbulence; as well as in Jackson Pollock's drips and Gerhard Richter's abstract paintings. Worked in many layers until the

2 "To the proposition belongs everything which belongs to the projection; but not what is projected . . . The propositional sign is a fact." Ludwig Wittgenstein, 1922, *Tractatus Logico-Philosophicus*, trans. C.K. Ogden (London: Routledge & Kegan Paul, 1981), p. 45 (pars. 3.13 and 3.14).

same homogeneous surface always emerges, Richter's paintings become diagrams of chaotic behavior. As complexity and randomness increase with each layer of paint, the artist becomes more and more removed and the painting increasingly self-reproducing and self-similar.

Today, fractal art can be divided into two categories: the first, a group consisting mostly of scientists, like Heinz-Otto Peitgen and Peter H. Richter in Germany, Clifford A. Pickover in the U.S., and the Asterisco Ponto Asterisco (∗.∗) Group in Brazil (composed of an architect, two scientists, a musician, two engineers, and a mathematician, their work was included in a special section on fractal art at the 20th São Paulo International Biennial). This fraction of non-artists emphasizes beauty and invention of form, categories that have long been abandoned in contemporary art, and stress the *democratic* potential of computer-generated art.

The second group consists of the growing number of contemporary artists who use, within their preferred medium, elements of chaos and fractalization, such as Carlos Ginzburg (photo assemblage) and Marie-Bénédicte Hautem (photography) in France; Eve Andrée Laramée (sculpture), Carter Hodgkin (painting), and Ellen Carey (photography) in the U.S. Unlike the first group, these artists are often inspired by but not limited to fractals and chaos theory. Laramée's installations involving water, salt, copper, and other chemically active materials celebrate the tangle of chaos and order that is peculiar to fractals. Embodied within a sculptural form, her work creates environmental situations that isolate and record changes of matter from one state to another. Ginzburg's photo assemblages take place in three parts: *deconstruction* (the breakdown of existing and readily available images), *dissemination* (images are distributed randomly without imposing any code or syntax), and *fractality* (a synthesis involving the concept of fractality, creating a proliferation of detail that exceeds the viewer's capacity to see the whole). Hodgkin's mixed-media works deconstruct and juxtapose the "high-tech" (images of

computer-generated fractals, computer circuit boards, or take from electronic microscopes) with the "primitive" (images of Australian aboriginal art, etc.). These high tech images take on a mythic, timeless quality with an underlying implication of the religious value technology has in our society. Hautem's photographs of water turbulence refer to a "photologie fractale," a photographic discourse that spans from Leonardo da Vinci to self-referential systems of Gödel and Mandelbrot. Carey's multiple-exposed Polaroids represent ten years of exploring photo-portraiture in relation to personal notion. Ritual body decoration and tattooing are recalled in the superimposed patterns that unite the human body with computer-generated images from fractal geometry. In her most recent works, Carey applies the concept of fractality more directly to images of flowers and trees.

Once again the artist is confronted with Lacan's mirror, only this time, the mirror is fractured; the armor of the alienating geometry gone to pieces.

CADY NOLAND: DEATH IN ACTION

Some say man ain't happy truly 'til man truly dies.
Oh why, oh why, . . .
Sign o' the times mess with your mind, hurry before it's 2 late.
— Prince, 1987

New York art has always had a predilection for the *object*, starting with the embrace of Marcel Duchamp's ready-mades and the collages of German Dadaist Kurt Schwitters by the neo-Dadaists Robert Rauschenberg, Jasper Johns, John Chamberlain, and Richard Stankiewicz. Duchamp, having chosen to be an American citizen and living much of his life in New York, was not nearly so well known in France as he was in America. Entire careers in art have since been devoted to the radical extension of the means for practicing art that Duchamp had opened up, from the Pop artists Andy Warhol, Roy Lichtenstein, and James Rosenquist to the consumer and appropriation art of Jeff Koons, Haim Steinbach, Richard Prince, and John Dogg.

The balance between fiction and reality has changed significantly in the past decades. Increasingly, their roles have become reversed. We live in a world ruled by fictions of every kind, created by television, advertising, technology, and science. Thus it becomes less and less necessary for artists to invent fictional content for their work. The fiction is already there; the artist's task is to invent reality.

Ever since the 1962 *New Realists* exhibition at Sidney Janis Gallery in New York linked the European new realism with the Pop art of Warhol, Lichtenstein, Rosenquist, and Robert Indiana, the American neo-Dada was left historically without succession. Cady Noland is one of a group of young Ameri-

This essay originally appeared in *artpress* 148 (June 1990).

can neorealists (such as Vik Muniz, Jessica Stockholder, Tony Tasset, and Jennifer Bolande) who set themselves apart from the neo-Pop of Jeff Koons or Richard Prince by resuming the discourse of Nouveau Réalisme. Rather than appropriating a fictionalized "hyperreality," they are engaged in *defictionalizing* reality.

In this sense, Noland's assemblages of new and used objects refer more to those of Arman, César, Daniel Spoerri, and their American counterparts Rauschenberg and John, than to Pop.

Accessories of American leisure (shopping carts, cameras, footballs, automobile parts, baseball bats, barbecue grills, hamburger buns, beer cans) are paired with insignias of power and violence (handcuffs, holsters, police badges, American flags) and symbols of restricted mobility (walkers, metal gates, wire containers, wall-mounted bars).

Noland applies Freud's classic distinction between the latent and manifest content of the dream, between the apparent and the real, to the external world of so-called reality. Her work follows a trail littered with violence and death — the trail of the postmodern, oversocialized psychopath:

I became interested in psychopaths in particular because they objectify people in order to manipulate them. By extension, they represent the extreme embodiment of a culture's proclivities; so psychopathic behavior provides useful highlighted models to use in search of cultural norms. As does celebrity . . . I remember reading several interviews with Paul Newman where he talks about being treated like an object.[1]

A series of works on aluminum panels focuses on the death of Abraham Lincoln, displaying photographs and texts that document isolated episodes that occurred on the night of his assassination. A recent assemblage, *Celebrity Trash Spill*, is arranged around the headline of Abbie Hoffman's drug-related murder on the front page of the *New York Post*.

1 *Journal of Contemporary Art*, vol. 3, no. 2 (Fall/Winter 1990): 22–23.

J. G. Ballard, the British science-fiction writer and author of *Crash, The Atrocity Exhibition,* and *Empire of the Sun,* describes our age as one in which the individual has the terrible existential freedom of choosing to do literally whatever he or she wants. The moral structures of society are provided for us, to a large extent, by science, technology, and the mass media without any contribution from ourselves, leaving a society in which psychopathic acts can be indulged without any concern for their consequences.

Our society is turning increasingly to perversions, particularly those involving violence, such as the vicarious enjoyment of war and murder in tabloids and on TV. Contemporary technology and mass communications are now giving us the means to fulfill our every fantasy. Sex has become an abstract pleasure, which led to what Ballard calls the "death of affect." In the introduction to the French edition of *Crash,* he writes,

This demise of feeling and emotion has paved the way for all our most real and tender pleasures in the excitements of pain and mutilation; in sex as the perfect arena, like a culture bed of sterile pus, for all the veronicas of our own perversions; in our moral freedom to pursue our own psychopathology as a game; and in our apparently limitless powers for conceptualization. What our children have to fear are not the cars on the highways of tomorrow, but our own pleasure in calculating the most elegant parameters of their deaths.[2]

Like Ballard, Cady Noland assembles materials for an autopsy on reality, American reality in particular. In her works America becomes a *case history,* an object of forensic inquisition. Her work is investigative, exploratory, but comes to no moral conclusions. There is a certain cool, moral and emotional detachment from the assembled objects, not only on the part of the artist but of the beholder as well, while, at the same time, it is concerned with the experience of an object in

2 J.G. Ballard, "Introduction to *Crash,*" in *RE/Search* 8/9 (1984): 96–98.

a *situation*, one that includes the beholder. Within the work, parts are unattached and can be moved in different positions. When a piece is reinstalled, it doesn't necessarily take an identical configuration. Noland's work has a fundamentally theatrical effect. In this respect, she responds to major trends in the sculpture of the late 1960s, especially to minimal art. Her assemblages have, what the American art historian Michael Fried, in his 1967 essay "Art and Objecthood," called "the theatricality" of minimal art.[3]

Noland's work must, above all, be taken as a whole rather than a number of singular pieces. It will be seen to have quite a profound significance for our viewing of reality and the experience of ourselves within that reality.

3 In *Minimal Art: A Critical Anthology*, ed. Gregory Battcock (New York: E. P. Dutton, 1968), pp. 116–47.

EXOTISM

I. The Discourse Which Is Not One

The order of philosophical discourse is based on the exclusion of difference. From its very beginnings, philosophy has been directed at the cognition of universal truths and principles. Its discourse is characterized by the logic of the One that excludes or equates difference. The differences of gender race, or ethnicity remain excluded. The philosophical discourse lies when it pretends to be sexually and racially indifferent and to represent the whole. Its notions and ideas are characterized by the linear dominance of white, male thinking in the history of Western metaphysics. The discourse of philosophy has always been a discourse of the masculine. Its statements are limited to the male sex, its notions deduced from male concretion: "The genitalia are more than any other *exterior member* of the body subjected only to the will."[1]

The Other does not exist, except as the nonrepresented, unthinkable — a remainder, like Kant's *Ding an sich:*

Women have no existence and no essence. They are not, they are nothing. One is man or one is woman, depending on whether one is someone or not. The woman has no part in the ontological reality.[2]

Difference appears in philosophical discourse only as *hierarchical* difference, the subjection of one under the other:

This essay originally appeared in *Exotism*, exhibition catalog (Middletown, Conn.: Ezra and Cecile Zilkha Gallery, 1990).
1 Arthur Schopenhauer, *Sämtliche Werke*, vol. 1 (Wiesbaden: F. A. Brockhaus: 1972), p. 389 (my translation).
2 Otto Weininger, Geschlecht und Charakter (Munich: Matthes & Seitz, 1980), p. 383 (my translation).

The arbitrary association of two people is not sufficient for the unity and indissolubility of a bond; one part has to be subjugated to the other.[3]

Difference becomes interesting only if it is a matter of dissolving opposites into hierarchies (lord and bondsman, husband and wife, parent and child), and then justifying these hierarchies.

Hegel developed his conciliatory dialectic out of the dualism of the sexes. But rather than restoring the original polarity of man and woman he followed a desexualized idea of androgyny, brought into German idealism by the romanticists. Aesthetically, this idea of nondifference was formulated before Hegel by Kant with his notion of "uninterested pleasure."[4] The ideal of asexuality is maintained in all variations of androgyny. The difference of the sexes is regarded as lust, as cause for all the evil in the world. This idea influenced profoundly the conception of love and marriage in romanticism and German idealism. The unity of the sexes is only possible in a condition without lust: in the unmixed relationship between brother and sister, in the prepubertal state, and in the act of procreation between husband and wife. The product of this "desireless" marital activity, the child, is as "its born visible identity and middle," the "purest" and "most sexless," which "eradicates the difference of the sexes completely and is both in absolute unity."[5]

Hegel's dialectic, which simulates biological reproduction, no longer takes place between man and woman but, like the Christian Trinity, occurs under the exclusion of femininity as a solely male event of procreation and birth. Just as the

3 Immanuel Kant, *Werkausgabe*, vol. 12 (Frankfurt am Main: Suhrkamp Verlag, 1977), p. 648 (my translation).

4 "Taste is the judgement of an object or an idea according to pleasure or displeasure, *without all interest.* The object of such a pleasure is called *beautiful.*" Ibid., vol. 10, p. 124 (my translation).

5 Georg Wilhelm Friedrich Hegel, *Frühe politische Systeme* (Frankfurt am Main: Ullstein, 1974), p. 27 (my translation).

Holy Spirit is indifferent and sexless, so is the notion created in the coitus of thoughts: "The substance of the discourse is like the child the most indeterminate, purest, most negative, most asexual."[6]

This exclusion of the feminine from the discourse is achieved through a characterization of the masculine as a "split being"[7] to which woman stands opposite in natural unity. Thus, difference and its neutralization become the center of Hegelian discourse; not the difference of gender, but the difference of man in himself:

The male character can abstractly be defined as the difference in itself . . . His destination is to be in unity with himself . . . a unity which is brought about through struggle, activity. The character of the woman is the more natural remaining unity.[8]

The influence of a dialectic that diminishes difference is still alive in Sartre:

Negritude appears to be the upbeat of a dialectical progression; the theoretical and practical assertion of white supremacy is the thesis; the position of negritude, as an antithetical value, is the moment of negativity. But this negative moment is not sufficient in itself . . . its aim is to prepare a synthesis or realization of the human in a society without races. Thus negritude exists in order to be destroyed.[9]

Hegel modeled his philosophy of law after the *Oresteia* of Aeschylus, which describes the conflict of the new patriarchal law with the old matriarchal law in ancient Greece and

6 Ibid., p. 29.
7 Georg Wilhelm Friedrich Hegel, *Grundlinien der Philosophie des Rechts* (Stuttgart: Reclam, 1976), p. 312 (my translation).
8 Georg Wilhelm Friedrich Hegel, *Vorlesungen über Rechtsphilosophie, 1818–1831*, vol. 4, ed. K.-H. Ilting (Stuttgart: Frommann-Holzboog, 1973), p. 441 (my translation).
9 "Orphée noir," preface to L.S. Senghor's *Anthologie de la nouvelle poésie nègre* (Paris: PUF, 1948), p. xli.

its "solution," the deprivation of the latter and its enclosure within the institution of the family. According to Hegel, in the precapitalist society, state (representing the patriarchal law) and family (the matriarchal law) stood irreconcilably opposite each other. With the separation of the area of production from the family, the creation of an extrafamilial factory system at the end of the eighteenth century, and the insertion of a capitalistic middle class, the bourgeois society, between family and state, the family loses its economic significance and power to the bourgeois society that replaces it as the area of production. The opposition of matriarchal and patriarchal law thus has been turned into an opposition of state and bourgeois society, an opposition that no longer is one, while women remain in the now deprived family, which becomes redefined by "love" and "piety":

The family as the immediate substantiality of the spirit has as its vocation the unity which it regards as itself, love.[10]

The war of the sexes does not take place.

10 G. W. F. Hegel, *Grundlinien der Philosophie des Rechts*, p. 302.

II. Speaking *(as)* the Other/Speaking of the Other

If the order of Western historicism is disturbed in the colonial state of emergency, even more deeply disturbed is the social and psychic representation of the human subject. For the very nature of humanity becomes estranged in the colonial condition and from that "naked declivity" it emerges, not as an assertion of will nor as an evocation of freedom, but as an enigmatic questioning. With a question that echoes Freud's *"What does woman want?,"* Fanon turns to confront the colonized world. "What does a man want?" he asks, in the introduction to *Black Skin, White Masks*; "What does the black man want?"
— Homi K. Bhabha, 1990

This is what I mean by my formula that the unconscious is *"discourse de l'Autre"* (discourse of the Other), in which the *de* is to be understood in the sense of the Latin *de* (objective determination): *de Alio in oratione* (completed by: *tua res agitur*).

But we must also add that man's desire is the *désir de l'Autre* (the desire of the Other), in which the *de* provides what grammarians call "subjective determination," namely that it is *qua* Other that he desires (which is what provides the true compass of human passion).

That is why the question *of* the Other, which comes back to the subject from the place from which he expects an oracular reply in some such form as *"Che vuoi?,"* "What do you want?," is the one that best leads him to the path of his own desire — providing he sets out, with the help of the skills of a partner known as a psychoanalyst, to reformulate it, even without knowing it, as "What does he want of me?"
— Jacques Lacan, 1960

The term "exotism" was coined by the French naval doctor, poet, archaeologist, and ethnologist Victor Segalen (1878–1921) in his fragmentary *Essai sur l'Exotism*. Segalen traveled extensively to China, Tahiti, East Asia, and Ethiopia, and in 1902, he followed the traces of Paul Gauguin on the Marquesas islands where the artist had died. Later he undertook a similar expedition to Ethiopia to retrace Arthur Rimbaud's "second" life. The documents of these subjective archaeolo-

gies were published in *Le Mercure de France* in 1904 *(Gauguin dans son dernier décor)* and 1906 *(Le double Rimbaud)*. Until recently, Segalen was rarely mentioned in literary circles, with most of his writings still untranslated.

In December of 1908 Segalen wrote "On Exotism as an Aesthetic of Diversity":

First of all, clear the ground. Throw over board all misused and stale content of the word exotism. Strip it from all its flashy rags: the palm trees and the camels; the tropical helmet, the black skin and the yellow sun . . .

Next, strip the word exotism of its purely tropical, purely geographical meaning. Exotism is given not only in space, but equally in relation to time.

And very quickly come to define, formulate the sensation of exotism: which in the end is only the notion of difference, the perception of diversity, the knowledge that something is not oneself, and the ability of exotism, which is the ability to conceive the Other.[11]

Exoticism had become fashionable in art and literature during first two decades of the twentieth century, a fascination that began with the great voyages in the sixteenth century and the discoveries and colonization of Africa, Asia, and America. At the time of Segalen's writing there was a flourishing colonial literature of exoticism or orientalism. Segalen's reflections and writings on exotism are different from the colonial infatuation with exoticism. Rather than producing a discourse in which the Other would be the subject or object, he attempted to provide a place for the Other in himself. The traveler Segalen became himself, the exotic, the Other: "There are among men born travellers: these are the *exotics*."[12] Like Michel Leiris, the author of *L'Afrique fantôme*, Segalen was an amateur. He excavated without being an archaeologist, mapping a poetic geography of the Other onto his life. Traveling

11 Victor Segalen, *Essai sur l'Exotism, une Esthetique du Divers* (Montpellier: Fata Morgana, 1978), p. 36 (my translation).
12 Ibid., p. 43.

as desire of the Other: in China, he became the Forbidden City; in Ethiopia, Rimbaud; in Tahiti, Gauguin.

Exotism is the experience of race, ethnicity, gender, nature — *Otherness*. But rather than focusing on colonial/touristic exoticism, embracing the Other in an exploitative manner (as the Cubists did with "primitivism"), it locates the Other within itself rather than without, and recognizes that there is no simple opposition of the One and the Other, that, in Lacan's words, "there is no Other of the Other."[13] Like Segalen's essay, this exhibition has as its subject the desire of the Other rather than the Other itself, speaking *(as)* the Other rather than of the Other. It asks with Lacan not only "What do I want of the Other?" but "What does the Other want of me?"

13 Jacques Lacan, *Écrits*, trans. Alan Sheridan (New York: W. W. Norton, 1977), p. 311.

Fascism was not simply a conspiracy — although it was that — but it was something that came to life in the course of a powerful social development. Language provides it with a refuge. Within this refuge a smoldering evil expresses itself as though it were salvation.
— Theodor W. Adorno, 1964

Always a bit unsettled and irritable, collaborating consciousness looks around for its lost naivité, to which there is no way back, because conscious-raising is irreversible.
— Peter Sloterdijk, 1983

Today, Adorno's *Jargon of Authenticity* has been supplanted by "enlightened false consciousness":

It is that modernized, unhappy consciousness, on which enlightenment has labored both successfully and in vain. It has learned its lessons in enlightenment, but it has not, and probably was not able to, put them into practice. Well-off and miserable at the same time, this consciousness no longer feels affected by any critique of ideology; its falseness is already reflexively buffered.[1]

Adorno's basic thesis was that after World War II German existentialism became an ideological mystification of fascism while pretending to be a critique of alienation:

In Germany a jargon of authenticity is spoken — even more so, written. Its language is a trademark of societalized chosenness, noble and homey at once — sublanguage as superior language. The jargon extends from philosophy and theology — not only of Protestant academies — to pedagogy, evening schools, and youth organizations, even to the elevated diction of the representatives of business and administration. While

This essay originally appeared in *Flash Art* 154 (October 1990).
1 Peter Sloterdijk, *Critique of Cynical Reason*, trans. Michael Eldred (Minneapolis: University of Minnesota Press, 1987), p. 5.

the jargon overflows with the pretense of deep human emotion, it is just standardized as the world that it officially negates; the reason for this lies partly in its mass success, partly in the fact that it posits its message automatically, through its mere nature. Thus the jargon bars the message from the experience which is to ensoul it.[2]

The cultures of both postwar Germanies are contaminated with an aesthetic formalism that had its origin in German fascism. As Benjamin Buchloh pointed out in his provocative *Artforum* essay on Beuys's creation myth,[3] postwar Germany found its new identity "by pardoning and reconciling itself prematurely" with the horrific crimes of its recent past.

After 1945, when the National Socialist language became unwanted, Heidegger's political discourse transformed into both an *Angst*-ridden critique of technology and an influential theory of art (Heidegger's *On the Origin of the Work of Art* is probably the most widely read text by art and philosophy students alike) that retain their ancestry to the National Socialist ideology. Philippe Lacoue-Labarthe has recently described how Heidegger turned his *völkische* philosophy into a "national-aestheticism":

It is not in the discourse of 1933 that "Heidegger's politics" is to be found . . . but in the discourse which follows the "break" or the "withdrawal" and which presents itself in any case as a settling of accounts

2 Theodor W. Adorno, *Jargon of Authenticity*, trans. Knut Tarnowski and Frederic Will (Evanston, Ill.: Northwestern University Press, 1973), p. 5.

3 "Beuys's story of the messianic bomber pilot, turned plastic artist, rising out of the ashes and shambles of his plane crashed in Siberia, reborn, nurtured and healed by the Tartars with fat and felt, does not necessarily tell us and convince us about the transcendental impact of his artistic work . . . What the myth does tell us, however, is how an artist, whose work developed in the middle and late 1950s, and whose intellectual and esthetic formation must have occurred somehow in the preceding decade, tries to come to terms with the period of history marked by German fascism and the war resulting from it." Benjamin H.D. Buchloh, "Beuys: The Twilight of the Idol, Preliminary Notes for a Critique" *Artforum* (January 1980): 38.

with National Socialism, *in the name of its truth* . . . In 1933, *techné* . . . is connected with *energeia*, itself interpreted as *"Am Werk-sein"* which we may in effect translate in this context . . . as "being-at work" (*être au travail*). Two years later, *energeia* in this sense has disappeared, but the discourse on *techné*, which has in the meantime become a discourse on art, culminates in the definition of art in its essence as "Ins-Werk-setzen," setting to work, of *aletheia*. "Work" (*le travail*) has been supplanted by "the work" (*œuvre*) and in the very same process, it seems to me, in the innermost "political" recesses of that discourse, National Socialism has been supplanted by what I shall call a national-aestheticism.[4]

Heidegger's vocational discourse had become an idealized formalism, devoid of its original fascist content. The anti-modernism that, fatally combined with antisemitism, stood at the center of the National Socialist ideology (going back to Pope Pius X's condemnation of modernism in his encyclical *Pascendi dominici gregis* of 1907, which resulted in the obligatory oath against modernism on Catholic universities),[5] returns in Heidegger's thinking as patriotic antinihilism: "The surmounting of nihilism nevertheless announces itself in the poetic thinking and the hymning of what is German," Heidegger wrote in 1945.[6]

For the National Socialist ideologues, the inseparability of politics and art, the aestheticization of politics, was crucial, as Goebbels stressed in his open letter to Wilhelm Furtwängler from 1933, in response to Furtwängler's protest of racial discrimination:

It is your right to feel as an artist and to look upon matters from the living artistic point of view. But this does not necessarily presuppose your assuming an unpolitical attitude toward the general development that has taken place in Germany. Politics, too, is perhaps an art, if not the highest and most all-embracing there is. Art and artists are not only there to unite;

4 Philippe Lacoue-Labarthe, *Heidegger, Art, and Politics*, trans. Chris Turner (Oxford: Blackwell, 1990), p. 53.
5 See Victor Farías, *Heidegger et le nazisme* (Lagrasse: Editions Verdier, 1987), p. 62.
6 Lacoue-Labarthe, *Heidegger, Art, and Politics*, p. 55.

their far more important task is to create a form, to expel the ill trends and make room for the healthy to develop . . . Art must not only be good, it must also be conditioned by the exigencies of the people or, rather, only an art that draws on the *Volkstum* as a whole may ultimately be regarded as good.[7]

According to the racial National Socialist aesthetics, as its leading advocate Alfred Rosenberg expounded under the influence of Wölfflin's *Formgefühl* (feeling for form),[8] form and content are inseparable: "In the efforts to separate the aesthetic object from all its extra-esthetic elements, one has among other things always also separated content from form . . . For all that, this methodically necessary separation has forgotten the most important fact: that the content in the case of the Nordic-Occidental art represents in addition to its content also at once a formal problem."[9]

Heidegger's *Angst* regarding technology often expressed itself in an alarmingly distorted form, as in this quote from 1949:

Agriculture is today a motorized food industry, essentially the same as the production of corpses in gas chambers and extermination camps, the same thing as blockades and the reduction of countries to famine, the same thing as the manufacture of hydrogen bombs.[10]

7 Ibid., p. 61.

8 Heinrich Wölfflin, in *Italien und das deutsche Formgefühl* (1931): "In Italian art . . . the human figure appears in isolation and more or less maintains its independence within all combinations . . . Each form is then presented as a self-sufficient independent entity . . . The North was of different opinion. The primary element was not the figure as such; instead, the Northern conception was determined by the figure-complex, by the interconnection of the form and its surroundings . . . Space and figure are not two separate entities but function together as a unity." Quoted in John F. Moffit, *Occultism in Avant-garde Art: The Case of Joseph Beuys* (Ann Arbor: UMI Press, 1988), pp. 91–92.

9 Alfred Rosenberg, *Der Mythus des 20. Jahrhunderts* (Munich: Hoheneichen-Verlag, 1943), p. 304.

10 First quoted in Wolfgang Schirmacher, *Technik und Gelassenheit: Zeitkritik nach Heidegger* (Freiburg: Karl Alber, 1983), p. 25.

Both mass media and technology were seen by Heidegger as forces that one was powerlessly subjected to.

Heidegger's discourse on technology, which repeats the National Socialist paradox of nurturing images of rural bliss while, at the same time, pushing technology ahead for their military and racial politics, is also reflected in Beuys's championing of the "green" movement. While submerged in Nordic metaphors of nature, he takes an almost totalitarian advantage of the media and technology in his performances, where the always present microphone transmitted his messages to the audience, just as Hitler's *Volksempfänger,* the radio receivers that were distributed to every household, spread the Führer's words to the German *Volk.*

While the *content* of Nazism has been condemned in postwar Germany (though lately reappearing under the pretense of provocation), its formal language or *Gestalt* is still widely used in the guise of a mythical antimodernism (not to be confused with postmodernism) and a "national-aestheticism." There are latent formal elements of fascism in the work of Joseph Beuys,[11] which are increasingly being isolated and passed on by the second and third generation of German artists, at a time of growing conservatism in Germany, especially in light of the current prospect of a reunification of both Germanies.

Like Heidegger, Beuys attempted to regain a tragic world experience and an historic greatness that is surrounded by mythology. This is also at the core of Anselm Kiefer's work. But ever since Adorno and Horkheimer's *Dialectic of Enlightenment* we have been warned against any enlightenment that produces its own myths. "Mythical" here is not meant as mythological but, rather, as onto-typological in the sense of a deeply embodied *archetypalism.*

11 On the *völkische* element in Beuys's work, see Moffit, *Occultism in Avant-Garde Art*, pp. 83–103.

The New York weekly *7 Days* recently celebrated the arrival of a new style in design and architecture, a retro-futuristic "archetypalism," whose exponents range from set designs for the movies *Blade Runner* and *Batman,* to the *Batplane*–inspired Stealth bomber, the Mazda Miata sports car, and Robert Gober's generic object art: "With postmodernism passe, the next design 'ism' is part Jung, part Gertrude Stein, and as familiar as an old sneaker."[12]

Reinhard Mucha's nostalgic sculptural assemblages, Felix Droese's neo-romantic paper silhouettes, the Germanic photographs and constructions of Bernhard Prinz, and the neo-realist photographs of the Becher students Thomas Ruff and Thomas Struth all manifest this antimodern "national-aestheticism." Just as Bernd and Hilla Becher focus in their photographs on premodern and early industrial architecture, so in Struth's stylized photographs of uninhabited streets Heidegger's truth is set to work. Ruff's archetypal portraits of young Germans are not unlike the realism of National Socialist art or the totalitarian realism of Honecker's East Germany, where photographic portraits of exemplary workers were displayed in stores and factories.

12 Phil Patton, "Archetypalism," *7 Days* (April 11, 1990): 21.

JUAN USLÉ: THE ABSOLUTE OF PASSAGE

I

When a writer calls his work a Romance, it need hardly be observed that he wishes to claim a certain latitude, both as to its fashion and material, which he would not have felt himself entitled to assume, had he professed to be writing a Novel. The latter form of composition is presumed to aim at a very minute fidelity, not merely to the possible, but to the probable and ordinary course of man's experience. The former — while, as a work of art, it must rigidly subject itself to laws, and while it sins unpardonably, so far as it may swerve aside from the truth of the human heart — has fairly a right to present that truth under circumstances, to a great extent, of the writer's own choosing or creation. If he think fit, also, he may so manage his atmospherical medium as to bring out or mellow the lights and deepen and enrich the shadows of the picture. He will be wise, no doubt, to make a very moderate use of the privileges here stated, and, especially, to mingle the Marvelous rather as a slight, delicate, and evanescent flavor . . . The point in which this Tale comes under the Romantic definition lies in the attempt to connect a bygone time with the very Present that is flitting away from us.
— Nathaniel Hawthorne, 1851

What is this "secret" dimension of language on which all mystics since time immemorial have agreed upon . . . ? The answer can hardly be doubtful: it is the symbolic character of language that defines this dimension . . . ; that something is communicated in language which reaches beyond the sphere of expression and form; that an unexpressed, which only shows itself in symbols and resonates in all expressions, underlies them and, if I may say so, shines through the crevices of the world of expression . . . The mystic detects in the language a dignity, an inherent dimension or, as one might say today: something at its structure, which is not directed at communi-

This essay originally appeared in *Juan Uslé: 147 Broadway*, exhibition catalog (Madrid: Galería Soledad Lorenzo, 1991).

cating the communicable but rather — and all symbology is based upon this paradox — at communicating the uncommunicable, which resides in it without expression.
— Gershom Scholem, 1970

Painting the uncanny, the un-homely (the hyphenated *un-* marking the process of displacement described by Freud through which the once homely and familiar becomes its negation: the unhomely or *das Unheimliche*). According to the *universe of possible discourse,* which pretends to represent the whole, the uncanny does not exist: it is the *nonrepresentable* — a remainder, like Kant's *Ding an sich.* As such, it lives on in the exile of dream and madness, in the language of hysteria, and in the fantasies of fiction and art. There, homely and un-homely at once, it generates a fearful pleasure of the kind Freud called "forepleasure," because, like fear, it is not in relation to a real object but in relation to the nonrepresentable.

Juan Uslé's paintings arouse this kind of pleasure. They lead to unknown, un-homely regions, haunted by memories of the past and the future.

Uslé's art possesses what Hawthorne called the "latitude of the Romance." Grounded in poetic and imaginative truth, it is filled with elements of adventure and the marvelous, with the mystical paradox of uttering the unutterable.

II

The sea is everything. It covers seven-tenths of the globe. Its breath is pure and healthy. It is an immense desert where man is never alone, for he can feel life quivering all about him. The sea is only a receptacle for all the prodigious, supernatural things that exist inside it; it is only movement and love; it is the living infinite . . . The world, so to speak, began with the sea, and who knows but that it will also end in the sea! There lies supreme tranquility . . . Ah, Monsieur, one must live — live within the ocean.
— Jules Verne, 1869

A recent modification of the standard Big Bang theory in cosmology, the inflationary universe model, states that the infant universe went through a brief period of extremely rapid expansion before settling into the slower pace of the standard model. The basic idea is that not one but several universes arose from bubbles inflating like balloons in the void. At first there were a number of extremely hot, energized spots. Because of their heat, these spots expanded so rapidly that each soon lost its heat and "supercooled" into a "false vacuum," a region of space that appears to be empty but actually contains stored energy. This false vacuum has been compared to water that is superchilled well below the freezing point. The water can exist in that state as a liquid for only an instant before crystallizing into ice. The same is true for supercooled bubbles. They exist for only an instant in an undisturbed state. Then the energy inside each bubble begins to condense into particles, which ultimately form the matter for the stars, planets, and galaxies of each universe. At this point the Big Bang scenario takes over.

Art history has accelerated rapidly in the last ten years. The development of art has expanded by loosing density, rushing toward a state of sheer meaninglessness and pure materialism.

Uslé's painted world resembles a translucent cosmic bubble containing poetic energy that travels through the expanding universe of art as the Nautilus, Nemo's submarine

in *Twenty Thousand Leagues Under the Sea*, journeys through the ocean depths. Uslé's art unfolds an unconscious organic world imbued with a pentecostal foreboding of life, not unlike the third day of creation inside the diaphanous crystal sphere, as depicted by Hieronymus Bosch on the outside panels of his *Garden of Earthly Delights*.

According to alchemic theory, God wedded his ethereal light and the primordial waters to create the world. From the reciprocal pervasion emerged the four elements earth, air, fire, and water. Similarly, the alchemic artist mixes pigment with light to recreate the physical world. Just as the electric light generated by the Nautilus meets with the phosphorescence of the deep ocean and turns the water into liquid light, Uslé's transparent paintings receive light, which is conjoined with their own luminous force and emitted again, reminding us that light needs to encounter light to make the world visible. The dream of Nemo is the dream of Uslé; it is the dream of art.

A deep fascination with sea-imagery and all its common resonances abounds in most of Uslé's work. In his paintings, landscape is always a state of mind, always without points of reference. Like Nemo, Uslé never leaves his world; his brushes never touch land. His bubble drifts endlessly in J. G. Ballard's "luminous, dragon-green, serpent-haunted sea" — without destination, in perpetual passage, *mobilis in mobile*.

Uslé's paintings are invested with a close-range "haptic space," which Deleuze and Guattari define as a characteristic of "nomad art":

The first aspect of the haptic, smooth space of close vision is that its orientations, landmarks, and linkages are in continuous variation; it operates step by step. Examples are the desert, steppe, ice, and sea, local spaces of pure connection. Contrary to what is sometimes said, one never sees from a distance in a space of this kind, nor does one see it from a distance; one is never 'in front of,' anymore than one is 'in'. . . There is no visual mode for points of reference that would make them interchangeable and unite them in an inertial class assignable to an immobile outside observer . . .

There exists a nomadic absolute, as a local integration moving from part to part and constituting smooth space in an infinite succession of linkages and changes in direction. It is an absolute that is one with becoming itself, with process. It is the absolute of passage, which in nomad art merges with its manifestation.[1]

1 Gilles Deleuze and Félix Guattari, *A Thousand Plateaus: Capitalism and Schizophrenia,* trans. Brian Massumi (Minneapolis: University of Minnesota Press, 1987), pp. 493–94.

ASTRID KLEIN'S PHENOMENOLOGY OF ABSENCE

In the field of photography there is an enormous amount that remains hidden. In order to acquire the right fingertip feel for the specific laws that govern its means, one must conduct practical experiments, including a.) photographs of structures, textures, surface treatments with regard to their reaction to light (absorption, reflection, mirroring, dispersal effects, etc.); b.) photographs in a so far unaccustomed style — rare views, oblique, upward, downward, distortions, shadow effects, tonal contrasts, enlargements, microphotographs; c.) photographs using a novel system of lenses, concave and convex mirrors, stereo-photographs on a disk, etc. The limits of photography are incalculable. Everything is so new that the mere act of seeking leads by itself to creative results.
— László Moholy-Nagy, 1928

What the psychoanalytic experience discovers in the unconscious is the whole structure of language. Thus from the outset I have alerted informed minds to the extent to which the notion that the unconscious is merely the seat of the instincts will have to be rethought. But how are we to take this "letter" here? Quite simply, literally. By "letter" I designate that material support that concrete discourse borrows from language.
— Jacques Lacan, 1957

While more and more German artists have become enthralled by a new emergence of anti-modernism (notably many who use photography, like Günther Förg or Thomas Ruff), Astrid Klein has, more than any other contemporary artist in Germany today, taken up the legacy of experimental photography, as practiced at the Bauhaus during the 1920s. Klein has extended the formal language of Bauhaus photography into a topology of desire, by way of a feminist-structuralist reading that corresponds to the investigations of Roland Barthes and Jacques Lacan into the libidinous texture of language. There

This essay originally appeared in *Astrid Klein*, exhibition catalog (Middletown, Conn.: Ezra and Cecile Zilkha Gallery, 1991).

is a striking analogy between Barthes's analysis of the photographic message and Lacan's reading of the "letter" of the unconscious. According to Barthes, the photograph is "a message without a code,"[1] a mechanical analogue of reality. As such, "its first order message . . . completely fills its substance and leaves no place for the development of a second-order message."[2] It can only be read literally. But at the same time it is subjected to a connotative process:

Connotation is not necessarily immediately graspable at the level of the message itself . . . but it can be inferred from certain phenomena which occur at the levels of the production and reception of the message . . . The photographic paradox can then be seen as the co-existence of two messages, the one without a code (the photographic analogue), the other with a code (the "art," or treatment, or the "writing," or the rhetoric, of the photograph); structurally, the paradox is clearly not the collusion of a denoted message and a connoted message . . . , it is that here the connoted (or coded) message develops on the basis of a message without a code.[3]

Similarly, Freud stipulated in *The Interpretation of Dreams* that the manifestations of the dream, the "letter" of the unconscious, have to be taken literally. The connotative process that Barthes referred to can be compared to the two mechanisms of distortion employed by the unconscious during dream-formation, which Lacan, in following de Saussure, called the "sliding of the signified under the signifier"[4]: condensation (the substitution of one word for another) and displacement (the combination of one word with another). Because of this process the interference of the signifier on the signified can reveal only "a signifying structure"[5] that implies

1 Roland Barthes, *Image, Music, Text,* trans. Stephen Heath (New York: Hill and Wang, 1977), p. 19.
2 Ibid.
3 Ibid.
4 Jacques Lacan, *Écrit: A Selection,* trans. Alan Sheridan (New York and London: W. W. Norton , 1977), pp. 147, 160.
5 Ibid., p. 152.

a certain loss or absence. While Astrid Klein's earlier photographs of building facades shadowed by black silhouettes of wild animals were characterized by an apocalyptic urban expressionism, her work subsequently embodied the experimental techniques of Bauhaus photography — the lack of focus, under-and overexposure, a certain photographic wit, and a focus on structure and "facture" (a term widely used by Bauhaus and Constructivist theoreticians to refer to the textual characteristics of a specific material). Her text-photomontages of coarsely magnified signifying factures, merged into one, their individual components no longer distinct, are reminiscent of Freud's "rapprochement forcé," the compulsion of the dreamwork to compound the various stimulative sources of the dream into one homogenous whole.[6]

As Andreas Haus has pointed out, "the Bauhaus photographic experiments did not restrict the design energy to the sheet format alone, but they easily developed a more universal tendency to functional total connections and were almost always possible montage elements for typographic or design purposes. This contains a fruitful reminder of the concept of 'space' that had been central to the Bauhaus idea placed there by Gropius with Moholy's practical help."[7] Astrid Klein has directed this architectural notion of space into the interstices of the photographic unconscious. With Klein's most recent body of work, the notion of absence and the discourse of desire are brought out "to the letter": the *Schränke* — photographs of dark, inner spaces, closed or half-open cabinets, obscenely enlarged with all the impurities of the negative; the *Teller* — grainy photographs of decorative plates that spell out signifiers of God from three major religions; and finally the *Wüsten-*

6 See Sigmund Freud, "Die Traumdeutung," in *Gesammelte Werke*, vol. 2/3 (Frankfurt am Main: S. Fischer Verlag, 1978), p. 185.

7 "Photography at the Bauhaus: Discovery of a Medium," in *Photography at the Bauhaus*, ed., Jeannine Fiedler (Cambridge, Mass.: The MIT Press, 1990), p. 148.

bilder — images of the infinite void of the desert endowed with the spirit of creation and eschaton, beginning and end. Her earlier apocalyptic expressions have become realized eschatology. Like the Torah, in which each letter signifies God, Astrid Klein's work has to be read, in Lacan's sense, *à la lettre.* At once a wry commentary on the Freudian symbology of the feminine, a metaphysical statement on the Hegelian murder of the signified[8] (which precipitated Barthes's mournful response to photography[9]), and a mystical revelation of the *deus absconditus,* it constitutes a diacritical phenomenology of absence.

8 "In Chapter VII of the *Phenomenology* [of Spirit], Hegel said that all *conceptual* comprehension (*Begreifen*) is equivalent to a *murder.*" Alexandre Kojève, *Introduction to the Reading of Hegel,* trans. James H. Nichols Jr. (Ithaca: Cornell University Press, 1980), p. 140.
9 "Certain photographs take you outside of yourself, when they are associated with a loss, an emptiness, and in this sense my book [*Camera Lucida*] is symmetrical to *A Lover's Discourse,* in the realm of mourning." Roland Barthes, *The Grain of the Voice: Interviews 1962–1980,* trans. Linda Coverdale (New York: Hill and Wang, 1985), p. 352.

ALFREDO ECHAZARRETA: *L'ARCHER-AU-LOGUE*

We shall distinguish between the simultaneity at the same place and the simultaneity of spatially separated events. Only the latter contains the actual problem of simultaneity; the first is strictly speaking not a simultaneity of time points, but an identity. Such a concurrence of events at the same place and at the same time is called a coincidence ... Practically speaking, such an identity never occurs since we could no longer distinguish the two events. But an approximate coincidence can be realized, in the example of two colliding spheres or two intersecting light rays.
— Hans Reichenbach, 1928

In all the laws of physics that we have found so far there does not seem to be any distinction between the past and the future ... The laws of molecular collision are reversible.
— Richard Feynman, 1964

Victor Segalen, French navy doctor, poet, archaeologist, and ethnologist, once made the following distinction between the prophet and the seer: "The prophet sticks to the forthcoming, the seer to that which was and is but has not been seen that way by anybody, whose existence has never before been grasped in this manner. They can conjoin and proudly bear the designation 'poet.'"[1] Segalen names, as an example of such an alliance, Rimbaud's poetic reinvention of the truth of the sea, "The Drunken Boat."

Like the poet, the artist has the ability to envision the future and create the past anew according to his vision. A painter of epic dimension, Alfredo Echazarreta is at once an explorer of continents yet to be discovered and times yet to come, and an

This essay originally appeared in *Echazarreta: Peintures, 1990–1991*, exhibition catalog (Lyon: Galerie Vannoni, 1991).

1 Victor Segalen, *Le Double Rimbaud* (Montpellier: Fata Morgana, 1986), p. 77 (my translation).

archeologist, *l'archer-au-logue* — the archer whose bow bends the arrow of time connecting the mythic past with the mythic future.

Echazarreta's paintings repeat in every layer of paint the "molecular" collision of two simultaneous events, the mythical and the actual. Each molecule of the paint seems to replay the paradoxical truth of atomic physics that time is reversible on a molecular level.

Adorno and Horkheimer, in *Dialectic of Enlightenment*, refuted Schelling's notion of the myth as a prerational phenomenon by demonstrating how myths are continuously produced by the *logos* itself. In Echazarreta's paintings, modern and ancient myths become interchangeable and mythos and logos coincide.

In his most recent works, Echazarreta extends the simultaneity of mythos and logos to the medium of photography. Here the painter/printmaker joins forces with the sculptor/photographer to furnish the photograph with its missing aura — a mythical aura that alludes to the "mythical" belief that photographs contain authentic particles of reality.

Photographs of sculpted figures and sets, which serve as models for the paintings, are added to the canvas to form an intrinsic part of the paintings after having first been reworked with etched lines by the artist, an accomplished printmaker, treating the negatives like a metal plate.

Echazarreta's paintings remind us that human thought is both mythical and logical, and that myths are inseparably linked with our dreams and realities.

God chose what is foolish in the world to shame the wise.
— 1 Cor. 1.27

In Kant's *Critique of Judgement,* aesthetic discourse is based on the exclusion of common or "barbaric" *(barbarisch)* taste that is affected by charm *(Reiz)* and emotion *(Rührung):*

Taste is always still barbaric where it needs the admixture of charms and emotions in order to be pleasing or even make these the measure of its approval . . . A judgement of taste which is not influenced by charm or emotion . . . is a *pure judgement of taste.*[1]

According to Kant, this pure judgement of taste must be a pluralistic, a priori aesthetic principle, common to all human beings — a s*ensus communis aestheticus:*

Were judgements of taste (like cognitive judgements) in possession of a definite objective principle, then one who in his judgement followed such a principle would claim unconditioned necessity for it . . . Therefore they must have a subjective principle, and one which determines what pleases or displeases, by means of feeling only and not through concepts, but yet with universal validity. Such a principle, however, could only be regarded as a *common sense.* This differs essentially from common understanding, which is also sometimes called common sense (*sensus communis*), for the judgement of the latter is not one by feeling, but always one by concepts . . .

This essay originally appeared in *ACME Journal,* vol. 1, no. 1 (Spring 1992).
1 Immanuel Kant, *The Critique of Judgement,* trans. J.C. Meredith (Oxford: The Clarendon Press, 1952), par. 13 (translation modified).

Hence if the import of the judgement of taste, where we appraise it as a judgement entitled to require the concurrence of every one, cannot be *egoistic*, but must necessarily, from its inner nature, be allowed a *pluralistic* validity, i.e. on account of what taste itself is, and not on account of the examples which others give of their taste, then it must be found upon some *a priori* principle.[2]

It is furthermore characterized by a universal communicability *(allgemeine Mitteilbarkeit)* without the mediation of a concept:

By the name *sensus communis* is to be understood the idea of a *public* sense, i.e. a critical faculty which in its reflective act takes account *(a priori)* of the mode of representation of every one else, in order, *as it were*, to weigh its judgement with the collective reason of mankind ... Taste is, therefore, the faculty of forming an a priori estimate of the communicability of the feelings that, without the mediation of a concept, are connected with a given representation.[3]

Despite Kant's efforts to exclude common taste from the *sensus communis*, the specter of common consciousness still haunts the *Critique;* Kant never conveys an analysis of common sense yet constantly presupposes it:

The judgement of taste, therefore, depends on our presupposing the existence of a common sense ... Only under the presupposition, I repeat, of such a common sense, are we able to lay down a judgement of taste ... But does such a common sense in fact exist as a constitutive principle of the possibility of experience, or is it formed for us as a regulative principle by a still higher principle of reason, that for higher ends first seeks to beget in us a common sense? Is taste, in other words, a natural and original faculty, or is it only the idea of one that is artificial and to be acquired by us, so that a judgement of taste, with its demand for universal assent, is but a requirement of reason for generating such a *consensus*, and does the "ought," i.e. the objective necessity of the coincidence of the feeling of all with the particular feeling of each, only betoken the possibility of arriving at some sort of unanimity in these matters, and the judgement of taste only adduce

2 Ibid., pars. 20, 29.
3 Ibid., par. 40.

an example of the application of this principle? *These are questions which as yet we are neither willing nor in a position to investigate.*[4]

Kant's *sensus communis* is essentially an imperative, an *ought (Sollen):*

Experience cannot be made the ground of this common sense, for the latter is invoked to justify judgements containing an "ought." The assertion is not that everyone will fall in with judgement, but rather that every one *ought to agree with it.*[5]

Hegel considered Kant's imperative solution of the antinomy of taste — the exclusion of common consciousness *(gewöhnliche Bewußtsein)* from the "science of art" *(Wissenschaft der Kunst)* as an *ought* — a major deficiency of the *Critique:*

But for the modern culture and its intellect this discordance in life and consciousness involves the demand that such a contradiction be resolved. Yet the intellect cannot cure itself free from the rigidity of these oppositions; therefore the solution remains for consciousness a mere *ought,* and the present and reality more only on the unrest of a hither and thither which seeks a reconciliation without finding one. Thus the question then arises whether such a universal and thoroughgoing opposition, which cannot get beyond a mere ought and a postulated solution, is in general the absolute truth and supreme end. If general culture has run into such a contradiction, it becomes the task of philosophy to supersede the oppositions, i.e. to show that neither the one alternative in its abstraction, nor the other in the like one-sidedness, possesses truth, but that they are both self-dissolving; that truth lies only in the reconciliation and mediation of both, and that this mediation is no mere demand, but what is absolutely accomplished and is ever-self-accomplishing . . . Philosophy affords a reflective insight into the essence of the opposition only insofar as it shows how truth is just the dissolving of opposition and, at that, not in the sense, as may be supposed, that the opposition and its two sides *do not exist at all,* but that they exist reconciled.[6]

4 Ibid., pars. 20, 22 (italics added).

5 Ibid., par. 22.

6 Georg Wilhelm Friedrich Hegel, *Aesthetics: Lectures on Fine Art,* trans. T.M. Knox, vol. 1 (Oxford: Oxford University Press, 1975), p. 54.

Hegel found this reconciliation in the Greek tragedies, particularly Sophocles's *Antigone* and Aeschylus's *Oresteia*, and has, to a large extent, built his philosophical system upon the examples of those tragedies. Not surprisingly, the discussion of tragic consciousness takes up a substantial part of his lectures on aesthetics:

The original essence of tragedy consists . . . in the fact that within such a conflict each of the opposed sides, if taken by itself, has *justification*; while each can establish the true and positive content of its own aim and character only by denying and infringing the equally justified power of the other.[7]

As in the Greek tragedies, where two powers of equal justification oppose each other, so in Kant's *Critique*, artistic beauty opposes natural beauty; the common consciousness, the pure judgement of taste; the subjectivity of the artist, the objectivity of nature.

While Hegel's *Philosophy of Right* focuses on the *Oresteia*, his *Aesthetics* centers on the *Antigone*. In the latter, Antigone's two brothers were killed during the siege of Thebes — one defending, the other attacking. The violation of the old matriarchal law by the decree of the new king, Creon, forbidding the burial of the traitorous brother, and Antigone's subsequent rebellion against Creon lead ultimately to the downfall of both Antigone and Creon; thus, the resolution of the conflict is conservative and restorative:

However justified the tragic character and his aim, however necessary the tragic collision, the third thing is the tragic resolution of this conflict. By this means eternal justice is exercised on individuals and their aims in the sense that it restores the substance and unity of ethical life with the downfall of the individual who has disturbed its peace.[8]

7 Georg Wilhelm Friedrich Hegel, *Aesthetics: Lectures on Fine Art*, trans. T. M. Knox, vol. 2 (Oxford: Oxford University Press, 1975), p. 1196.
8 Ibid., p. 1197.

Hegel clearly favors the (dialectical) "democratic" resolution introduced in the *Oresteia.* There, patriarchal law (represented by the matricide Orestes) stands opposite matriarchal law (represented by the Erinyes, the furies of Clytaemnestra, who constitute a constant threat to the new patriarchal society). The resolution of the conflict, negotiated by Athena, is accomplished by way of a cunning contract between the state and the Erinyes, which deprives them forever of their (political) power and encloses them within the depoliticized sphere of worship. Similarly, in the *Philosophy of Right* Hegel views the precapitalist society as one where family and state are opposed to one another. With the separation of the area of production from the family, the creation of an extrafamilial factory system at the end of the eighteenth century, and the insertion of a capitalist middle class (bourgeois society) between family and state, the family looses its economic significance and political power to the bourgeois society, which replaces it as the area of production. The opposition of matriarchal and patriarchal law has thus been turned into the opposition of state and bourgeois society, which no longer is one, while women remain in the now deprived family that has become redefined by "love" and "piety."

Hegel responds to Kant's question (as to whether the *sensus communis* exists as a constitutive aesthetic experience or as a regulative principle of reason) with the elimination of art by proclaiming the precedence of idea over form, criticism over art. Hence it is no longer necessary to presuppose a common sense, as Kant does:

But just as art has its "before" in nature and the finite spheres of life, so too it has an "after," i.e. a region which in turn transcends art's way of apprehending and representing the Absolute. For art has still a limit in itself and therefore passes over into higher forms of consciousness. This limitation determines, after all, the position which we are accustomed to assign to art in our contemporary life. For us art counts no longer as the highest mode in which truth fashions an existence for itself . . . Thus the *"after"* of art consists in the fact that there dwells in the spirit the need to satisfy itself solely

in its own inner self as the true form for truth to take. Art in its beginnings still leaves over something mysterious, a secret foreboding and a longing, because its creations have not completely set forth their full content for imaginative vision. But if the perfect content has been perfectly revealed in artistic shapes, then the more far-seeing spirit rejects *[stößt fort]* this objective manifestation and turns back into its inner self. This is the case in our own time. We may well hope that art will always rise higher and come to perfection, but the form of art has ceased to be the supreme need of the spirit . . . The Idea is alone the genuinely actual.[9]

The French sociologist Pierre Bourdieu, who conducted extensive research into the aesthetic taste of the middle and lower classes in contemporary France, distinguishes, in his study on amateur photography, between the "sphere of aesthetic legitimacy with universal claim" (including painting, sculpture, classical music, literature, and theater), the "sphere of practices that may take part in legitimacy" (such as film, photography, and popular music), and practices that are outside the sphere of aesthetic legitimacy (such as clothing and makeup). Accordingly, he differentiates among three legitimizing authorities: academies, criticism, and advertising:

The various systems of expression, from theater to television, are objectively organized according to a hierarchy independent of individual, which defines the *cultural legitimacy* and its gradations.[10]

In the same study, Bourdieu compares the aesthetic judgements of the lower classes, in regard to photography, to Kant's "barbaric" taste:

There is nothing more alien to popular consciousness than the idea that one can and should want to conceive an aesthetic pleasure which, to use Kantian terms, is independent of being agreeable to the senses . . . It is precisely popular taste that Kant is describing . . . In fact, tangible, informative or moral interest is the supreme value of the popular aesthetic.[11]

9 Ibid., 1:102, 1:110.
10 Pierre Bourdieu, *Photography: A Middlebrow Art*, trans. Shaun Whiteside (Stanford: Stanford University Press, 1990), p. 95.
11 Ibid., p. 92.

Since Bourdieu's study was conducted in the early 1960s, there has been a significant shift within that hierarchy of authorities, from the legitimate ones, the academies and critics, to the "illegitimate" ones, particularly television and advertising, which have become the legitimizing authorities for much of traditional artistic practice, such as painting or sculpture, as well as for aesthetic practices of the common consciousness, such as (amateur) photography and home videos.

Recently, Luc Ferry has given a Rousseauian reading of Kant's *sensus communis* as "direct communication" *(communication directe):*

Kant takes up here, in the aesthetic domain, the famous opposition, which Rousseau worked out in his *Letter to d'Alembert on Spectacles* between the *theater*, symbol of the monarchy, of the indirect communication which goes through the intermediary of the stage, and the *festival*, symbol of democracy, of the direct communication where the spectators' eyes are not directed toward an external object but rather themselves provide the show.[12]

He goes on to emphasize Kant's *sensus communis* as one that sustains, in itself, difference as such:

That's exactly the theme, Kant, *mutatis mutandis*, transposes into the third *Critique* and which grounds an aesthetic conception of the public space as an intersubjective space of free discussion, not mediated by a concept or rule — which in no way means, as we can see, some sort of "articulation of difference" but on the contrary, the articulation of difference with the idea of common sense.[13]

Ferry's interpretation of the *sensus communis* as *spectacle* resembles Bourdieu's characterization of the aesthetics of the lower classes as an aesthetics of celebration:

12 Luc Ferry, *Homo Aestheticus: The Invention of Taste in the Democratic Age*, trans. Robert de Loaiza (Chicago: University of Chicago Press, 1993), p. 96.
13 Ibid., p. 97.

This is why photographic practice, a ritual of solemnization and consecration of the group and the world, perfectly fulfils the deeper intentions of the "popular aesthetic," the festive aesthetic, that is, the aesthetic of communication with others and communion with the world.[14]

The *sensus communis* still constitutes a valid principle of criticism if its communicability is extended to the common consciousness and is understood as an imperative articulation of sustained difference and "direct communication." In addition, particularly in light of issues of multiculturism that abound in the critical discourse today, Kant's *sensus communis* articulates the difference of ethnicity, race, and (implied) gender in the notion of an "aesthetic normal idea" *(Normalidee):*

A negro must necessarily . . . have a different normal idea of the beauty of forms from what a white man has, and the Chinaman one different from the European.[15]

While focusing on the exclusion of racial or ethnic differences, multiculturalism does not, in general, address the exclusion of the common aesthetic consciousness. The recourse to the imperative of a *sensus communis* within critical discourse would enable a redefinition of criticism that can regain validity for the common consciousness in the face of the deprivation of traditional authorities of cultural legitimacy.

14 Bourdieu, *Photography*, p. 94.
15 Kant, *The Critique of Judgement*, par. 17.

LEON GOLUB

A tragedy, then, is the imitation of an action that is serious, complete in itself, and has a certain magnitude. It arouses pity and fear wherewith to accomplish a catharsis of such emotions.
— Aristotle

The demonic is anxiety about the good. In innocence, freedom was not posited as freedom: its possibility was anxiety in the individual. In the demonic, the relation is reversed. Freedom is posited as unfreedom, because freedom is lost. Here again freedom's possibility is anxiety. The difference is absolute, because freedom's possibility appears here in relation to unfreedom, which is the very opposite of innocence, which is a qualification disposed toward freedom.
— Søren Kierkegaard, 1844

Leon Golub could be described as the painter of the *inhuman* condition. His work deals with what Karl Jaspers has called "anonymous powers." These anonymous powers are the ancient demons of our religiously deprived modern world — the demons of nothingness. In Golub's paintings, being and nothingness struggle with each other for existence.

Recently, as in *So Much the Worse*, Golub has added graffiti to his repertory of images. Rudely scratched statements and drawings are literally worked into the "skin" of the paintings like tattoos. Here again the letter becomes the calligraphy of the nonrepresentable, or, in existential terms, of *nothingness*.

Graffiti looks back to the origin of the nonrepresentable. The nonrepresentable had its beginnings in the cave, which

This essay originally appeared in *43rd Biennial Exhibition of Contemporary American Painting*, exhibition catalog (Washington, D.C.: The Corcoran Gallery of Art, 1993).

contained the secrets of birth and death. Secrets that only the *women* knew. For the men who were excluded from the events in the cave — childbearing, the spiral dance, the graffiti on its walls — the cave became the nonrepresentable, the *Other.*

It is the same cave that with Plato, in a process of inversion, became the birthplace of (male) philosophy — a philosophy whose only concern is the segregation from the nonrepresentable. Its truth had to originate therefore in the *light* (the "enlightenment") — as opposed to the darkness of the cave. The cave itself became the mysterious and terrifying *labyrinth.* The archaic gesture of graffiti, once itself the signified, became the signifier or the *letter.*

Golub's paintings attain an existentialist form of catharsis that replaces the Aristotelian fear with a Kierkegaardian anxiety — an anxiety that is begotten by nothingness. When it seems that the inhuman has gotten the better of us, his paintings accomplish this catharsis by taking all the terrors committed by the modern world upon themselves, and, in an act of momentary redemption, returning us to a state of innocence, giving pause to remember our humanity.

PREFACE TO *CONCRETE JUNGLE*

In her novel *The Children of Men*, set in the year 2021, P.D. James describes a world without a future for mankind. By 1995, all males worldwide has become infertile due to a mysterious disease. The human race is growing older with no hope of there ever being a new generation. The British monarchy has lost its meaning, and England, like much of the rest of the world, is ruled by a totalitarian regime. There is no need to care for the environment or political equality. All of previously protected nature is turned into amusement parks and golf courses. The nations of the world are preparing to store a record of their culture for some unknown aliens who may one day visit this planet, long after the last human has walked its ground, after all buildings have crumbled and all signs of the human race have disappeared from the earth while nature continues its evolution:

Of the four billion life forms which have existed on this planet, three billion nine hundred and six million are now extinct. We don't know why. Some by wanton extinction, some through natural catastrophe, some destroyed by meteorites and asteroids. In the light of these mass extinctions, it really does seem unreasonable to suppose that *Homo Sapiens* should be exempt.[1]

NATURE as an autonomous aesthetic principle is an invention of the nineteenth century. The modern notion of Nature implies an opposition of nature versus culture that goes back to the Sophists' distinction between that which

This essay originally appeared in *Concrete Jungle: Mark Dion, Alexis Rockman, Bob Braine*, exhibition catalog (Middletown, Conn.: Ezra and Cecile Zilkha Gallery, 1993).

1 P.D. James, *The Children of Men* (New York: Alfred A. Knopf, 1993), p. 12.

existed originally and that which is the result of human intervention.

Before the mid-nineteenth century, the representation of nature in art was always symbolic: in the Middle Ages, nature symbolized RELIGION; in the Renaissance, SCIENCE; in the Baroque, POLITICS, which began with the formal Baroque gardens, signifying the power of the monarchy, and ended with John Locke's natural law discourse ("Men are by nature free, equal, and independent") that found its implementation in the American and French revolutions.

The establishment of the first national park in 1872, Yellowstone National Park, under President Ulysses Grant, coincided with the appearance of nature as an autonomous subject in the paintings of van Gogh and Cézanne. While van Gogh became lost in the physical and emotional qualities of nature, which he rendered in expressive brush strokes and vibrant colors, Cézanne approached nature in a more scientific and theoretical manner: "Render nature with the cylinder, the sphere, and the cone."[2] His renderings of Mont St. Victoire became the first abstract paintings in the history of modern art. Both men were equally obsessed with the physical beauty of nature and stressed the artist's need to be physically present in it.

The second important change in the history of the representation of nature in art has its origin in the 1930s in Germany. For the National Socialist ideologues, the inseparability of politics and art, the aestheticization of politics, was crucial, as Goebbels stressed in his open letter to Wilhelm Furtwängler in 1933, in response to Furtwängler's protest of racial discrimination:

It is your right to feel as an artist and to look upon matters from the living artistic point of view. But this does not necessarily presuppose your assum-

2 In a letter to Emile Bernard, in *Conversations with Cézanne*, ed. Michael Doran (Berkeley, Calif.: University of California Press, 2001), p. 29.

ing a nonpolitical attitude toward the general development that has taken place in Germany. Politics, too, is perhaps an art, if not the highest and most all embracing there is.[3]

Art no longer symbolized politics, it had become politics.

After World War II, when the National Socialist language became unwanted, Heidegger turned his political discourse from 1933 into both a critique of technology and an influential theory of art. National Socialism had been supplanted by what Philippe Lacoue-Labarthe has described as a "national aestheticism."

After 1945, the two most influential artists in regard to the representation of nature were Joseph Beuys in Germany and Robert Smithson in the United States. With Beuys, who adopted Heidegger's national aestheticism, nature became POLITICS; with Smithson, who introduced the notion of time into art, NATURAL HISTORY.

Consequently, two distinct traditions of artists dealing with nature are apparent today; the first turns Beuys's "conservative" aestheticism into environmental ACTIVISM; the second, influenced by Smithson, places art within the geological and biological evolution of nature and creates NATURE FICTION (where science meets natural history).

In "Entropy and the New Monuments," Smithson writes about the minimal artists of his time, particularly Donald Judd and Dan Flavin, whom he opposed:

Instead of causing us to remember the past like the old monuments, the new monuments seem to cause us to forget the future . . . They are not built for the ages but rather against the ages . . . Both past and future are placed into an objective present. This kind of time has little or no space . . . Time as decay or biological evolution is eliminated by man of these artists.[4]

3 In Philippe Lacoue-Labarthe, *Heidegger, Art, and Politics*, trans. Chris Turner (Oxford: Blackwell, 1990), p. 55.
4 In *The Writings of Robert Smithson*, ed. Nancy Holt (New York: New York University Press, 1979), p. 10.

Instead, Smithson calls for an art where "remote futures meet remote pasts." Later he writes about his *Spiral Jetty:*

> Once, when I was flying over the lake, its surface seemed to hold all the properties of an unbroken field of raw meat with gristle (foam); no doubt it was due to some freak wind action . . . The dizzying spiral yearns for the assurance of geometry. One wants to retreat into the cool room of reason. But no, there was van Gogh with his easel on some sun-baked lagoon painting fern of the Carboniferous Period. Then the mirage faded into the burning atmosphere.[5]

Concrete Jungle is a collaborative project by artists Mark Dion, Alexis Rockman, and Bob Braine. It combines environmental ACTIVISM with NATURE FICTION in its concern for the ecological balance of our planet without yielding to a romantic vision of nature.

5 Ibid., p. 113.

EVGEN BAVČAR'S MNEMONIC IMAGES

Here I am in the presence of images . . . perceived when my senses are
opened to them, unperceived when they are closed.
— Henri Bergson, 1908

Photographers have long been captivated by blindness. Im-
ages of the blind have been abundant throughout the history
of photography (from the early photographs of Paul Strand
and Walker Evans to those of such contemporaries as Joel
Sternfeld, Sophie Calle, and Nicholas Nixon).

Perhaps the fascination with the absence of vision has its
source in the fact that photography has as much to do with
darkness as it does with light. Most of its mechanical and
chemical processes take place in the dark — from the expo-
sure of the film inside the camera to the development of the
film and the printing of the photographs in the darkroom.
Even the actual moment of picture-taking itself involves, in
most cameras, a "blind spot" as, at the precise moment of ex-
posure, the viewfinder turns dark while the mirror inside the
camera flips up to let the image be projected onto the film.
Despite this complicity, photographic depictions of blind
people are often unsettling, as they put the subjects at a disad-
vantage in relation to both the photographer and the viewer.

So much has been made of the "eye" of the photographer,
the "decisive moment," and the issues of composition and
exposure that the existence of a blind photographer arouses
both amazement and skepticism.

Evgen Bavčar is such a photographer. Born in Slovenia, the
northwestern region of former Yugoslavia, he grew up in the
small village of Lokavec. At the age of eleven he lost the sight

This essay originally appeared in *The Print Collector's Newsletter,* vol. 25,
no. 4 (September–October 1994).

in both his eyes in two consecutive accidents. While attending the Institute for the Young Blind in Ljubljana, he began to take photographs. He later studied philosophy of art and aesthetics in Paris, where he now lives and works. Also a prolific writer and filmmaker, he has exhibited his photographs widely throughout Europe. His photographs are without equivalent in the history of art and pose questions about the nature of photography, memory, and perception.

Bavčars singular universe is filled with images from his childhood in Slovenia before the accidents that caused his loss of vision. He describes becoming blind as a slow transition that occurred over the course of several months, as a "long good-bye to the light," giving him the chance to impress the images of his childhood on his memory forever: "Thus I had time to grasp the most precious objects, the images of books, colors, and the phenomena of the sky, and to take them with me on a trip without return."[1]

Most of Bavčar's photographs are taken at night, either in the studio or outdoors, with the subjects illuminated only by a *flambeau* or lighted torch. The light of the flame becomes a substitute for the photographer's missing sight and a literal reminder that the word photography means "to paint with light."

Bavčar's portraits and nude studies are subtly but distinctly different in comparison to those made by conventional photographers. The lack of visual confrontation with the photographer compels the subjects to look as much at the camera as at themselves. In the absence of the photographer's complicity with the narcissism of his subjects, these works appear to be less posed and more introspective.

Bavčar creates multiple images by holding his hands, cutout paper swallows, or photographs of himself as a young boy in front of his subjects during long exposures. One of the

1 Evgen Bavčar, *Le Voyeur absolu* (Paris: Seuil, 1992), p. 8 (my translation).

most compelling images features a photograph of the young Bavčar — most likely his last visual memory of himself — surrounded by a flight of white paper swallows.

These interventions of the hand and the light, caressing, exploring, and touching his subjects, while surrounding them with darkness, give Bavčar's photographs a unique tactile quality, not usually associated with the smooth, non-tactual surface of photographic prints, and create an eerie, almost ghostly aura.

In this way Bavčar establishes his presence in the photographs perhaps even more strongly than a "normal" photographer would by selecting and shooting what he sees.

Swallows are perhaps the strongest symbol of Bavčar's nostalgia for the lost visions of his childhood. Their freedom and unrestrained mobility is in stark contrast to the limited, "geometrical" space to which blindness has confined him.

Bavčar's mnemonic images bring to mind the studies of the great French philosopher of the beginning of the century, Henri Bergson, who in his important phenomenological study *Matter and Memory* questioned the dualism of external reality (matter) and internal reality (memory). According to Bergson, one is neither the cause nor the duplicate of the other. Matter is a composite of images that are neither representations nor things but halfway between both. Bergson argues that perception is temporal and perception is always a function of memory. Memories are not just weak revivals of a perception, not a regression from the present to the past, but rather a progression from the past to the present. Perception and memory are different in kind but not in degree.

Bavčar has stated that he considers himself not a photographer but an "iconographer." Like Ted Serios's mind photographs, his images raise the question whether photography is foremost a mental image of the world.

Bavčar's exclusion from an immediate, direct aesthetic experience of the visual arts has made the latter all the more alluring to him. He has developed an unusual intellectual

approach to perception and photography. Faced with the irreversibility of his loss of sight, he decided early on to make it his accomplice and has since successfully transcended the boundaries of the medium of photography.

Most of Bavčar's works are printed as collotypes, a vanishing technique related to lithography. Like photogravure, it is capable of reproducing the rich tonal range of the original negative since it requires no halftone screens. The prints are published by Patrice Forest, of item éditions in Paris, who is also Bavčar's collaborator. The nostalgic look and tactual feel of the collotype also contributes greatly to the singular character of these works.

PETER HOPKINS

The critical function of art, its contribution to the struggle for liberation, resides in the aesthetic form. A work of art is authentic or done not by virtue of its content (i.e. the "correct" representation of social conditions), nor by its "pure" form, but by the content become form.
— Herbert Marcuse, 1978

Peter Hopkins inserts the notion of the beautiful into the (post)modern condition as criticality — as a "critical" quality rather than an appeasing sentiment of taste. He abandons the "text" of the paintings for a deep and intense visual experience that disrupts the senses by emptying the visual field of his paintings of its history and "discourse."

Hopkins liberates himself from treating painting as *painting* by transferring Smithson's concept of the "marked site" onto painting. His practice of pouring bleach on canvas and his use of perfume and toxic fluids constitute acts that are both destructive and cleansing; each, in their calculated way, mark a social field and comment on the collapse of *painting as model.*

Relinquishing traditional paints for "social" fluids allows Hopkins to reinvestigate and recontextualize the formal issues of beauty. At the same time it engages in a political critique, which is contained in his material's reference to issues of the body, sexuality, and the environment.

Applying cosmetic and medical dyes to decorative fabrics and holographic foils, Hopkins creates the facade of a "critical sublime" that neither excludes the beautiful nor sets it-

This essay originally appeared in *44th Biennial Exhibition of Contemporary American Painting,* exhibition catalog (Washington, D.C.: The Corcoran Gallery of Art, 1995).

self apart from it. He pushes the sublime further, toward the fringes of social and emotional perception, toward aesthetic entropy.

Just as Smithson brought Cézanne out of the studio again and reclaimed the physicality of his painted terrains, Hopkins reintroduces content into empty formalism by literally pouring the *outside* of art over and into the fabric of his paintings.

Hopkins accomplishes a momentary conciliation of beauty and politics, a synthesis of the sublime and the beautiful that shifts the horror of the sublime for a fleeting instant to the cathartic power of the purely beautiful — just long enough not to fall into the trap of desire for the fascist terror of unsublimated beauty.

JAMES HYDE

Modern aesthetics is an aesthetics of the sublime, though a nostalgic one. It allows the unrepresentable to be put forward only as the missing contents; but the form ... continues to offer for the reader or viewer matter for solace and pleasure ... The postmodern would be that which ... denies itself the solace of good forms, the consensus of a taste which would make it possible to share collectively the nostalgia for the unattainable.
— Jean-François Lyotard, 1982

James Hyde introduces a subversive element of formal terrorism into the postmodern condition. In his works, the unrepresentable becomes *politicized*. Structuralism has made us see images as text. For Hyde, paintings are a body of knowledge; the way they revise history is their *politics* — a politics that is anchored in a "structuralist" formalism that attributes ideological meaning to form itself and treats form and content as equal elements.

Hyde's structuralist formalism relates to the European formalism of Riegl, Eisenstein, and Barthes rather than the American formalism of Greenberg, which recognizes form as ideology and does not avoid content. Consequently, Hyde is engaged in an intimate investigation into the materiality of his objects and its "functioning."

In a recent artist statement, Hyde refers to the act of painting as reversed hermeneutics: "A painting is made by covering a surface with paint. It is this covering which reveals the painting ... Covering to reveal, does that sound like the logic of lingerie?"

Hyde's politics of painting is rooted in the Baroque dialectics of the interior and the exterior. Like Baroque architecture,

This essay originally appeared in *44th Biennial Exhibition of Contemporary American Painting*, exhibition catalog (Washington, D.C.: The Corcoran Gallery of Art, 1995).

postmodern painting can be defined as the "severing of the facade from the inside, of the interior from the exterior and the autonomy of the interior from the independence of the exterior, but in such conditions that each of the two terms thrusts the other forward."

Hyde's abstract paintings on Styrofoam are a case in point. Executed in the traditional fresco technique by brushing pigments onto wet lime plaster, their historical references to the frescos of Giotto and Leonardo da Vinci summon the longing of the modern for the (absent) content while, at the same time, the Styrofoam boldly denies the solace derived from this nostalgia.

Hyde expands Lyotard's definition of the (post)modern by turning his audaciously physical abstractions into a reference to the Baroque notion of texture as a political force, boldly giving momentum to the *resistance* of matter.

DECEIVING APPEARANCES

Evidently a different nature opens itself to the camera than opens to the naked eye.
— Walter Benjamin, 1936

The philosophical discourse of the early Middle Ages revolved almost exclusively around the issue of universals — whether genus and species are subsistent extramental entities or whether they are merely conceptual constructions. The exposition on this question continued for three centuries and was based upon the writings of Boethius who had offered two ways in which ideas that do not have a real existence in nature may be conceived: *composition* and *abstraction*. He concluded that a mental image formed by composition, for instance a centaur (man and horse joined together), would be a "false" image, while the abstracted idea of a line would be a "true" image since lines do exist in nature. Therefore, composition produces false ideas, while abstraction produces true ideas. Other examples of true ideas would be plant or animal species.

In the seventeenth century, the French rationalist René Descartes condemned imagination forever to the side of nonreason:

Whether awake or asleep, we ought never to allow ourselves to be persuaded of the truth of anything unless on the evidence of our reason. And it must be noted that I say of our *reason,* and not of our imagination or of our senses: thus, for example . . . we may very distinctly imagine the head of a lion joined to the body of a goat, without being therefore shut up to the conclusion that a chimaera exists . . . And because our reasonings are never so clear or so complete during sleep as when we are awake . . .

This text originally appeared in *Joan Fontcuberta: Wundergarten der Natur,* exhibition catalog (Salzburg: Rupertinum, 1995).

reason further dictates that . . . those possessing truth must infallibly be found in the experience of our waking moments rather than in that of our dreams.[1]

Boethius's allocation of "composition" to fiction and "abstraction" to truth became for Descartes the foundation of idealist philosophy and aesthetics. (The word "abstract" is used here in the sense of the universal, archetypal, rather than in the modernist sense of nonrepresentation.)

There is a striking analogy in the relationship of the body to the mind in Cartesian philosophy to that of photography to painting in the early days of the medium. Just as Descartes regarded the body merely as a machine, an *automaton* constructed by God or nature to contain its own principal of motion separate from the mind, so the camera had been seen as a mechanistic device that produces "machine-made pictures"[2] without artistic value, a "handmaid to art,"[3] a tool for recording details for the use of artists and scientists alike.

The prejudice against photography as an autonomous art form even found its way into the writings of the early modernist critics and theoreticians of photography, particularly those coming from a leftist position. Both Walter Benjamin and Louis Aragon criticized the indifference of "creative" photography to social and political conditions. Benjamin directed his criticism in particular to the works of Albert Renger-Patzsch, who in 1928 published *The World Is Beautiful*, a book of photographs that focus on the objective beauty of plants, machines, and buildings, devoid of external references.

1 René Descartes, *A Discourse On Method*, trans. John Veitch (London: J. M. Dent & Sons, 1937), p. 32.

2 Joseph Pennell, "Is Photography Among the Fine Arts?," in *Photography in Print*, ed. Vicky Goldberg (New York: Simon and Schuster, 1981), p. 212.

3 Oscar C. Rejlander, "An Apology for Art Photography," in ibid., p. 144.

Benjamin saw this type of photography as a capitulation to fashion. In his "Short History of Photography," he remarks,

When photography has extracted itself from the connections that a Sander, a Germaine Krull, a Blossfeldt gave it, when it has emancipated itself from physiognomic, political, scientific interests, that is when it becomes "creative" . . . The "creative" principle in photography is its surrender to fashion.[4]

Likewise, Aragon dismissed Man Ray's experimental photography as "studio art"[5] that is sterile, self-referential, and detached from everyday life. He favored the photomontages of John Heartfield, which combine collaged images with antifascist messages.

Photography fit the surrealist ruse perfectly because of photography's inherent antinomy of possessing an unmatched aura of truth while, at the same time, being a supreme manipulator of that truth. Photography is associated with truth more than any other medium because it so easily sets up a state of parareality that induces in the viewer a desire to believe what he sees. Surrealism, with its strong ties to automatism, psychoanalysis, and dreams, has a congenital affinity for the "false" ideas abandoned by rationalism.

The suggestive powers of photography are perhaps most strikingly evident in its relationship with parapsychology. From the spirit photographs of William H. Mummler in 1860 and the famous photographs of the Cottingley Fairies, taken in the summer of 1917 by two young girls, Elsie Wright and Frances Griffiths,[6] to those of the monster of Loch Ness,

4 Walter Benjamin, "Short History of Photography," trans. Phil Patton, *Artforum* (February 1977): 50.
5 Christopher Phillips, ed., *Photography in the Modern Era: European Documents and Critical Writings, 1913–1940* (New York: The Metropolitan Museum of Art/Aperture, 1989), p. 72.
6 Widely publicized and celebrated by Arthur Conan Doyle, they remained, despite much speculation, "true" until 1981, when one of the "photographers" finally admitted to having faked them.

photography has been used to prove the existence of the imaginary, legendary, and paranormal.[7]

Surrealism naturally co-opted what Roland Barthes has called the "fatality of photography," the fact that a photograph can never be distinguished from what it represents:

By nature, the Photograph . . . has something tautological about it: a pipe, here, is always and intractably a pipe . . . It is as if the Photograph always carries its referent with itself . . . like those pairs of fish . . . which navigate in convoy, as though united by an external coitus.[8]

In the essay that lends its title to this text, Man Ray writes,

Photography is not limited to the role of copyist. It is a marvelous explorer of those aspects that our retina never records and that, every day, inflict such cruel contradictions on the adorers of familiar visions.[9]

In the very broadest sense, Modernist (and for that matter, contemporary) photography can be seen as falling loosely within the terms of "abstraction" and "composition" (in the previously defined sense), with the former including the onto-typological photography of the Neue Sachlichkeit — August Sander, Karl Blossfeldt, and such contemporary artists as Hilla and Bernd Becher and their disciples Thomas Struth and Thomas Ruff; and the latter including the experimental photography of both the Bauhaus and surrealism — Moholy-Nagy and Man Ray — as well as their "postmodern" counterparts, notably, the German photographer Astrid Klein and the Catalan photographer Joan Fontcuberta.

7 On photography and paranormal phenomena see Rolf H. Kraus, *Jenseits von Licht und Schatten* (Marburg: Jonas Verlag, 1992).

8 Roland Barthes, 1980, *Camera Lucida*, trans. Richard Howard (New York: Hill and Wang, 1990), p. 5.

9 Man Ray, "Deceiving Appearances," in *Photography in the Modern Era*, p. 12.

The most transitory of things, a shadow, the proverbial emblem of all that is fleeting and momentary, may be fettered by the spells of our "natural magic," and, may be fixed forever in the position which it seemed only destined for a single instant to occupy.
— William Henry Fox Talbot, 1839

The marriage of surrealism and photography is renewed in Fontcuberta's works, which combine a surrealist heritage with information-theory and semiotics. Fontcuberta's training and background in communications and advertising rather than fine arts is at the heart of his ongoing exploration of multiple levels of reality through the medium of photography.

Surrealism is paired with postmodern irony in Fontcuberta's "Herbarium" series. The whimsical constructions that border on the grotesque, made by conjoining various plant parts and other suitable materials and photographed in black and white, parody Karl Blossfeldt's 1920s photographs of botanical specimen. They are also an homage to the surrealist *cadavre exquis*, the exquisite corpse, a game in which participants took turns drawing on a piece of paper that had been folded to hide the work of the previous artist. The resulting drawing is a composite with accidental connections.

Fontcuberta considers irony an important strategy in his work, "a gentle facade for a very deep criticism."[10] The mix of surrealism and irony is continued in the "Fauna" series, a multimedia Renaissance curiosity cabinet or *Wunderkammer* filled with notebooks, photographs, anatomical drawings, and taxidermied specimens of hybrid creatures, from the laboratory of a fictive German naturalist from the early 1920s, that seem to contradict Darwin's theory of evolution. A modern bestiary of imaginary animals presented in the guise of a natural history exhibit, it questions the faith and credibility

10 *Journal of Contemporary Art*, vol. 4, no. 1 (Spring/Summer 1991): 44.

invested in science and its institutions, whose truths often rely on photographic proof.

In his "Frottograms" Fontcuberta translates Max Ernst's technique of *frottage* (which involved placing paper on the surface of an object and rubbing over it with a lead pencil) into photography. Using Polaroid positive-negative film, Fontcuberta rubs the wet negatives onto the photographed objects — cacti, his bearded face, or the fur of an animal — before making the final print. The scratches, specks of dust, or the soft fuzziness caused by the animal hair bestow upon the prints the physicality and texture of the original object turning the photographs into tactual images. The technique eliminates the traditional distance and difference between the photographer and his subject and alludes to the nineteenth-century notion of nature depicting itself on the photographic paper, in particular to the photogenic prints of William Henry Fox Talbot.

References to Fox Talbot are prevalent in Fontcuberta's works, particularly in his "Paper Gardens" series, which had been tentatively titled "The Pencil of Nature?" after Fox Talbot's album of the same title. "Paper Gardens" forms, with "Shadowing Paintings," an ongoing series entitled "Palimpsests," the title referring to the multiple layering of real and simulated nature involved, and consisting of photograms made by placing matching fresh flowers, birds, or fish onto floral wallpaper, fabrics, or exhibition posters coated with photo-sensitive emulsion.

With the "Shadowing Paintings" Fontcuberta began a complex collaboration with painters from the period when photography tried to mirror the aesthetic rules and subject matter of painting. Reproductions of paintings by impressionists such as Monet and Cézanne, and also Picasso, were used as the basis for photograms made with real flowers, fruit, and human models to reflect or shadow the ones on the reproduced paintings. These works engage the viewer in the multiple relationships that exist among the various layers of represented

reality: the original subject of the painting, its painted copy, the printed reproduction of the painting, the actual objects Fontcuberta places on top of the painted ones, and their shadows fixed onto the reproductions by the photo-gram, thereby bringing the original subject of the painting back into the reproduction.

With the "Light Calligrams" the theme of the earlier "Herbarium" series is picked up again, but in a radically different manner. Leaves, roots, and flowers are soaked in developer and placed on photographic paper previously exposed to the sun. The "abstract" imprints of the real specimens of the "Light Calligrams" are in seeming contrast to the "realistic" photographs of the fake specimens in the "Herbarium" series, reversing the rationalist distinction between real and false images, between "abstraction" and "composition."

Fontcuberta's natural history of photography seduces, intrigues, and causes the "exquisite joy" that Jean Cocteau once described in a letter to Man Ray, as "[reaching] a previously unknown limit."[11]

11 *Photography in the Modern Era*, p. 1.

MARK MORRISROE AND HIS WORKS

This is "photographic ecstasy": certain photographs can take you outside
of yourself, when they are associated with a loss, an emptiness.
— Roland Barthes, 1980

Writing on Aubrey Beardsley, the art historian Julius Meier-
Graefe once remarked, "Of a hundred important artists born
within so many years, a certain number are indispensable . . .
because they affect their age and because they are symbolical
of ourselves. To have seen every one of [Beardsley's] fragments
is a more urgent necessity than to know a single picture by
Burne Jones or Watts."[1]

It is tempting to compare Mark Morrisroe with Beardsley.
Both had extraordinary but brief lives and careers (Beardsley
was 25 when he died from tuberculosis in 1898; Morrisroe
died at the age of 30 from AIDS-related complications almost
a century later, in 1989). Both were physically frail (a bullet
lodged in Morrisroe's chest from a shooting at the age of 16
caused him to limp).

They shared an erotically charged aestheticism and a self-
conscious, deliberate decadence. Yet unlike the essentially
asexual Beardsley, whose reveries, whatever their sexual ori-
entation, were confined to his art and his infamous collec-
tion of erotica, Morrisroe's life and work were inseparable,
defined by his early experiences with male prostitution and
dominated by a libidinous narcissism evident not only in

This essay originally appeared in *Mark Morrisroe* (Santa Fe: Twin Palms,
1999).
1 Stephen Calloway, *Aubrey Beardsley* (New York: Harry N. Abrams, 1998),
p. 11.

his self-portraits but extending into almost every one of his photographs. More than merely autoerotic and exhibitionist, Morrisroe's self-portrayals, as well as the portraits of his friends and lovers, seem to offer their subjects sexually to the viewer.

But most of all, like Beardsley, Morrisroe is an "indispensable artist." Like others who broke through the conventionality of their time, Morrisroe died too young to effect the revolution of which his genius was capable. Since his death, Morrisroe's aura has been a continuous presence and an inspiration for artists and photographers alike. It was left for other, younger photographers such as Doug and Mike Starn (whose grainy, scratched, torn, and scotch-taped photographs clearly echo Morrisroe's works) to carry on and complete his achievements. The object of this essay is not so much to provide a full account of Morrisroe's career but to give some idea of the position his photographs hold with respect to the art of other periods and the photography of the present day.

Until recently, his greatness, while denied by most, was perceived predominantly by fellow artists. His works are discussed primarily in the context of a group of photographers who met at the School of the Museum of Fine Arts in Boston and the Massachusetts College of Art during the 1970s and shared a highly personal documentary style of photography. Generally labeled the Boston School, the group includes, among others, Nan Goldin, Jack Pierson, Philip-Lorca DiCorcia, and David Armstrong.

Morrisroe's accomplishments as a photographer and the range of his stylistic innovations are most evident in his Polaroids, the most personal and intimate of his works. From 1979 to 1989 Morrisroe made more than two thousand portraits on Polaroid film, mostly shot with a 195 Polaroid Land camera

given to him by Elco Wolf, then director of marketing and communications at the Polaroid Corporation. Wolf also supplied him with an almost unlimited amount of film.

Since its introduction in 1947 by Edwin H. Land, the instant camera has been used by innumerable artists and photographers, functioning both as the photographic equivalent of the artist's sketchbook and an ideal medium for creative experimentation. During development of the Polaroid print, which takes place within seconds after exposure, the emerging image is highly sensitive to temperature, applied pressure, and the amount of time before the negative and positive layers are separated. The ability to instantly manipulate and view images made Polaroid film ideal for an imaginative artist like Morrisroe who wished to challenge formal traditions and transcend methods and mediums.

Delacroix once wrote that "mediocre painters never have sufficient daring; they never get beyond themselves. Method cannot supply a rule for everything, it can only lead everyone to a certain point."[2] Morrisroe was never a mediocre artist, and he had no tolerance for lack of imagination and experimentation in his own works or those of others. In a review of a fellow student at the Museum School, he wrote: "[Her] work, to me, shows amazing talent in the craft but is completely void of anything personal and/or individual. It is pure technical copy. She lacks imagination and is horrified by the idea of experimentation . . . I wish to have nothing more to do with [her] and other people of her mindset."

It could be argued that the Polaroid is to traditionally processed photography what the plein-air oil sketch was to landscape painting at the beginning of the nineteenth century:

The sketch was . . . a loophole in the traditional definition of artistic practice, which allowed a generally unacknowledged but formidable shift in

2 *The Journal of Eugène Delacroix*, trans. Lucy Norton (London: Phaidon Press, 2004), p. 145.

artistic values to develop. Thus, although lacking the status of high art and rarely receiving full artistic attention, the landscape sketch — particularly the landscape sketch in oil — became around 1800 the primary vehicle of a tentative but profoundly original sense of pictorial order.[3]

Looking at Morrisroe's Polaroids, one notices a certain resemblance to various types of oil sketches. Some are composed and shot almost carelessly, looking unfinished, under- or overexposed, with various manipulations and thus reminiscent of the preliminary oil sketch, the *esquisse*, literally an unfinished drawing without shading. Others are elegantly composed and shot in a straightforward, controlled manner, without any visible subsequent intervention by the artist, relating more to the *étude*, the detailed study of a single motif, made independently of any finished painting, or even the *modele*, a highly finished sketch, executed prior to undertaking the final, full-scale version. (Morrisroe shot many of his Polaroids on positive-negative film, which in addition to the black-and-white positive image also produces a usable negative. He used a number of these negatives to print larger versions of the same image.) Like the plein-air oil sketches of Constable and Corot, the Polaroid, in the hands of Morrisroe and other contemporary photographers, including Lucas Samaras, Fazal Sheik, and Dawoud Bey, is a profoundly original vehicle for experimentation in realism. Deeply personal, informal, and immediate, their works indulge in a humanist attitude toward the photographic portrait that is intensified by explorations of the formal properties latent in the material.

It should also be kept in mind that, like Corot's sketches (which were never intended to be exhibited but lent freely to his friends and, as a result, frequently copied), Morrisroe's Polaroids were not exhibited during his lifetime and were given mostly to friends and lovers. (One of his self-portraits

3 Peter Galassi, *Before Photography: Painting and the Invention of Photography* (New York: The Museum of Modern Art, 1981), p. 21.

from 1986, which depicts Morrisroe holding up a letter, carries the following inscription on the back: "Here's me writing your letter. You can buy a polaroid selfportrait similar to this at Pats for $300 so save this! XX love Mark.")

In Morrisroe's signature color photographs (some of which are stills from his Super 8 films, carrying titles and comments he scrawled onto the margins of the prints), he mixed a raw and unrelenting diaristic style with a mannerist pictorialism, manipulating the images through painting, retouching, toning, blurring, or "sandwiching" (by using two negatives, one color and one Polaroid black-and-white, to print a single image). They reveal the same desire to retain the immediacy of the sketch that gave the oil paintings of Delacroix what Baudelaire called their "magical atmosphere."

If Nan Goldin's images are somewhat reminiscent of Brassai's photographs of the vagrants, streetwalkers, and bohemians living on the fringes of Paris society in the 1930s, Morrisroe's self-portraits have more formal affinities to Walker Evans's snapshots from the 1920s and his early self-depictions from the 1930s, often made with a small handheld camera in collaboration with his friend, fellow photographer Paul Grotz. (There is also a striking resemblance to Evans's 1970s experiments with SX-70 Polaroid film.) Morrisroe's images lack the sentimental pose that sweeps through most of Goldin's work, which despite its realism lends her photographs a nostalgic emotionality. In comparison, Morrisroe's photographs possess an in-your-face brashness, an unedited, unprotected, and uncompromising intimacy that never appeases the viewer. Morrisroe's Polaroids, color prints, and Super 8 films embrace the "trash" aesthetic celebrated in films by Andy Warhol, Jack Smith, and John Waters, and ubiquitous in Goldin's early pictures and her slide show *The Ballad of Sexual Dependency* (which itself was highly influenced by Jack Smith's hours-

long slide shows). Morrisroe would routinely ask people who were introduced to him to pose nude for his camera. According to Megan Smith, a friend and fellow photographer during Morrisroe's days at the Museum School in Boston, this was his way of testing their seriousness.

As unconventional and crude as Morrisroe succeeded in being, he was also capable of many unabashedly beautiful and lyrical photographs, such as *Fascination* (1983), Morrisroe's tender portrait of his lover Jack (Jonathan) Pierson lying on an unmade bed with his arm stretched upward, a parakeet perched on his hand. Visible in the foreground of the picture is the dark silhouette of a black cat staring at the bird while a second cat lingers behind the bed. Jonathan's eyes wander obliviously into space, seemingly unaware of both the camera and the cats. The photograph captures a moment of dreamy timelessness, immersed in a soft, yellow glow, but it is also a portent of imminent danger, a premonition of less complacent times to come. Morrisroe's most remarkable photograph, it is arguably one of the greatest images in the history of photography.

At first glance, what sets Morrisroe's work apart from that of his peers and other contemporary photographers is his concentration on self-portraiture. Although almost every known photographer has taken self-portraits, few have devoted as substantial a part of their oeuvre to the genre as has Morrisroe. The photographic self-portrait is by definition a representation of the self, a moment of truth that removes the distance between the photographer and his subject. As the direct descendant of the sixteenth-century mannerist convex mirror (Parmigianino's *Self-portrait from a Convex Mirror* of 1524 marks the beginning of late-Renaissance mannerism), photography is the mannerist art form par excellence. In the photographic self-portrait the camera lens replaces the mirror. Like Parmigianino's self-portrait, the photograph replaces the reflection of the self with the experience of the other.

It was not until the beginning of the twentieth century that the body of the artist became a medium of art, beginning with works such as *Tonsure*, Man Ray's 1919 photograph of Duchamp's shaved head. In the 1960s and 1970s the emergence of happenings, performances, and body art, and its photographic documentation by artists such as Vito Acconci, Bruce Nauman, Gina Pane, and Chris Burden, led to the autoerotic and transsexual photographs by Jürgen Klauke, Luciano Castelli, Lucas Samaras, and ultimately to the self-representations of Cindy Sherman, Yasumasa Morimura, and Mariko Mori. According to Merleau-Ponty, every technique is a technique of the body. In *Eye and Mind*, he writes, "'The painter takes his body with him,' says Valèry. Indeed we cannot imagine how a *mind* could paint. It is by lending his body to the world that the artist changes the world into paintings"[4]

In taking pictures, Mark Morrisroe lent his body to the world. He resolved the problem of authenticity in his art by imposing his self upon the world. His mannerism, despite its occasional stylized banalities, was heavily invested in humanism. What we discover in Morrisroe's photographed body is ultimately our own. In his constant self-inventions, his cross-dressing, and performances on film, we find the possibility for the reinvention of ourselves. In the blindness of the photographic mirror, our own humanism is called upon. His portraits become, through their unabashed narcissism, an ethical summons for the beholder. They are expressions of Morrisroe's humanism and contribute to an aesthetic education of the self. Instead of simply recording himself and others, Morrisroe renders himself as other and the other, as himself.

4 In *The Merleau-Ponty Aesthetics Reader: Philosophy and Painting*, ed. Galen A. Johnson (Evanston, Ill.: Northwestern University Press, 1993), p. 123.

A handwritten list of Morrisroe's life events, titled "My Life," which he wrote in his diary in 1988, one year before his death, begins with the notations "Childhood + Judy Garland," "Prostitution + Celebrity," "Love," and moves on inevitably to "Depression" and "AIDS"; yet it ends with the rhetorical question, "Mind if I cross-dress?"

THE WORLD AS PICTURE:
IMAGE PRODUCTION AT THE END OF
THE TWENTIETH CENTURY

What is a world picture? Obviously a picture of the world. But what does "world" mean here? What does "picture" mean? World serves here as a name for what it is in its entirety. The name is not limited to the cosmos, to nature. History also belongs to the world . . . World picture, when understood essentially, does not mean a picture of the world but the world conceived and grasped as picture. What is, in its entirety, is now taken in such as way that it first is in being and only in being to the extent that it is set up by man.
— Martin Heidegger, 1938

We see, then, why we must speak of a structuralist *activity:* creation or reflection are not, here, an original "impression" of the world, but a veritable fabrication of a world which resembles the first one, not in order to copy it but to render it intelligible.
— Roland Barthes, 1963

Heidegger saw the emergence of the "world picture" as the fundamental event of the modern age. In the modern age, which begins for Heidegger with Descartes, man has become "subject." No longer is the world conceived as *ens creatum*, observed from the outside by God, as with the Creator-God looking down at the world hovering inside a crystalline globe on the third day of creation on the outer panels of Hieronymus Bosch's *Garden of Earthly Delights*. Rather, in the modern age, the world is presented from within by the human self-consciousness. Modern science is for Heidegger the foremost manifestation of man's being as subject.

This essay originally appeared in *Poiesis: A Journal of the Arts and Communication* I (1999).

Quantum theory and structuralism have arguably become the defining powers for representing the world in the twentieth century, and will continue to mark every aspect of life at least during the next quarter century (until the so-called unified theory, which has eluded theoretical physicists for more than sixty years, combines general relativity with quantum theory). And if it is ever successful, it would undoubtedly bring about a new era of science and art, just as the discovery of general relativity and quantum mechanics did in the opening years of this closing century.

Quantum theory brought the observer (and therewith the "world picture") inside physics. Its radical departure from the idea of an outside observer, and the knowledge that there could never be a complete picture of the world, fundamentally and irreversibly changed our perception, bringing about the revolutionary pictorial inventions that, presaged by Cézanne, began with Picasso and Cubism and ended with Pollock and Abstract Expressionism.

Both quantum theory and structuralism emerged during the first twenty-six years of this century. Ferdinand de Saussure's *Course of General Linguistics* (1916) was published the same year that Einstein's theory of general relativity was finalized. Both quantum theory and structuralism focus on *activity*, on what we *do* rather than on what *is*. Just as quantum theory is more concerned with the experiment than with its outcome, structuralism is concerned with the *fabrication* of meaning rather than meaning itself. Both insist on an immanent analysis, which is located within a system — the universe or a work of art or literature, respectively.

In the subsequent paragraphs, I am loosely following Roland Barthes's 1963 introduction to structuralism, "The Structuralist Activity,"[1] as well as certain ideas introduced

1 In *The Structuralists: From Marx to Lévi-Strauss*, eds. Richard T. and Fernande M. De George, trans. Richard Howard (Garden City, N.Y.: Doubleday, 1972), pp. 148–54.

in a recent book by the theoretical physicist Lee Smolin.[2] Barthes cites two principle operations that define structuralism, which also seem applicable to quantum theory: "dissection" and "articulation." Dissection involves identifying elementary units of a system that, though not actually bearing meaning themselves, are involved in the attribution of meaning, such as letters in a word or particles in quantum physics. Articulation involves the recomposing of these elementary units into what Barthes calls a "simulacrum" of the system (a world picture) in order to reveal the rules of their functioning. Quantum physicists would call this simulacrum the "quantum state" of a system. The quantum state is a construction into which the information we observe about the world is coded.

As Heisenberg's uncertainty principle states, it is intrinsically impossible for one observer located within a system to give a complete description of that system. A single observer can never view or learn more than fifty percent of the world to which he or she belongs. Thus quantum physicists have suggested a community of observers who would be able to collect a participatory world picture, comprised of a multiplicity of world views.

The impossibility of a complete description of the world ever being attained by a single human or super-human intelligence is at the root of the modern "world picture" and the complete break with the idea that art is "representational" that occurred in the 1950s. One might say, in fact, that the modern crisis of representation is the essence of the world picture. Ironically, *the possibility of a "world picture" brings with it the impossibility of representing the world as picture.*

It seems fitting to revisit Heidegger's notion of the world picture in regard to the predominant forms of image production (art, painting, photography, installations, video, and

2 Lee Smolin, *The Life of the Cosmos* (New York and Oxford: Oxford University Press, 1997).

film) as the twentieth century approaches its close. As the new millennium advances, no new revolutionary pictorial inventions are likely to emerge. Rather, like quantum physics, much of recent art is again engaged in a structuralist analysis of our world and a new participatory humanism — or as Heidegger would say, in a renewed involvement in the question of Being.

What appears is a series of disjointed world pictures explored in a variety of mediums. I am thinking foremost of Lucian Freud's paintings of his studio and the naked flesh and emotions of those who inhabit his world; Marlene Dumas's sexually and morally ambiguous depictions of physically and emotionally wounded and disfigured women and children; the photographs of urban pedestrians by Beat Streuli, which are not taken close-up, in the tradition of street photographers such as Gary Winogrand and William Klein, but from a respectful distance and, in spite of the anonymity of its subjects, command a profound human presence through their life-size scale; Sharon Lockhart's film stills of children and adults reenacting scenes of kindness and affection from films by John Cassavetes or François Truffaut; Chantal Akerman's work, such as her recent installation based on her quasi-documentary film *D'Est*, which patiently yet curiously records the personal and political topography of Eastern Europe during her journey through Germany, Poland, and Russia and is presented on twenty-eight video monitors, simultaneously showing fixed-frame or moving scenes from the film; the monumental photographic fictions of Jeff Wall, who shares with Akerman a quasi-documentary approach but accomplishes his reconstruction of our social realities through recourse to allegory and storytelling executed within the monumental scale of history painting; Rirkrit Tiravanija's installations that isolate specific human social

activities such as cooking and sharing food and transposes them into a deeper comprehension of Being; and finally Gerhard Richter's ongoing diaristic and encyclopedic project *Atlas*, which allows the public access to Richter's private universe and his process of painting.

These artists, and others not mentioned here, seem to participate in the "unfolding" of a collective world picture, which Heidegger describes as

the structured image that is the creature of man's producing which represents and sets forth . . . Because this position secures, organizes, and articulates itself as a world view, the modern relationship to that which is, is one that becomes, in its decisive unfolding, a confrontation of world views.[3]

3 Martin Heidegger, "The Age of the World Picture," in *The Question Concerning Technology and Other Essays*, trans. William Lovitt (New York: Harper & Row, 1977), p. 134.

I AM:
A NEW HUMANISM IN AMERICAN ART AND DESIGN

As the twentieth century approaches its close and the new millennium advances, no new revolutionary pictorial inventions are likely to appear. What is emerging from within the predominant forms of image production in American art — painting, sculpture, photography, and video/film — is a new participatory humanism and a synergism of art and design that is inspired by leisure, play, and sports.

Examples of this new trend in design are the new Pop-inspired industrial products made by Volkswagen (the new Beetle, which was specifically designed for the American market) and Apple (the translucent, multicolored iMac); and a fashion trend that is derived from leisure suits and sporting clothes using hybrid techno textiles with silicone coatings or holographic laminates that revolutionize color and form, as adopted by Issey Miyake, Helmut Lang, and Rei Kawakubo (for Comme des Garçons whose newest store, in the heart of New York's Chelsea gallery district, featuring a spaceship-like aluminum entrance tunnel and slanting glossy-white walls that seem inspired by Richard Serra's sculptures).

In the visual arts, Fabian Marcaccio alters the color and texture of painting by dissecting the brush stroke into separate components, allowing each to act independently and making painting transparent, revealing its wooden substructures or using clear silicone in place of paint. Andrea Zittel's customizable "E-Z Escape Vehicles" are inspired by mobile homes and vacation vehicles and, like her earlier "Living Units," combine comfort with functionality while engaging both artist and user in a structuralist analysis of privacy. The playful, amorphously shaped sound objects made from rubber

4 This essay originally appeared in *Domus* 816 (June 1999).

and modeling clay by Charles Long, in collaboration with Stereolab, invite the viewer's participation, to play, touch, or listen. Elizabeth Peyton's portraits focus on celebrity, fame, youth, and sexual ambivalence. Sharon Lockhart's collaborative films and film stills of children and adults reenact scenes of kindness and affection from films by John Cassavetes and François Truffaut.

Korean artist Nikki S. Lee's continuous construction of her own persona show a renewed involvement in the question of being. Joining different social groups in New York and adapting her appearance and behavior to become the Other — lesbian, punk, Hispanic, or yuppie, the I of the artist and the I of the Other become one within the construct of the color snapshot. Lee continues the tradition of the body as a medium of art, which began with such works as Man Ray's 1919 photograph of Duchamp's shaved head, *Tonsure*. In the 1960s and 1970s, happenings, performances, and body art ultimately led to the self-representations of Mark Morrisroe, Cindy Sherman, Yasumasa Morimura, and Mariko Mori. Lee's photographs are included in the multidisciplinary exhibition *Generation Z*, currently on view at P.S.1 Contemporary Art Center in Long Island City. The exhibition seeks out new artists, architects, and filmmakers using media to address subjective issues.

This emergence of the self as a collaborative persona corresponds in the corporate world to the new trend of "affirmation advertising" exemplified in the "I AM" campaign by Lotus Development for its new R5 information sharing software ("I AM a team . . . I AM a force . . . I AM everywhere . . . I AM connected"), and has been imitated by Mattell for its Barbie clothing line, realtor Coldwell Banker, and Esprit fashion. American art and design is informed by an affirmative attitude of personal and group empowerment, a futuristic comfort with technology, and a new sensual aesthetic. Colorful, translucent plastics and textiles expose the technology underneath in a happy marriage of techno and Pop, Bill Gates and Austin Powers.

SPIRITUAL MATERIALITY:
CONTEMPORARY SCULPTURE AND
THE RESPONSIBILITY OF FORMS

There is a history of forms, structures, writings, which has its own particu-
lar time — or rather, *times*: it's precisely this plurality which seems threat-
ening to some people.
— Roland Barthes, 1967

With the introduction of the notion of artistic will or urge, the
Kunstwollen, which the nineteenth-century Austrian art his-
torian Alois Riegl believed to be an expression of the spiritual
conditions of the time, he opened the prevailing mechanical-
materialistic formalism, the *Kunstmaterialismus* of Gottfried
Semper and his followers, to concept and ideology.

The American critic Clement Greenberg, whose essay
"Avant-Garde and Kitsch" has dominated American formal-
ism since its publication in 1939, can be considered a modern
descendant of Semper's materialism. Just as Semper defined
art exclusively by the parameters of material and technique,
so Greenberg speaks of the "pure preoccupation" of the mod-
ern avant-garde "with the invention and arrangement of spac-
es, surfaces, shapes, colors, etc., to the exclusion of whatever
is not necessarily implicated in those factors."[1]

While Greenberg's formalism denies form meaning, a Euro-
pean version, independently proposed by Sergei Eisenstein and
Roland Barthes and following Riegl's model, recognizes form as
ideology and is engaged in an intimate investigation into the
materiality of an object and its "functioning."

In a conversation with Guy Scarpetta, Barthes hinted at a
possible alternative to Greenberg's formalism:

This essay originally appeared in *Sculpture* (April 2002).

1 Clement Greenberg, "Avant-Garde and Kitsch," in *Art and Culture*
(Boston: Beacon Press, 1961), pp. 3–21.

We should not be too quick to jettison the word "formalism" . . . attacks against formalism are always made in the name of content . . . The formalism I have in mind does not consist in "forgetting," "neglecting," "reducing" content . . . content is precisely what interests formalism, because its endless task is each time to push content back . . . It is not matter that is materialistic but the refraction, the lifting of the safety catches; what is formalistic is not "form" but the relative, dilatory time of contents, the precariousness of references.[2]

Instead of a mechanical-materialistic formalism, Barthes suggests a scrupulous examination of an object's materiality as theoretical act. It is this "structuralist activity" that defines the object. Materiality becomes structure, an "*interested* simulacrum." It "makes something appear which remained invisible, or if one prefers, unintelligible, in the natural object."[3]

Much of contemporary sculpture has been newly engaged in a materialist formalism, one that is based in part on a structuralist analysis of the world that attributes ideological meaning to the materials themselves or inscribes linguistic codes onto them, and in part on a participatory humanism — a renewed involvement in the question of being, transcendence, and the social by way of its materiality — a new variant, which I have chosen to name "spiritual materiality."

This spiritual materialism ranges from art that either reconstructs or simulates, whether reflexive or poetic, "material" in such a way as to manifest thereby its rules or ideological structure, as do Roni Horn's sculptures and photographs; combines an expressed materialism with the goal of changing social praxis, as do the sculptures of Wolfgang Laib and the installations of Felix Gonzales-Torres; or pushes the existential questions of the Human Condition, embedded in

2 Roland Barthes, *The Grain of the Voice: Interviews 1962–1980*, trans. Linda Coverdale (New York: Hill and Wang, 1985), p. 115.
3 Roland Barthes, 1963,"The Structuralist Activity," in *The Structuralists: From Marx to Lévi-Strauss*, eds. Richard T. and Fernande M. De George, trans. Richard Howard (Garden City, N.Y.: Doubleday, 1972), p. 149.

the materiality, toward a new extreme subjectivity, as do the works of Marc Quinn and James Lee Byars.

According to French philosopher Emmanuel Levinas, who combined the ideas of the German phenomenologists Edmund Husserl and Martin Heidegger, transcendence is not a modality of essence — not a question of being or not-being — but rather an ethical imperative; it is not a "safe room" of solipsistic inwardness but a site of responsibility for others. We are ordered toward the responsibility for the other in the transcendental beyond. This responsibility, which Levinas calls the "otherwise than being,"[4] substitutes subjectivity (the self of the artist) for another: it becomes the other in the same. Inspired by the other, it exists through the other and for the other without losing its original identity.

One artist who has been creating works that are both highly materialist and intently transcendental is the German sculptor Wolfgang Laib, best known for slabs of white marble covered with milk and fields of yellow or orange pollen sifted onto floors. All of his works are, in one sense or another, aimed at suspending reality, through both his choice of materials (wax, milk, or pollen) and the shapes of his sculptures (houses, ships, pyramids, cones, and ziggurats), many of which imply transgression, going "Somewhere Else" (as the title of one of Laib's sculptures suggests).

Yet for Laib, art is not purely an act of transgression but also of participation — participating in nature and sharing that experience with others. Laib's works are not merely visual experiences but are ultimately meant to contribute to social and spiritual change. According to Laib, art has to be "world-shaking" (*weltbewegend*). The spiritual reality of the work is embedded in its materiality — the two cannot be separated.

4 Emmanuel Levinas, *Otherwise Than Being: Or Beyond Essence*, trans. Alphonso Lingis (Pittsburgh: Duquesne University Press, 1998).

The art historian Georges Didi-Hubermann describes how, as we come face to face with sculpture (which we unconsciously perceive as hollow, empty vessels), we experience a deep-seated fear of emptiness and death.[5] He cites two examples from art history that have dealt with this fear in opposite ways: Christian art takes comfort in faith by creating "myths" (such as depictions of the resurrection of Christ); and minimalist art stands on tautology by claiming that there is nothing beyond what is manifest.

Laib's sculptures (most of which are indeed vessels) suggest a combination of both approaches. While he acknowledges the emptiness of his sculptures by filling them with rice or milk, these life-sustaining substances remain hidden or, in the case of the milkstones, become almost imperceptible; thus his sculptures' "content" has to be taken on faith. The word "certitude," which appears in the titles of several of Laib's works, implies a leap of faith, a belief in something that needs no objective proof or cannot be subjected to it.

Felix Gonzales-Torres's "Placebo" series, consisting of fields of endlessly supplied, wrapped candies amassed on the floor, are reminiscent of minimal art, yet are endowed with an enormously complex matrix of human emotions, ranging from desire, joy, and hope to sadness, fear, and mourning. As with his paper stacks, the viewer is encouraged to take one piece off the pile and keep it; however, while the candy is given away freely, there is a price to be paid: the work not only invites participation but demands the viewer to share responsibility. It is precisely the "historical responsibility of forms," of which Roland Barthes speaks or the inspired substitution of the self for the other through responsibility that Levinas describes. We (the viewers) are summoned by the work to responsibility: by taking a piece of candy or a sheet of paper, we enter into an irrevocable contract with the artist; his mourning, his desire, his

5 Georges Didi-Hubermann, *Ce que nous voyons, ce qui nous regarde* (Paris: Les Editions de Minuit, 1992).

fear becomes ours by substitution: "Without the public these works are nothing. I need the public to complete the work. I ask the public to help me, to take responsibility, to become part of my work, to join in."[6] Gonzales-Torres reminds us that both giving and receiving are active forms of communication and that all matter is "interested"; even in abundance, it demands responsibility from those who offer it to others, whether as a commodity or a gift, and from those who accept it from others with or without an exchange of money.

Roni Horn, an artist working in a variety of idioms — sculpture, drawing, writing, photography — is always intent on maintaining the integrity of her chosen materials, be they solid glass, literature, or the volcanic topography of Iceland, where she has stayed frequently over the past twenty years. Her series of aluminum sculptures, which feature fragments from the writings of Franz Kafka or Emily Dickinson, such as *Kafka's Palindrome* (1991–94) and *Keys and Cues* (1994), are reminiscent of the minimalist sculptures of Donald Judd as well as Michael Fried's famous definition of minimal art as "literal art" (in the sense that it was a matter of words).[7] However, Horn's "literal" transfer of words onto matter changes the meaning of both the original words and the materials used: taken out of context, the meaning of the original words becomes amalgamated with the meaning embedded in the material. By adding literacy to matter, the sculpture becomes nonliteral but not devoid of content.

Like Gonzales-Torres and Laib, Horn firmly believes in the viewer's responsibility: "I try to reach the viewer by addressing the bodily and not just the mental/nonphysical being. The viewer must take responsibility for being there, other-

6 Quoted in Nancy Spector, *Felix Gonzalez-Torres* (New York: Guggenheim Museum, 1995).

7 Michael Fried, "Art and Objecthood," in *Minimal Art: A Critical Anthology*, ed. Gregory Battcock (New York: E. P. Dutton, 1968), pp. 116–47.

wise there is nothing there."[8] Like the structuralists, she is less interested in the meaning of the work (the "why" and "what") than in the interaction between action and being, "the How," and ultimately in creating art that unites both: "an object that never changes, where action and being, the 'how' and the 'what' emerge."[9]

Like Horn's photographs of the geological active landscape of Iceland, with its fields of hardened lava and pools of hot water that tell of a primordial, unstable earth in constant formation, Marc Quinn's sculptures of bodies are in a permanent state of metamorphosis, a transformation on an almost molecular level, like the shape-shifting android composed of liquid mercury in *Terminator 2*. His sculptures are comprised of matter onto which form has yet to be imposed upon, that is at once suspended in time and in constant search of form. Quinn's bodies thus lead our senses away from content and toward a deeper understanding of materiality and with it our own being.

From his early works made from bread dough and then cast in bronze or lead, to the haunting self-portraits consisting of his own frozen blood, to his more recent casts of silvered glass, Quinn has been obsessed with representations of the human body as *material*. His sculptures are engaged in a structuralist morphology of the human condition that, like its counter branch in biology, deals with the forming and structure of life, with spiritual needs suspended in materialized form — life as exigencies of form.

James Lee Byars is known for creating works extreme in their formal simplicity, yet exceedingly luxurious in the choice of materials: marble, gold, silk, and glass. Living in Japan during his early, formative years, Byars formed his highly unique style by adopting the highly sensual and symbolic practices of Japanese Noh theater and wedding them to Western conceptual and minimalist art and analytical philosophy.

8 *Journal of Contemporary Art*, http://www.jca-online.com/horn.html.
9 Ibid.

Byars's objects are a reflection of his lifelong pursuit of the transient nature of beauty and perfection, which operates on both a perceptual and conceptual level, providing the viewer with a very physical experience of a concept that is abstract in nature. His symbol system consisting of succinct shapes, materials, and colors presents the viewer with probing questions and abstract forms that encourage a contemplative/meditative response.

While his earlier, dominantly performative works, guided by the model of the Noh theater, sought to *dematerialize* his objects, then mostly made of silk or paper, through actions and performances, his later works *rematerialize* performance with the materials taking the role of actors who raise philosophical questions.

Throughout his life Byars was obsessed with finding ever more perfect materials. One of his last major works, *Concave Figure* (1994) consists of five concave columns of white marble from the Greek island of Thassos, praised throughout history for the purity of its marble. Standing still in tranquil solidity and solemn whiteness, and bowing gently in one direction, the five shapes emanate modesty and humility. Unlike the minimalist sculptures of Donald Judd and Tony Smith, they provide questions rather than answers; they are without pretense, far from knowing what they are. By forcing matter to question itself, Byars forces the viewers to question their own materiality.

In works by such artists as Wolfgang Laib, Roni Horn, James Lee Byars, Marc Quinn, and Felix Gonzales-Torres, the spiritual faith of "believing in what we cannot know" is allied with a certain tautological knowledge, the "what you see is what you see" of formalist minimalism. This tautological certitude is the promise of a spiritual materiality that substitutes minimalist literalism for the historical responsibility of forms.

CHRISTIAN MARCLAY'S *VIDEO QUARTET*

As the title suggests, Christian Marclay's 14-minute *Video Quartet* (2002) consists of four digitally-synchronized video channels projected simultaneously, sampling hundreds of found film and television footage featuring musical performances from a variety of genres, including animated films, classic Hollywood movies, and musicals, both color and black-and-white.

Commissioned jointly by the San Francisco Museum of Modern Art and the Musée d'Art Moderne Grand-Duc Jean in Luxembourg, *Video Quartet* premiered in San Francisco in the late spring of 2002. Until then, the 47-year-old sound and visual artist was known primarily for his Fluxus-and surrealism-inspired objects and installations that straddle the whimsical and the earnest.

Marclay was born in California and raised in Geneva, Switzerland. He came to music through performance art. Influenced by the punk and art bands of the late 1970s and early 1980s, Marclay started to perform in clubs in New York, playing his own record collages, which he had made by cutting up vinyl records and gluing them back together in different configurations. As they were played on turntables, they sampled various fragments of music.

Marclay is highly influenced by John Cage who in the late 1930s began to introduce sampling techniques into his *Imaginary Landscapes* by employing variable-speed phonographs and later live radio broadcasts. Marclay regards the makeshift art of Fluxus and Duchamp's concept of the ready-made conceptually married to improvisation in music.

This essay is previously unpublished.

For Marclay, "the turntable is a perfect *machine céliba-taire* in the Duchampian sense."[1] For him, making objects is about altering objects in order to extract new meaning, like his stitched-together record covers, or *Records without Cover* (1985), vinyl records without sleeves that accumulate dust and scratches. Similarly, *Footsteps* (1989) consists of hundreds of vinyl records, which cover the gallery floor and is meant to be walked upon.

His most widely-exhibited work until *Video Quartet* has been *Tape Fall* (1989), which features a ladder with a Revox tape player perched on top and single reels of recorded magnetic tape that falls continuously onto the floor beneath the ladder. When the reel is empty, it is simply replaced with a new one, creating an ever-growing mountain of loose and entangled audiotape.

Video Quartet is first and foremost a musical work, one in which unrelated performers play together but are separated by time and space. It is at once a continuation of and a departure from Marclay's previous works, which either are visual collages of audio material, such as his record covers and his surreal, nonfunctional musical instruments, or audio montages of visual material, such as *Up and Out* (1998), an earlier feature-length projection, which synchronizes the footage of Michelangelo Antonioni's 1966 film *Blowup* with the soundtrack of *Blow Out*, Brian De Palma's 1981 homage to Antonioni's classic.

Unlike *Up and Out*, *Video Quartet* makes a qualitative leap forward. Far from being simply an Academy Awards Show compilation of film clips that feature musical performances, it uniquely combines musical sampling techniques first pioneered by Cage with video sampling — a technique used primarily in commercial video, fashion, and advertisement. But *Video Quartet* is not simply a music video with sophisticated digital sampling; it elevates the medium of video art

1 *Journal of Contemporary Art*, vol. 5, no. 1 (Spring 1992): 73.

to a new level. His artistic process brings to mind an essay written in 1926 by the Hungarian-German film theorist Béla Balázs' on "the future of film." In it he writes that "film can become a work of art only when photography itself ceases to be mere *reproduction* and becomes the work itself."[2] Balázs sees a "hidden symbolic expressiveness" or "hidden figurative quality" at work in Eisenstein's films, "that has nothing to do with "decorativeness or beauty" and is created "exclusively by the methods and possibilities of photography."

"Like a hymn of ecstasy," Eisenstein's cinematography evokes a "collective display of enthusiasm." I can think of no better words to describe Marclay's achievement in *Video Quartet* than Eisenstein's own description of the montage as "the stage of the explosion of the movie frame."[3] Not only has Marclay shown that video, like Eisenstein's cinema, is first and foremost montage, but that montage can add a "third meaning," to use a term by Roland Barthes, which, simply put, proves that in auspicious instances the whole is indeed more than the sum of its parts.

2 Béla Balázs, "The Future of Film," in *The Film Factory: Russian and Soviet Cinema in Documents, 1896–1939*, ed. Richard Taylor (New York and London: Routledge, 1988), pp. 144–45.

3 Manfredo Tafuri, "The Dialectics of the Avant-Garde: Piranesi and Eisenstein," *Oppositions* 11 (Winter 1977): 75.

THE ART OF HAPPENSTANCE:
THE PERFORMATIVE SCULPTURES
OF JAMES LEE BYARS

Byars travels to Oxford University to discover which questions exist in the Faculty of Philosophy. He meets the expert on Wittgenstein, G.E.M. Anscombe at home with her children. He speaks to two doctoral candidates who are studying event identity and the difference between extraordinary event and miracle.[1]

In the romantic comedy *Le Battement D'Aile du Papillon*[2] by the French film director Laurent Firode, a group of strangers become connected during the course of a single day by random events (a thrown pebble, lettuce falling off a truck, grains of sand blowing out of an open window) that in the end fulfill the predestined fates of two of them, who happen to share the same birthday, as predicted by their horoscopes.

The French title refers to the so-called "Butterfly Effect," ascribed to the MIT meteorologist Ernst Lorenz, who first recognized the existence of "chaotic attractors." Attractors are geometric forms that result from the long-term behavior of a chaotic system, proving that even random systems can be "predictable." In a paper delivered in 1963 at the New York Academy of Sciences, Lorenz remarked that one flap of a seagull's wing could alter the course of weather. A decade later, the seagull had evolved into the more poetic butterfly in the title of a talk given in 1972: "Does the Flap of a Butterfly's Wings in Brazil Set Off a Tornado in Texas?"

Originally published in *Sculpture* (November 2002).

1 From "A Chronology of Almost Forgotten Circumstances in the Life of James Lee Byars" in *James Lee Byars: The Philosophical Palace* (Düsseldorf: Kunsthalle Düsseldorf, 1986), p. 106.

2 The film was released in the U.S. under the title *Happenstance*.

The American performance artist and sculptor James Lee Byars (1932–97) left his hometown, Detroit, in the late 1950s to live in Kyoto, Japan, for ten years, returning to the U.S. only for short visits. During these formative years, Byars adapted the highly sensual and symbolic practices of Japanese Noh theater and Shinto rituals to Western science, art, and philosophy.

He supported himself by teaching English, an activity that he occasionally turned into an art performance. The architect Robert Landsman, who met Byars in Kyoto during that time, recalls one particular lesson on a late spring evening. That day, Byars instructed his class not to speak and to follow him out of the school to his apartment, where he had laid a ten-by-ten-foot piece of white paper on the floor. He then asked his students to lie face down on the paper and form a circle with their heads meeting at its center, while in the backroom Landsman played the *shakuhachi*, a Japanese bamboo flute traditionally played by monks in Shinto ceremonies. Later, as Landsman joined the students on the floor, a large insect suddenly flew through the open window into the room and began to dance inside the circle on the paper, before dropping dead. Putting his finger on his lips, Byars then gestured his class to get up and leave. His "English" lesson had ended. Byars had already mastered the art of happenstance.

In Byar's works, as in Firode's story, nothing and everything happens by chance. What made Byars's work and life remarkable was the almost hypnotic effect he had on others. He was able to enact seemingly random events that almost needed to be explained by some form of "psychic magnetism." He was a conjurer who bet the fate of his art on random events supervised by carefully orchestrated rituals. His performances were chaotic attractors, at once controlling and summoning random intervention. He was alternately a sleight-of-hand artist and a truth-seeking philosopher — two roles that for him were not contradictory. In his performative works, the extraordinary and the miraculous often became one.

The Danish philosopher Søren Kierkegaard famously distinguished between "genius" and "apostle" — two exclusionary figures, one standing for absolute faith, the other for absolute knowledge. Byars managed to wear both hats, at times playing the role of the analytical philosopher and the founder of the "World Question Center," and at other times the spiritual artist/apostle who rejoiced in the paradoxes of faith.

Byars's works of the late 1950s and early 1960s consisted primarily of large–scale black-ink drawings on paper that predated Richard Serra's black-and-white drawings by at least a decade, and performative sculptures made of hundreds of sheets of hinged Japanese flax paper folded into solid geometric shapes. Byars was one of a number of artists (among them, Richard Tuttle and Serra) who, in the 1960s and 1970s, expanded the medium of drawing into sculpture.

One of his most important performative sculptures from that period is *Performative Square* (1963–64), an eighteen-inch-square cube consisting of 1,000 sheets of hinged Japanese flax paper that unfolds into a 600-by-600-inch surface. It was first exhibited at the National Museum of Modern Art, Kyoto, in 1964, but not performed until fourteen years later, in March 1978, during Byars's exhibition at the University Art Museum in Berkeley. There it was unfolded by the exhibition's curator, James Elliott, with the assistance of David Ross, Mark Rosenthal, and Earl Michaelson. It is now in the collection of the Museum of Modern Art, New York. To my knowledge, it has not been performed since.

In a 1964 letter to Wernher von Braun at NASA, Byars inquired whether it would be possible "to employ a government rocket or satellite" to send an eight-mile-by-four-inch piece of folded white paper into space "to be dropped to fall on our beautiful prairie at its flattest point using international instantaneous Tel-Star announcements."[3]

3 Archive of American Art, Samuel Wagstaff Papers, 1962–1984.

In 1967 Byars "performed" a paper scroll, two feet wide and one hundred feet long, in the exhibition of the Kyoto Independents. The audience was held in suspense as tens of feet of blank paper were unrolled before a drawn shape was revealed, followed by an equal amount of blank paper.

Arguably, Byars's most spectacular performative sculpture was *The Giant Soluble Man,* which was performed on 53rd Street between Fifth and Sixth Avenues in New York on November 16, 1967, during the opening of the *Made on Paper* exhibition at the Museum of Contemporary Crafts. A large silhouette of a man glued together from 400 feet of Dissolvo,[4] a water-soluble paper donated by the Gilbreth Company in Philadelphia, covered all of 53rd Street between Fifth and Sixth Avenues from curb to curb, with the help of the New York City Police Department, which stopped the traffic and removed all cars from the block. The action was ended by two street-cleaning trucks hired by the artist to wash the figure away.

Even Byars's first show in New York, in 1958 at the Museum of Modern Art, occurred as a result of happenstance. Impressed by a Rothko painting he saw exhibited at the Cranbrook Academy outside of Detroit, Byars hitchhiked to New York with some of his paintings on paper, walked to the Museum of Modern Art, and asked the receptionist for Mark Rothko's address so he could show him the paintings he brought with him from Japan. After explaining that the museum's policy did not allow giving out the addresses of artists, he convinced the receptionist to call the museum's curator, Dorothy Miller, to come down and have a look at his

4 Byars had a lifelong fascination with paper, magical or otherwise. He once wrote to the collector Sam Wagstaff, from Japan: "S[am] — I've just found a fantastic paper for anot.[ther] B[oo]K. It's Jap.[anese] and waterproof. The FR[ench] are copying it — I soon read in the Bath." (Ibid., undated).

paintings. Miller ended up buying one work for herself and allowing Byars to have a show in the emergency stairwell of the museum one evening. He installed several works there, which unfolded down the fire stairs. Most were sold, including one to the architect Philip Johnson. The exhibition apparently lasted only a few hours, and that night Byars personally delivered the sold pieces to the collectors' homes.

As RoseLee Goldberg notes, "Performance in the United States began to emerge in the late thirties with the arrival of European war exiles in New York. By 1945 it had become an activity in its own right, recognized as such by artists and going beyond the provocations of earlier performances."[5] Black Mountain College in North Carolina became the center of performance art in the United States, beginning in the 1930s with the residencies of Annie and Josef Albers. In the early 1950s the college's influence resurged with the music and dance activities of John Cage and Merce Cunningham, which were inspired by Zen Buddhism. For Cage, "Art should not be different than life but an action within life. Like all of life, with its accidents and chances and variety and disorder and only momentary beauties."[6]

Another center of early performance art was the Judson Dance Theater, an offspring of the Dancer's Workshop in San Francisco. Established in 1962 by, among others, dancers and choreographers Yvonne Rainer, Trisha Brown, Lucinda Childs, Steve Paxton, and David Gideon, it performed in the Judson Memorial Church in New York. The group regularly collaborated with artists such as Robert Rauschenberg and Robert Morris. By the mid-1960s, American experimental dance was strongly influenced by the rising move to minimalism in art.

5 RoseLee Goldberg, *Performance: Live Art, 1909 to the Present* (London: Thames and Hudson, 1979). p. 79.
6 Cage, quoted in ibid., p. 82.

Recently, Mikhail Baryshnikov's White Oak Dance Project revived a number of these early minimalist dance performances at the Brooklyn Academy of Music, in a program entitled *Past Forward*. One of the pieces performed was Yvonne Rainer's *Chair/Pillow* (1970), in which chairs and pillows are used to execute simple actions, such as sitting, standing, holding, and throwing. There appear to be definite affinities between the Judson group's choreographies and Byars's performances. In 1965, at the Carnegie Museum of Art in Pittsburgh, Judson group member Lucinda Childs, dressed in a full-length ostrich feather costume, performed Byars's *The Mile-Long Paper* (1964–65), a long strip of handmade Japanese white flax paper in seventy-five sections joined with rivets.

Chairs in particular played an important role in Byars's work as early as the late 1950s. For Byars, chairs served both as extensions of and as stand-ins for the human body. One of his earliest sculptures, *The Black Figure* (c. 1959) a minimalist human figure made from rough wooden planks painted black, which suggests both a ladder and an empty stretcher and emphasizes the absence of the human body, is somewhat chair-like as well. More related to the Judson group is an undated action, about which little is known except for a series of color photographs[7] that show Byars sitting still in various locations in New York on a chair, very much present in a red suit and his signature black hat.

Chairs also appear in Byars's later installations of objects, often gilded or painted red, symbolizing thrones, oracles, and other seats of knowledge and power. As was typical of Byars's sculptures made during the 1980s and 1990s, the performative character of his work began to become more autonomous, requiring less and less of his presence. While Byars's earlier, dominantly performative works were guided by the model of the Japanese Noh theater and sought to dematerialize the art object through actions and performances, his later

7 Found in the artist's estate.

works reobjectify actions by transforming the material of the objects into performers who raise philosophical questions.

Byars was essentially a sculptor who either "performed" his objects or allowed the materials and objects to perform like actors in a play — a notion he shared with the painter he admired most, Mark Rothko. Rothko perceived his painted floating rectangles as "objects" and as "actors" playing out universal human emotions on his canvases. In Byars's sculptures, what was played out were not emotions but ritual acts of body, speech, and mind.

One of Byars's earliest series of permanent sculptures consisted of several untitled "Tantric Figures" (c. 1960). Borrowing formally from Brancusi, each consists of two blocks of granite, the top one featuring two eyelike holes. Like his later *Figure of Death* (1986), constructed from basalt blocks, and his gilded-marble "Figures of Question" (1987/1995), the "Tantric Figures" represent religious-philosophical systems. They refer to the system of esoteric and secret practices in Hindu or Buddhist religion that revolve around concepts of time and the conjunctions of the planets. There are two classes of Buddha's teaching: sutras and tantras. While sutras are communicated publicly, tantras are taught individually, but only if the student is ready for them, and their content is kept between the teacher and the student. Thus these early sculptures already point to the participatory and meditative aspects of Byars's later works.

Another idea that greatly influenced the art of the 1960s was the emergence of speech act theory. The theory of performative speech acts (also referred to simply as "performatives") was introduced by the eminent Oxford analytical philosopher J.L. Austin in a series of lectures given at Harvard University in 1955 that were later published under the title *How To Do Things With Words.*[8]

8 J.L. Austin, *How To Do Things With Words* (Cambridge, Mass.: Harvard University Press, 1975).

The basic question posed by speech act theory was, as John Searle writes,

How do words relate to the world? How is it possible that when a speaker stands before a hearer and emits an acoustic blast such remarkable things occur as: the speaker means something; the sounds he emits mean something; the hearer understands what is meant; the speaker makes a statement, asks a question, or gives an order?[9]

According to Austin, performatives are utterances that perform an action as opposed to simply saying something, for example, "I believe," "I do," " I declare," "I bet."

As defined by Austin and Searle, Anglo-American speech-act theory shares with French structuralism (another linguistic theory that gained popularity in the 1960s) a predilection for function over meaning. Both theories are concerned more with the production of meaning — the act of communicating — than with meaning itself:

All linguistic communication involves linguistic acts. The unit of linguistic communication is not, as has generally been supposed, the symbol, word, or sentence, or even the token of the symbol, word, or sentence, but rather the production or issuance of the symbol or word or sentence in the performance of the speech act.[10]

Byars's actions and sculptures carry out what Austin called "illocutionary" acts (stating, questioning, commanding, promising, etc.), for example, *The Book of Question* (1987), *The Philosophical Chair* (1977), and the aforementioned "Figures of Question."[11]

9 John R. Searle, *Speech Acts: An Essay in the Philosophy of Language* (Cambridge: Cambridge University Press, 1969), p. 3.

10 Ibid., p. 16.

11 The five "Figures of Question" are *The Figure of Question is in the Room, The Figure of One Questions, The Figure of the Question of Death, The Figure of the Interrogative Philosophy,* and *The Figure of the First Question.* Each stele has two abbreviated capital letters engraved into the top part of the

What distinguishes speech acts from random noise or gestures is *intention*. Even the arrangement of furniture can be understood as a performative speech act as long as it is the result of intentional behavior. As Searle remarks, "The attitude one would have to such an arrangement of furniture, if one 'understood' it, would be quite different from the attitude I have, say, to the arrangement of furniture in this room, even though in both cases I might regard the arrangement as resulting from intentional behavior."[12]

One of Byars's first "actions" was the removal of all furniture, windows, and doors from his mother's house. Soon after he "rearranged" their neighbor's garden (with the neighbor's consent) by removing all flowers and replacing them with a large circle of white sand. Like the Japanese art of ikebana, Byars's installations distinguish themselves from other kinds of "arrangements" by the use of empty space as an essential feature of the composition, a characteristic of the aesthetics shared by traditional Japanese paintings, gardens, architecture, and design.

The "Great James Lee Byars" (as he preferred to sign his letters and postcards) was attracted by the great minds of our time. As Landsman remarked, "The three people [Byars] admired most were Stein, Einstein, and Wittgenstein." With the writer and poet Gertrude Stein he shared a fondness for word-

front side: Q.R., O.Q., Q.D., I.P., F.Q., respectively, in Byars's customary abbreviated writing style. In Byars's symbolic lexicon, Question is represented by Q, which contains the perfectly rounded O and thus "points" to the Perfect, which, like a black hole, is the point of infinite density, where time and space collapse. "Q Is Point" is the origin of everything. It is also the point where philosophy and physics become one in Byars's work. The placement of the two letters on each stele recalls Byars's earlier "Tantric Figures." Instead of two "eyes," the steles feature two letters from Byars's alphabet of the Perfect. Originally made of white marble, all five steles were gilded by the artist in 1995 for his exhibition *The Golden Room* at the Stedelijk Museum in Amsterdam.

12 Ibid., p. 17

play; with the analytical philosopher Ludwig Wittgenstein, an obsession with questions; and with Albert Einstein, a fixation on time.

Byars's art and life seem to have been affected by Einstein's "time dilation": the phenomenon of time almost appearing to come to a full stop as particles approach the speed of light. Like the paralyzed theoretical physicist Stephen Hawking, who suffers from incurable amyotrophic lateral sclerosis, Byars, a master thief of time, was in a state of compressed acceleration (which intensified toward the end of his life as he was fighting cancer).[13] It brought his sculptures close to Hawking's "event horizon," which defines the edge of black holes, beyond which there is no difference between extraordinary events and miracles.

13 Byars suffered from a rare form of cancer, *pseudomyxoma peritonei* or "false mucinous tumor of the peritoneum," an incurable, slowly progressing disease.

Frank Stella's monumental sculpture *Prinz Friedrich von Homburg, Ein Schauspiel, 3x* (*Prince Friedrich of Homburg, A Play, 3x*), 2001, is the culmination of the artist's three-year preoccupation with the German Romantic poet, writer, and playwright Heinrich von Kleist (1777–1811).

Commissioned by the National Gallery in Washington, D.C., the sculpture is situated at the northeast corner of the museum's East Building (outside the sculpture garden), where it faces Capitol Hill with an almost unobstructed view. Its location is as politically charged as it is architecturally poignant.

Kleist's *Prince of Homburg* has a long history of questionable interpretations. The play was banned from the theaters in Berlin immediately following its posthumous publication in 1821 because the local aristocracy was offended by Kleist's portrayal of their kind. During Nazi Germany it was misread by Hitler as a parable about the surrender of the individual to the (fascist) state, and more recently Hans Jürgen Syberberg used the play to exemplify the relationship between romanticism and fascism in his multimedia installation *Cave of Memory*, shown at *documenta X*.

In light of recent political events, the commotion and confusion of ethical, political, and emotional forces in Kleist's play seem more timely than ever. What only one year earlier may have been met by Washingtonians at best with unversed incomprehension and at worst with the kind of symbolic vexation that during the Nixon administration drove H.R. Haldeman to the forebodingly surreptitious act of having Barnett Newman's *Broken Obelisk* removed from the grounds of the Corcoran Gallery in the middle of the night, has in 2001 taken

This essay originally appeared in *Sculpture* (June 2004).

on a veracious irony. Stella's "structural mess," as it was perceived by much of the local press after the sculpture's placement, is increasingly becoming a metaphor for the ethical and political ambiguities that characterize much of today's American politics.

During the 1970s Stella moved away from a minimalist-tautological toward a maximalist-structural approach, from the passive attitude of "what you see is what you see" to an *interested* activity of simulation, described by Roland Barthes as the goal of the "structural" artist:

Structuralism is essentially an *activity*, i.e. the controlled succession of a certain number of mental operations ... The goal of all structuralist activity is to reconstruct an "object" in such a way as to manifest thereby the rules of functioning (the "functions") of this object. Structure is therefore actually a *simulacrum* of the object, but a directed, *interested* simulacrum, ... not in order to copy it but to render it intelligible. Hence one might say that structuralism is essentially an activity of imitation.[1]

Like Barthes's "structural man," Stella has long been engaged in "reconstructing" literary texts by transposing them into three-dimensional (or, as the artist prefers to call it, 2½-dimensional) objects, thereby exposing their often hidden political, psychological, and historical content.

Kleist, the last of his family in a long line of Prussian military officers, was a "writer's writer" who pushed his creative impulses to extremes not only in his plays and stories but in his life as well (on the battlefield and in his obsession to find a woman with whom to end his life in an act of mutual suicide). He is probably best known to the English-speaking public for his short story "The Marquise of O." Throughout the twentieth century, Kleist's work attracted the attention of countless artists, writers, filmmakers, and composers, among

1 Roland Barthes, 1963,"The Structuralist Activity," in *The Structuralists: From Marx to Lévi-Strauss*, eds. Richard T. and Fernande M. De George, trans. Richard Howard (Garden City, N.Y.: Doubleday, 1972), pp. 149–50.

them, Luciano Visconti, Eric Rohmer, Hans Jürgen Syberberg, and the composer Hans Werner Henze, whose 1958 opera, based on Kleist's *Prince of Homburg*, features a libretto by the German novelist Ingeborg Bachmann.

Kleist saw himself as the true successor to the literary throne of Goethe and Schiller and sought to achieve this status by continuously deconstructing their strict classicism. Thus his plays were unpredictable, multi-layered, and ethically ambiguous, with interposing storylines, characterized by grammatically broken language and heretofore unheard-of expressive form.

His reading of the philosopher Immanuel Kant's *Critique of Pure Reason* and its propagation of the uncertainty of knowledge unsettled Kleist "deeply and painfully" and became a leitmotif in all of his plays. As he wrote to Wilhelmine von Zenge,

We cannot determine whether what we call truth is indeed truth or whether it only seems to us as such. If the latter is the case, then the truth that we collect here, *is* no more after death.[2]

Prince of Homburg is a complex play, the story of a sleepwalking officer in the Prussian cavalry (a true romantic hero) who, consumed by his desire for a woman he saw in his dreams, unwittingly disobeys an order of his superior, the Elector of Brandenburg, which leads to his trial for treason and certain death by execution, despite his victorious battle against the Swedish army.

As he looks into his already open grave, Prince Friedrich first succumbs to his fear of death, throwing himself on the mercy of the Elector's niece, Princess Natalie (whom he recognizes as the woman in his dream). In the end, military reason prevails over his passion, and Friedrich rejects the pardon negotiated by Nathalie. Only then is he truly redeemed

2 Heinrich von Kleist, *Sämtliche Werke und Briefe*, vol. 2 (Munich: Carl Hanser Verlag, 1984), p. 634 (my translation).

and his life spared. Inspired by the Prince's noble decision to accept his punishment, the Elector retracts a proposed truce between the two armies and prepares his troops for yet another battle.

Because the events of the play are essentially motivated by the erotically charged opening scene, in which the sleepwalking Prince of Homburg is offered a laurel crown and Princess Natalie's glove, the play has been compared to Bellini's opera *La Somnabule*, first performed in 1831. In a recent performance of *Prince of Homburg* at the Lyric Theatre Hammersmith in London, the director Neil Bartlett chose a photograph by Robert Mapplethorpe for the poster, which shows a man's cropped head and tense naked upper body. His mouth is open and his eyes closed. What the photograph does not reveal is the fact that the model was masturbating at the time. It seemed an appropriate choice to illustrate Kleist's morbid eroticism.

In the play, nothing ever turns out to be what it seems. From Friedrich's daydream of glory and love to the fate of the Elector (who switched horses with his adjutant, unbeknownst to his soldiers, and is therefore believed to have died when his horse went down in the battle), to Friedrich's victory (which does not count as it is the consequence of a disobeyed order).

Stella's twisted sculpture portrays the Prince of Homburg as a modern-day Laocoon. As in the Hellenic sculpture, it represents the struggle between irreconcilable forces — a soldier wrestling with the enemy *within*, in a war organized by orders, confusion, and errors. However, Stella's *Prince of Homburg* transforms Winckelmann's famous notion of classical Greek sculpture's "noble simplicity and quiet grandeur" *(edle Einfalt und stille Größe)* into restless monumentality paired with complexity — a complex entanglement of noble metal (aluminum) and "emotive" construction (in the sense of arousing deep emotions as well as being in motion).

Heisenberg's uncertainty principle states that the location and momentum of a particle cannot be determined precisely

at the same time; thus physics can never arrive at a complete picture of the universe — it can only approach its truth step by step, forever changing. The French philosopher Alain Badiou has linked the process of truth to "events," which in turn he links to the notion of undecidability. For Badiou, an event is an unpredictable and incalculable "wager" that begins with a decision — the decision to go ahead regardless of the outcome.[3] Alain Resnais and Alain Robbe-Grillet's 1961 film *Last Year in Marienbad*, with its exasperating multiplicities of interpretations, Susan Sontag's 1964 book *Against Interpretation*, and Stella's 1960s shaped aluminum paintings, composed of stark parallel black bands, were all responses to this crisis of meaning. In Stella's case, it was directed against the "confusion" of traditional European painting rooted in rationalist philosophy. As fellow artist Donald Judd said in a 1964 radio broadcast with Stella, "All that art is based on systems built beforehand, *a priori* systems; they express a certain type of thinking and logic that is pretty much discredited now as a way of finding out what the world's like."[4] This involved a complete departure from what Stella regarded as "the humanistic values" in painting: the assertion "that there is something there besides the paint on the canvas." Instead he proposed that in his paintings "only what can be seen there *is* there . . . All I want anyone to get out of my paintings, and all I ever get out of them, is the fact that you can see the whole idea without confusion."[5]

At the time, in 1964, Stella had chosen the opposite direction of Resnais and Robbe-Grillet, opting to wager on the absence of interpretation rather than employing a structuralist strategy of ambiguities and multiplicities of meaning. But

3 See Alain Badiou, "The Ethics of Truths: Construction and Potency," *Pli: The Warwick Journal of Philosophy*, vol. 12 (2001): 247–55.

4 In *Minimal Art: A Critical Anthology*, ed. Gregory Battcock (New York: E.P. Dutton, 1968), p. 151.

5 Ibid., p. 158.

even then, Stella had to profess that "we're all still left with structural or compositional elements . . . I don't think our work is that radical in any sense, because you don't have any really new compositional or structural elements."[6]

Clement Greenberg famously dismissed minimal art for its lack of power to "move and affect" in his belief in the precedence of aesthetics over phenomenology: "There is hardly any aesthetic surprise in Minimal Art, only a phenomenal one . . . Aesthetic surprise hangs on forever — it is still there in Raphael as it is in Pollock."[7] However, during the 1970s Stella's works became increasingly more aesthetic and less phenomenological, almost as Greenberg had wished they would; first by combining brightly colored, circular-shaped canvases, and later by constructing the surface of the paintings to project outward from the wall. (Stella insists that his three-dimensional works are paintings, not sculptures: "They're paintings because they function in a pictorial way... They are organized in a pictorial way."[8]

Stella's "paintings" also became more aleatory — characterized by chance or indeterminate elements in the sense of post-Schönbergian music (e.g., Stockhausen, Cage, and Boulez), where specific previously defined material may be reorganized into different forms by introducing the elements of chance or unpredictability with regard to either composition or performance. Guided by the pictorial inventions of Caravaggio, whose paintings he began to study intensely, Stella at last realized "really new compositional or structural elements."

6 Ibid., p. 154.

7 Clement Greenberg, "Recentness of Sculpture," in *Minimal Art: A Critical Anthology*, p. 184.

8 Franz-Joachim Verspohl, ed., *Heinrich von Kleist by Frank Stella* (Jena/Cologne: JENOPTIK AG/Verlag der Buchhandlung Walther König, 2001), p. 250.

In his Norton Lectures, delivered in 1983–84, Stella posed the paradigmatic question that provides the key to understanding his radical move toward representational abstraction: "Can we find a mode of pictorial expression that will do for abstraction now what Caravaggio's pictorial genius did for sixteenth-century naturalism and its magnificent successors?"[9]

Stella praised Caravaggio for creating a spherical pictorial space that is "capable of accommodating movement and tilt" within which the spectator experiences "the moment and motion of painting's action ... the sensation of real space within and outside of the action of the painting." And he concluded that "Caravaggio created ... something that twentieth-century painting could use: an alternative both to the space of conventional realism and to the space of what has come to be conventional painterliness."[10] Thus after his radical shift to expressive, sculpted paintings, Stella at last embraced a structuralist strategy of resisting interpretation by adding chance and ambiguity to meaning.

Sanford Schwartz calls Kleist "the prince of pure feeling": "There was a knot at the center of Kleist's feelings, and it wouldn't come undone — it got only tighter."[11] The same could be said about Stella's sculpture. The longer one studies it, the more entangled its structure becomes. It perfectly reflects the emotional and existential roller coaster of the antagonist.

The sculpture's lightweight support system of steel trusses and cables belies its true mass, weighing just under 20,000 pounds. Constructed primarily of curved aluminum, fiberglass (a covering material made of glass fibers in resins), and carbon. Three times the size of the 1999 prototype, *Prince Frederick Arthur of Homburg, General of Cavalry, ix* (Daimler-

9 Frank Stella, *Working Space* (Cambridge, Mass.: Harvard University Press, 1986), p. 4.
10 Ibid., p. 11.
11 In the *New York Review of Books* (Januray 20, 1983).

Chrysler Collection, Stuttgart), it is Stella's largest work and his first outdoor sculpture to enter a public collection in the United States. The supportive trusses give the work an eerie resemblance to the lunar module that was used during the Apollo moon landings and is now at the Smithsonian Air and Space Museum, further strengthening the illusion of motion and enriching it with just a hint of science fiction.

Carbon, which occurs in all organic life, has the interesting chemical property of being able to bond with itself, as well as with a wide variety of other elements. It references "life-world," to use a term introduced by the phenomenologist Edward Husserl, and forms an ideal foundation for endless complexity. The sculpture's entropy reverberates in the archway in the town of Würzburg, about which Kleist wrote to Wilhelmine on November 16, 1800:

There I went, pondering, back into town through the arched gate. Why, I thought, does the arch not collapse, since it has no support? It stands, I answered myself, *because all of its stones want to tumble down at once.*[12]

Like Kleist's archway, Stella's *Prince of Homburg* gains strength and stability from the sum of its seemingly collapsing parts. The artist's signature black carbon smoke rings are prominently featured. Stella creates these shapes by blowing cigar smoke into a cube lined with black cloth and then photographing them from various angles at regular intervals. Later these photographs are rendered on the computer into two- and three-dimensional layered construction diagrams, from which he casts solid models.[13] Just as the wave shape became

12 von Kleist, *Sämtliche Werke und Briefe*, p. 593 (my translation).
13 In a photograph taken by Hollis Frampton in 1963, Stella is depicted blowing smoke rings. Frampton later comments, "Looking at the photograph recently, it reminded me, unaccountably, of a photograph of another artist squirting water out of his mouth, which is undoubtedly art. Blowing smoke rings seems more of a craft. Ordinarily, only opera singers make art with their mouths." In *Hollis Frampton: Recollections/ Recreations* (Cambridge, Mass.: The MIT Press, 1984), p. 61.

the signature motif for Stella's "Moby Dick" series, 1985–97, the smoke rings have become a motif linked to his Kleist series since he introduced them in a number of small-scale wall sculptures based on Kleist's love letters to Wilhelmine. Stella's smoke rings spell out Kleist's passion in the air.

Stella's *Prince of Homburg* also appears to combine in almost perfect balance the two fundamental forces of the universe: inertia and energy. Frozen in a moment between explosion and implosion, it deconstructs the "dark matter" in the subconscious of Kleist's universe, not unlike the suspended explosions of the British artist Cornelia Parker. In *Cold Dark Matter: An Exploded View*, 1991, she hung the exploded parts of a garden shed (executed on her behalf by the British army) on wires from the ceiling. Parker's efforts result in the sort of comic suspension of cause and effect and the laws of gravity that we have become accustomed to from watching cartoon characters such as Chuck Jones's creation Wile E. Coyote who, in his fanatic pursuit of the Road Runner, is never permanently harmed by his failures — only humiliated — and winds up getting repeatedly run over by trains or smashed against a rock. When running off a cliff he never drops downward immediately; instead, ignoring the laws of gravity, he remains suspended in mid-air during a moment of inertia. Like Parker's installations, Stella's *Prince of Homburg* is not without such comic qualities. Most of his sculpted paintings contain cartoon-like shapes and suspended motion, and the *Prince of Homburg* is no exception. Even the title notation "3x" could be read as a reference to the repetitive nature of cartoons, just as the work's enormous size imparts a spark of silliness.

On the whole, Stella's *Prince of Homburg* is a prime example of public art that is able to materialize a web of complex ethical, aesthetical, and political issues without didacticism — very much in the sense of what Barthes once called "the responsibility of forms." In Stella's words,

Art must be communicable whole, and perception tends to be fragmented and self-serving. In the most obvious and fundamental way the artist wants to see what is going on around himself. His paintings, almost by definition, should have a spherical sense of spatial containment and engagement . . . The artist should strive to encourage a response to the totality of pictorial space.[14]

14 Frank Stella, *Working Space*, p. 9.

THE STRANGE LIFE OF ANDREI ROITER'S OBJECTS

The French Dadaist and surrealist painter Francis Picabia once said that God made our heads round so that our thinking can change direction. Andrei Roiter's art changes direction all the time. I think much of that has to do with his permanent state of dislocation: Roiter's head is not only round but two-headed; it looks in more than one direction at a time (usually east toward Moscow and west toward New York).

In his book on the art of collecting, *The Strange Life of Objects*, Maurice Rheims distinguishes among three types of collectors: the dedicated collector, who is animated by a desire to own everything; the dilettante, who collects more or less without system; and the curiosity hunter, who looks out for the unexpected rather than the beautiful and precious. Most artists are collectors and Roiter belongs undoubtedly in the last category. He is a "curio-artist," continuously on the lookout for whimsical, often silly objects, which, upon closer inspection, reveal themselves to be deeply metaphysical or existential: dysfunctional appliances, discarded boxes, or abandoned signs. He collects these things by either taking them to his studio or capturing their image with his digital camera, without which he never leaves home. They reappear in his drawings and paintings or become sculpture.

Like jokes, Roiter's objects have a relationship to the subconscious. According to Freud, dreams and jokes relate to the subconscious in different ways: dreams serve to spare us *Unlust* (displeasure); jokes, to yield pleasure. Jokes are like games whose prize money comes in the form of *Lust* (pleasure or *jouissance*). Roiter's objects should be considered part of a language-game — in the sense of Wittgenstein's model of

This essay originally appeared in *Andrei Roiter: Inscapes*, exhibition catalog (Recklinghausen: Kunsthalle Recklinghausen, 2004).

a child learning languages by pointing and naming. Roiter's objects are ostensible, always pointing and naming but resulting in a "private language" (another notion from Wittgenstein's repertoire) that uses the techniques of the joke, as described by Freud — displacement, errors in reasoning, nonsense, etc. — to carefully obscure meaning just enough to provide a *little* pleasure, or to use another Freudian expression, *Vorlust* (fore-pleasure). They are objects that tease the truth but stop short at foreplay.

All artists are tricksters; their relationships to truth are, to say the least, elastic. The trickster artist Duchamp is the forefather of postmodern art, and Hermes, the messenger between gods and mortals, and a notorious trickster (and hermeneutics's namesake), is its patron saint. Roiter is a trickster artist who speaks with two tongues and plays with his objects, like Wittgenstein did with his building blocks, slabs, and beams, in order to confuse as well as amuse.

GATEWAYS OF THE NOW:
REMARKS ON THE DRAWINGS OF WOLFGANG LAIB

There are artists whose works are so completely their own that established methodologies and approaches are inadequate to the task of the critic or art historian. In the postwar period, the roster of these few, highly autonomous artists includes the American artists James Lee Byars and Eva Hesse and the German artists Joseph Beuys and Wolfgang Laib.

What makes Laib more singular than most is that he identifies with no school or movement and has never taught any students. Laib also distances himself from Western European aesthetic traditions more generally; he sees himself as largely alone among his peers, for he has little interest in contemporary art apart from his own practice, which originates equally in the natural environment of his home, in a small village in southern Germany, and in his encounters with non-Western art and religion. Only marginally influenced by other artists (even though Laib's unique style would be unthinkable without the path prepared before him by artists such as Marcel Duchamp, Constantin Brancusi, Robert Smithson, Mark Rothko, and Agnes Martin) and without a formal art education (he attended medical school), Laib is the absolute source for his own work and defies easy categorization. For almost thirty years, he has been true to his solitary art and to his desire for a new artistic expression.

Laib's work is informed by his deep relationship with nature and a commitment to the purity and simplicity he finds

This essay originally appeared in *Die Essenz des Wirklichen: Wolfgang Laib. Zeichnungen und Fotografien*, exhibition catalog (Bonn: Kunstmuseum Bonn, 2005).

both in his native Protestantism[1] and in Eastern philosophies. Since the 1970s Laib has created objects and installations with such elemental materials as pollen, stones, marble, milk, beeswax, rice, and natural resin. He has established an artistic vocabulary of timeless forms that is infused by his knowledge of Western and Eastern spirituality. The artist is especially inspired by the temple altars of southern India — a place he considers his spiritual home— replete with their offerings of flowers and food and their portable bronze deities. Produced between the ninth and the thirteenth centuries, these figures are integral to daily Indian rituals and ceremonial processions and are bathed, clothed, and given offerings of incense and food, including milk, which is often poured over them. Both his milkstones and his rice houses, Laib says, are inspired by these observances and cultural practices.

The entire lexicon for Laib's sculpture and installation pieces can be found in the photographs he takes to both record his extensive travels through India, Turkey, Myanmar, Cambodia, China, and Japan and to document his installations. While formally recalling nineteenth-century images by travel photographers such as Francis Frith, Samuel Bourne, and Maxime DuCamp, Laib's photographs capture a spiritual rather than geographic journey. There is an intimate relation to his drawings, which are often made in direct response to the photographs and give expression to the ephemeral but enduring qualities of his larger works.

Laib's drawings condense the essential forms of his sculptural works into playful, minimalist compositions on paper. The drawings are often made in dialogue with his photographs and rendered in pencil and oil pastel, with colors that refer to the materials of his sculptures: yellow, to the pollen that he ritualistically collects in the meadows near his home;

1 See Margit Rowell, "Modest Propositions," in Klaus Ottmann, *Wolfgang Laib: A Retrospective*, exhibition catalog (New York/Ostfildern-Ruit: American Federation of Arts/Hatje Cantz, 2002).

red or orange, to the beeswax and sealing wax of rice houses and ziggurats. The tentative sensitivity of his pencil lines and his sparing use of oil pastel reveal the essence of Laib's unique artistic philosophy: to challenge the notion of monumentality — central to Western sculpture — by grasping the fleeting, intangible essence of life itself: the ephemeral becomes the eternal.

Laib's exquisitely rendered, diaphanous drawings are independent of his sculptures and installations. Like the autonomous drawings of the Italian early-modernist sculptor Medardo Rosso — whose innovative technique of modeling beeswax over plaster casts allowed him to retain aspects of his working process, thus making preparatory sketches unnecessary — or those of the minimalist sculptor Richard Serra, which are installed *as* sculpture, Laib's drawings are designed as works of art in their own right.

They are also a relatively late addition to Laib's oeuvre: he began making them in the form of "presentation drawings," primarily as gifts to friends,[2] and he has made drawings regularly since then. He made the first drawing in 1983, when asked to donate a work on paper on the occasion of the curator Johannes Cladders's sixtieth birthday, using his father's tempera paint set. Laib quickly realized that drawing allowed him to play with visual ideas that could not be expressed easily or at all in sculpture: placing a pyramid inside a mountain, for example. Drawing also permitted him to further explore the spiritual dimensions initiated in his sculpture; it became yet another medium through which Laib was able to express his "spiritual materiality."[3] The pencil lines might be visually striking; yet it is the sparse accents of color that give the drawings

2 A term originally coined by the Michelangelo scholar Johannes Wilde, "presentation drawings" first appeared in the latter half of the fifteenth century. Michelangelo himself made a large number of such drawings, which he presented as gifts to young men and women he favored.

3 See pp. 183–89 of this volume.

their specific resonance. The oil pastel calls to mind the organic materials used in Laib's sculptures; the sculptures, in turn, often confuse these materials with pigment. In raising fundamental phenomenological questions about what, exactly, they are made of, Laib transposes their materiality into a spiritual dimension. In essence, he transgresses their materiality.

Laib's drawings reveal an extremely controlled formalism that is expressionistic and emotional, yet tenaciously minimalist. His earliest drawing, *The Rice Meals for the Nine Planets (or how else the connections could be)* (1984), is less minimal than his subsequent works on paper, but the tense energy of his pencil lines is already evident. The drawing depicts nine yellow triangles representing the brass-and-tin cones used in the sculpture *The Rice Meals for the Nine Planets* (1983). These are set within the pencil contours of a large equine animal (an element that appears only in his drawings), underneath which are drawn objects representing five of the nine Indian symbols for the planets, symbols that reappear in several other drawings and can also be spotted in a photograph Laib took at a temple in southern India.

All of Laib's works aim at suspending reality, particularly the intensely sensuous, inwardly directed wax chambers, which temporarily induce a lost awareness of time and place. One of his wax chambers is titled *Somewhere Else — La Chambre des certitudes* (1997), and a 1995 drawing carries a similar title, *La Chambre des certitudes — La Certitude c'est l'imaginaire* [The Room of Certitudes — Certitude Is the Imaginary]. The drawing is composed of pencil outlines with accents of red oil pastel, displaying a flat-top mountain shape containing a red ziggurat. (Laib has erected, in recent years, several monumental ziggurats — modeled after the ancient stepped pyramids of Mesopotamia and coated with beeswax or Burmese Thitsi lacquer). Three smaller outlines of mountains are visible to the left side of the large mountain. Another drawing, *A Waxroom for a Mountain* (1994), depicts a similar mountainlike shape, containing a three-step pyramid, accentuated with yellow

oil pastel — the Meidum pyramid, the oldest one in Egypt, located just south of Memphis. Laib photographed it on a visit to Egypt and has used its shape in several drawings. Below the pyramid, he drew a vertical rectangle, which, because of its central position, is read as a doorway — a reference to his life-long dream to build a wax chamber inside a mountain (fulfilled in the summer of 2000, when he created a permanent wax room in the French Pyrenees by blasting a large hollow into the Roc del Maure, a granite mountain in the Masif du Canogou, and coating it entirely with liquid beeswax).

While Laib's sculptures and installations suspend or transpose space, his drawings accomplish a suspension of time. Hannah Arendt located the place of thinking in "a timeless region, an eternal presence of the complete quiet, lying beyond human clocks and calendars altogether . . . the quiet of the now in the time-pressed, time-tossed existence of man."[4] Arendt calls this moment of non-time within time *nunc stans* (standing in the now), borrowing a term from medieval philosophy. Laib's drawings are like the gateway of the Now in Nietzsche's *Thus Spoke Zarathustra:*

Two roads come together here: no one has yet followed them to the end. This long alley backwards: it continues for an eternity. And that long alley forward — it is another eternity. They are antithetical to one another, these roads; they directly abut one another: — and it is here, at this gateway, that they come together. The name of the gateway is inscribed above: "Now."[5]

Heidegger saw in this passage Nietzsche's doctrine of the eternal recurrence of the same:

4 Hannah Arendt, "Thinking," in *The Life of the Mind* (New York/London: Harcourt, Inc., 1981), pp. 206–11.
5 In Friedrich Nietzsche, *Kritische Studienausgabe*, eds. Georgio Colli and Mazzino Montinari, vol. 4 (Munich: Deutscher Taschenbuch Verlag/ Walter de Gruyter, 1999), p. 199 (my translation).

Nietzsche summarizes here . . . a substantial thought of his philosophy . . . : 1. The infinity of time in regard to the future and the past. 2. The reality of the time, which is not a "subjective" view. 3. The finiteness of things and material events. On the grounds of these premises everything that exists now must have already existed before; since the course of an infinite world is necessarily already completed in an infinite time.[6]

The eternity is in the Now.

Laib's drawings, which refer to Hindu and Buddhist practices and philosophies that involve concepts of time and the conjunctions of the planet, are manifestations of the *nunc stans*, of standing fast in time (in the sense of Kierkegaard's *motion in place*) — standing fast at the boundary of time. It is here where we experience certitude, which implies a leap of faith in something that needs no objective proof or cannot be subjected to it. (The word "certitude" appears in the titles of several of Laib's works.)

The most radical position on certitude is found in Wittgenstein's last body of writings, *On Certainty*. It is Wittgenstein's response to G. E. Moore's essays on "common-sense propositions" and Moore's assumption that one can "know" truths that are held to be "certain," i.e., that cannot be doubted. Wittgenstein objects not so much to the assumption of such certainties as to Moore's use of the words "I know." Wittgenstein holds that knowledge and certitude are entirely dissimilar, that there is a difference between saying that one is certain of something and saying that one knows it to be so — if "I know" is meant to imply that it is beyond any doubt. It is therefore possible to be in a state of knowledge without being certain and to be certain without having knowledge. Neither requires the other. "Standing fast" is one of the terms Wittgenstein uses for certitude and must be distinguished from knowing. He identified certitude with acting, not with seeing propositions to be true:

6 Martin Heidegger, *Nietzsche*, vol. 1 (Pfullingen: Verlag Günther Neske, 1961), p. 296 (my translation).

Giving grounds, however, justifying the evidence, comes to an end; — but the end is in that certain propositions striking us immediately as true, i.e. it is not a kind of *seeing* on our part but our *acting*, which lies at the bottom of the language-game.[7]

The German *feststehen* implies a certainty without knowledge while the English translation "standing fast" carries with it the additional meaning of "being in motion," in the sense of Kierkegaard's qualitative leap (which suggests that Wittgenstein's "activity of standing fast" may be his "leap to certitude").[8]

For Laib, this leap to certitude — the "activity of standing fast" *sub species aeternitatis* — takes place in the activity of drawing. In Laib's works, certitude, the "believing what you cannot know," is allied with a certain tautological knowledge, the "what you see is what you see" of minimalism. This "tautological certitude," although evident in Laib's sculptures, is more transparent in his drawings. In a 1995 drawing entitled *Nowhere*, for example, Laib placed three yellow ships, stacked vertically, inside a mountain. Another drawing from 1983 shows nine orange cones within the pencil outline of a mountain, which is itself situated within a large penciled outline of a ship. In the drawings Laib asks the viewer to "believe" what he or she sees but cannot "know," such as a ship containing a mountain.

7 Ludwig Wittgenstein, *On Certainty*, trans. Denis Paul, G. E. M Anscombe (New York: Harper & Row, 1972), p. 28e, par. 204 (translation modified).

8 See Klaus Ottmann, "Wittgenstein's Leap," chap. 5 in *The Genius Decision: The Extraordinary and the Postmodern Condition* (Putnam, Conn.: Spring Publications, 2004).

On September 21, 2004, *The New York Times* reported under the headline "Only in Quantum Physics: Spinning While Standing Still: "In an experiment with supercooled helium, researchers at Penn State say they have found that *as a solid ring spins around, part of it can remain perfectly still.*" (my italics)

A number of unorthodox physicists have recently sug-
gested that there may be a perspective from which past, pres-
ent, and future events exist at once. Einstein already put for-
ward that the "spooky action" of quantum mechanics (which
makes two particles affect each other instantaneously, even
though they may be light years apart) should be attributed
to "hidden variables." Mark Hadley, a young British quantum
physicist who presented the radical theory that General Rela-
tivity could explain Quantum Theory (while most of his col-
leagues were still trying to find a quantum theory of gravity),
has recently revived Einstein's notion of a quantum state of
certitude by proposing that the present is affected as much by
the future (calling it a "hidden variable") as it is by the past.[9]
And the controversial theoretical physicist Julian Barbour,
who lives on a farm north of Oxford and makes his living by
translating Russian while pursuing independent research in
physics, argues that neither the past nor the future exists.
Instead, there are only moments of time — a succession of
Nows: "There are Nows, nothing more, nothing less."[10]

Although Laib uses highly simplified forms, he is not a
minimalist. His spirituality does not adhere to any one re-
ligion, though his work is deeply affected by the divinity of
and active participation in nature and the sharing of this
experience with others. His drawings illustrate his unortho-
dox notion of sculpture: despite the fragility and modest size
of many of his works he considers himself a "monumental"
sculptor. In his drawings, as in his sculpture, a 3-inch-high
mountain of pollen can be as monumental as an 18-foot-high
beeswax ziggurat. For Laib, it is about seeing something
large in something small: "It is about the least, which is also
the most."

Like the American artist James Lee Byars, whose life and
work seems to have been affected by Einstein's time dilation,

9 See http://www.warwick.ac.uk/~phsem/
10 See http://www.edge.org/documents/archive/edge6o.html

the phenomenon of time almost coming to a full stop as particles approach the speed of light, Wolfgang Laib creates a timeless art of the Now by dividing or multiplying time and space by its smallest or largest factors. The suspension of time achieved in Laib's drawings extends to his artistic practice. His earliest works reached maturity instantaneously. While he sometimes uses new shapes, colors, and materials, Laib has not made any essential changes in his work since the 1970s. Most of his works first created almost thirty years ago are still produced by the artist today. There are no distinct bodies of work and the dating of his works merely denotes the actual time of their execution; it cannot be used to group them into "early" and "late periods."

The idea of progress, and consequently of linear time, has been at the core of Western culture and history; yet Laib continues to create milkstones and pollen fields in forms virtually unchanged since the mid-1970s. As Laib says, "I will still make [pollen mountains] in twenty years. Even if people find it old-fashioned, I don't care."[11] Alluding to his cyclical practice, Laib once refered to pollen as "a detail of infinity."

What Agnes Martin once wrote about her fellow artist Leonore Tawney's work, can equally be said about Laib:

With directness and clarity, with what appears to be complete certainty of image . . . this work flows out without hesitation and with a consistent quality . . . There is an urgency that sweeps us up, and originality and success that holds us in wonder.[12]

11 Laib, in a conversation with the author at the artist's studio in the summer of 1998.

12 *Lenore Tawney* (New York: Staten Island Museum, 1961).

ROBERT GROSVENOR IN HIS OWN PLACE

In English writing we seldom speak of tradition . . . If the only form of tradition, of handing down, consisted in following the ways of the immediate generation before us in a blind or timid adherence to its successes, "tradition" should be positively discouraged. Tradition is a matter of much wider significance. It cannot be inherited, and if you want it you must obtain it by great labor. It involves, in the first place, the historical sense, which we may call nearly indispensable to anyone who would continue to be a poet beyond his twenty-fifth year; and the historical sense involves perception, not only of the pastness of the past, but of its presence . . . No poet, no artist of any kind has his complete meaning alone.
— T.S. Eliot, 1917

These words by T.S. Eliot were quoted by Robert Venturi in the preface to his groundbreaking book *Complexity and Contradiction in Architecture.* Venturi adds to Eliot's words the following preamble of his own:

As an artist I frankly write about what I like in architecture — what we are easily attracted to — we can learn much of what we really are. Louis Kahn has referred to 'what a thing wants to be,' but implicit in this statement is its opposite: what the architect wants the thing to be. In the tension and balance between the two lie many of the architect's decisions.[1]

It seems entirely appropriate to begin a discussion of one of the most American of artists, Robert Grosvenor, by referring to two of the most American of poets and architects. Like Eliot's poems, each of Grosvenor's sculptural installations seems to contain the whole of American culture. With Venturi, Grosvenor shares a genuine respect for and attraction to the vernacular, that which is neither sublime nor beauti-

This essay originally appeared in *Sculpture* (October 2005).
1 Robert Venturi, *Complexity and Contradiction in Architecture* (New York: The Museum of Modern Art, 1966), p. 13.

ful yet represents perhaps the most original contribution of American culture to the history of art and architecture; and he also shares Venturi's preference for richness rather than clarity of meaning.

Grosvenor, whose formative years coincided with those of the leading minimalist sculptors — Donald Judd, Carl Andre, Sol LeWitt, and Robert Morris — is somewhat of an outsider even among his peers. Yet he shares with them an essentially structuralist disposition. Unlike phenomenology, structuralism (which gained popularity in the United States in the 1960s through the films of Alain Resnais and the writings of Roland Barthes and Susan Sontag) does not render the world as it appears, but investigates its *functionality*. Barthes defined structuralist activity as a "controlled succession of a certain number of mental operations" whose goal it is "to reconstruct an 'object' in such a way as to manifest thereby the rules of functioning (the 'functions') of this object."[2] Thus structuralism is ultimately concerned not with meaning but with the *fabrication* of meaning. Grosvenor's sculpture replaces essence in art with presence and place; his work relies on the void, and the space around it, a space that since the Renaissance has been seen as distinct and unrelated to the art object. Proceeding from Brancusi's *Bird in Space* (1919), which treats the pedestal as an essential part of the sculpture, object-based art interacts with the space it occupies, to the extent that even the surrounding architectural space becomes an intrinsic part of it.

Unlike mainstream minimalism, Robert Grosvenor's sculptures dispense with the reductiveness and intellectual gravity of that period. Grosvenor's objects are playful, capricious, or mischievously thoughtful. They are dynamic rather

2 Roland Barthes, 1963, "The Structuralist Activity," in *The Structuralists: From Marx to Lévi-Strauss*, eds. Richard T. and Fernande M. De George, trans. Richard Howard (Garden City, N.Y.: Doubleday, 1972), p. 149.

than inert. While the structuralists approached the multiplicity of meanings with a scrupulous examination of an object's materiality as *theoretical* act (the "structuralist activity"), Grosvenor's attitude consists of a purely sensuous immediacy. He seems concerned more with what the Japanese linguist Toshihiko Izutsu called the "fundamental magic of meaning":[3] the pleasant surprise of the unknown into the semantic constitution of his objects, recognizing that the objects of our daily life are unanalyzed, indistinguishable, and blurred in meaning, and surrounded by an aura of impressions, emotions, and expectations.

Grosvenor was one of the artists included in *Primary Structures*, the 1966 landmark exhibition at the Jewish Museum that became a showcase for American minimalist sculpture, although it featured works by an equal number of British sculptors and many artists who did not or at least did not fully ascribe to the minimalist credo. Among those were the American sculptors belonging to the artist-run Park Place Gallery, the most prominent of which were Grosvenor, Ronald Bladen, and Mark di Suvero (who was not in the exhibition). Grosvenor exhibited *Transoxania* (1965), his second major sculpture whose askew angles and dynamic shape were, like Bladen's untitled three monoliths that stood at a 65-degree angle, in stark contrast to the right-angled sculptures of Robert Morris or the rigid seriality of Donald Judd's galvanized iron boxes.

Transoxania was named after a region of Turkistan and means literally "That Which Lies Beyond the River." It was a cantilevered structure made of plywood measuring 31 feet in width, which was attached to the ceiling and formed an immense V that stopped short of touching the floor. It was painted red on top and black on the bottom (color was a prominent

3 Toshihiko Izutsu, *Language and Meaning: Studies in the Magical Function of Speech* (Tokyo: The Keio Institute of Philological Studies, 1956).

feature in the exhibition).[4] A steel channel above the ceiling was used by Grosvenor to balance the weight of the cantilever, and steel reinforcements inside the sculpture next to the ceiling and a steel "saddle" under the plywood at the center joint were used for further stability. Grosvenor chose plywood because it was both inexpensive and easy to work with. At that time, his materials had not yet gained an importance of their own. In his catalogue statement Grosvenor declared that his works were to be thought of as "ideas that operate in the space between floor and ceiling." *Transoxiana* was destroyed after the exhibition at the Jewish Museum.

In fact, a number of his works from the 1960s were either destroyed or altered against the artist's original intention, like the widely praised *Topanga* (1965), his first cantilevered plywood and steel sculpture, inspired by Skidmore, Owings & Merrill's Kitt Peak Observatory in Arizona (1963), which was remade in stainless steel after it was sold to a collector.

In a rare conversation with Ulrich Loock, the curator of the survey of Grosvenor's work at the Museu Serralves in Porto, the notoriously reticent sculptor confessed that at the time of *Primary Structures* he felt that there was mutual disconnect between his work and that of the minimalists:

I don't believe they took my work seriously. And I found theirs rather distant but I respected it. It took me a long time to really understand it or to get to love it.[5]

However, at least one artist who, while not in the minimalist camp himself, was sympathetic to their ideas, also took a serious interest in Grosvenor's work. In his 1966 *Artforum* article "Entropy and the New Monument," the land artist Robert Smithson compares the ideas of the Park Place artists with

4 See Bruce Altshuler, "Theory on the Floor," chap. 12 in *The Avant-Garde in Exhibition: New Art in the 20th Century* (New York: Harry N. Abrams, 1994).

5 *Robert Grosvenor* (Porto: Museu Serralves, 2005), p. 50.

R. Buckminster Fuller's notion of a fourth dimension, which Smithson referred to as "ha-ha" (the entropic verbalization of laughter) and the topsy-turvy world of Lewis Carroll's *Alice in Wonderland*:

How could artists translate this verbal entropy, that is "ha-ha" into "solid-models"? Some of the Park Place artists seem to be researching this "curious" condition . . . we must not think of Laughter as a laughing matter, but rather as the "matter-of-laughs" . . . The "grin without a cat" indicates "laugh-matter and/or anti-matter," not to mention something approaching a solid giddiness.[6]

Smithson praised the group's "new kind of insight" in regard to other dimensions, alongside Duchamp and Judd:

Charles Peirce (1839–1914), the American philosopher, speaks of "graphs" that would "put before us moving pictures of thought" . . . This synthetic math is reflected in Duchamp's "measured" pieces of fallen threads, "Three Standard Stoppages," Judd's sequential structured surfaces, Valledor's "fourth dimensional" color vectors, Grosvenor's hypervolumes in hyperspace, and di Suvero's demolitions of space-time. These artists face the possibility of other dimensions, with a new kind of sight.[7]

In 1972 Grosvenor began to work with massive solid wood beams, which he would carefully break and either display in two parts or put back together by bracing the pieces invisibly with steel underneath the beam. As Joseph Mashek points out, these fractured beams relate to Smithson's entropic ideas: "Smithson, in *Partially Buried Woodshed*, stopped when the roof beam broke . . . Grosvenors works begin with the fracture of the beam."[8] Grosvenor himself explains the origin of those

6 In *The Writings of Robert Smithson*, ed. Nancy Holt (New York: New York University Press, 1979), pp. 17–18.
7 Ibid., p. 18.
8 Joseph Mascheck, "Robert Grosvenor's Fractured Beams," *Artforum* (May 1974): 37.

works, much more pragmatically, to his practice of drawing with tape:

I was moving a lot of tape around in my drawings and slightly changing the direction of the tapes. Masking tape has a way of tearing or breaking that suggested this could be done with a wood beam. In this particular piece there is a break, a saw cut and a break.[9]

Grosvenor clearly has a stronger alliance to sculptors who, like him, surprise the viewer with whimsical material intelligence and who do not fit neatly into a style or artistic label, such as the California sculptor and jewelry designer Claire Falkenstein and the European-trained modernist Richard Stankiewicz.

But it is the sparse works created since the 1990s that have proven him to be one of the most intriguing American artists working today. Grosvenor's work is his relentless pursuit of contradictions and paradoxes. While his early sculptures deal primarily with gravity and tension within given architectural structures, his newer installations, assimilating influences from art history, everyday life, and commercial design, bring his work closer to the Las Vegas–influenced postmodernism of Robert Venturi. A certain material giddiness is still evident in Grosvenor's recent sculptural installations, combined now with a felicitously roguish wit that performs its semantic magic in the artist's characteristically reticent fashion. In addition, each of Grosvenor's sculptural installations done since the 1990s is in itself an autonomous creation, making little or no references to his previous work. This precludes considering his production in terms of a body of work.

What makes Grosvenor's work in any notable way or degree more American than others? To answer this question,

9 *Robert Grosvenor*, p. 62.

it may be helpful to examine his work in the context of the distinct American philosophical tradition known as pragmatism. Founded in the late nineteenth century by the American mathematician, philosopher, and logician Charles Sanders Peirce, who is considered the father of semiotics as a critical theory of representation and interpretation, pragmatism holds that both the meaning and the truth of any idea is a function of its practical outcome. Fundamental to pragmatism is the conviction that all principles are to be regarded as working hypotheses rather than as metaphysical truths. Pragmatism was highly influential in America in the first quarter of the twentieth century. Peirce developed it as a theory of meaning in the 1870s, asserting that an intrinsic connection exists between meaning and action — that the meaning of an idea is to be found in its "conceivable sensible effects" and that humans generate belief through their "habits of action." Peirce's pragmatism was closely connected to his theory of "abduction," which explained scientific and artistic innovation as the outcome of creative processes — an intuitive "fuzzy" logic of discovery unimpeded by rules:

The abductive suggestion comes to us like a flash. It is an act of *insight,* although of extreme fallible insight. It is true that the different elements of the hypothesis were in our minds before; but it is the idea of putting together what we had never before dreamed of putting together which flashes the new suggestion before our contemplation.[10]

I regard this intuitive "magical" logic of discovery as the fundamentally American spirit in scientific and artistic innovation, quite distinct from the European concept of *bricolage.*[11]

10 *The Essential Peirce: Selected Philosophical Writings,* vol. 2, ed. The Peirce Edition Project (Bloomington, Ind.: Indiana University Press, 1998), p. 227.
11 See also N. R. Hanson, *Patterns of Discovery: An Inquiry into the Conceptual Foundations of Science* (London: Cambridge University Press, 1958).

In bricolage, which Claude Lévi-Strauss first applied to define "primitive" science, the universe of the bricoleur or artist is closed and the rules of his game are always to make do with *whatever is at hand*, that is to say with a set of tools and materials that is always finite. Unlike the surrealists who were essentially engaged in bricolage and abandoned all logic, Peirce insisted that abduction, though little hampered by logical rules, nevertheless constitutes logical inference — a letting go of logic within logic. Peirce's abductive thinking is the ontological equivalent of the semantic trickery or magic that is in play in Grosvenor's works.

Grosvenor's *Untitled* (1997) consists of rough-hewn boulders embedded in concrete, evocative of suburban garden walls. On the left side, two glass spheres — one blue, the other green and each resembling a bowling ball — are propped on top of the wall. On the right, a large antennalike structure made of steel rods rests on its side. However, the artist's works are not intended to glorify or make fun of suburban culture. In fact, *Untitled* (1997) was partially inspired by a wall Grosvenor saw in Aruba. The wall was newly built but made to look like time had caused part of it to sink:

The slumped part of the wall. It was so curious. Sometimes in New England this happens over a period of time but here I could see that it was built in. That was my starting point.[12]

Untitled (1999) features two distinct elements: a central, 16-foot-long piece of sheet metal with sharply cut edges that appears to float several inches above the floor. It is spray painted with red, yellow, and orange enamel. Two silver plastic spheres sit symmetrically on top of the sheet metal, attached to thin, crisscrossed poles. The second element, composed of a pair of coral rock cairns dipped in red paint, marks the space some distance away at each side of the central sculpture.

12 *Robert Grosvenor*, p. 106.

Grosvenor's most recent sculpture, *Albatrun* (2002), is a large, flat, vertical leaflike shaped sculpture, punctured with two symmetrical holes, that stands upright on a large base. It is accompanied, at some distance, by a set of steel rods. While more contemplative than his preceding works, it is no less obfuscating. *Albatrun* is Grosvenor's most "classically modern" sculpture and seems indebted to Brancusi's formal compositions, an influence that can be traced back to works made as early as the mid-1980s, such as *Untitled* (1986–87), which consists of a "base" of cinder blocks resting on a blue tarp roofed over with corrugated steel standing on four rusted metal disks. Despite their quirkiness and the artist's unusual choice of materials, Grosvenor's sculptures since that time evoke Brancusi's "four-sidedness": they do not have a distinct front or back, rather all four sides are designated equally.

In his installations, Grosvenor creates a space that is in-between — neither recognizable nor unknown, neither familiar nor strange — not unlike the ever-sprawling suburban spaces between cities and the countryside. At first, his sculptures, objects, and arrangements do not quite add up. They are vaguely identifiable, yet nothing is quite right. Grosvenor's labored arrangements are not assembled from found ready-mades — most of the elements are fabricated by the artist, and while the odd familiarity of his objects and structures is clearly intentional, they are always modified, stylized, or "upgraded" to a different logical position. This temporary abduction or suspension of logic enables the artist to create a cognitive space of anomaly, near familiarity, and surprise. Accompanied by *some* kind of explanatory meaning, it is then refitted into an organized conceptual pattern, thus creating something new each time, as if for the first time.

An examination of Grosvenor's color snapshots, which he takes as visual notes and sometimes find their way into his collaged drawings, may shed more light on his working process and his sources of inspiration. While his sculptures clearly play hard to get, they are not without visual clues.

Untitled (1999) actually incorporates a stylized Chinese ideogram, similar to the ones seen in Grosvenor's photograph of red Chinese neon lettering above a roadside restaurant, a photograph that could have been taken anywhere. As Grosvenor mentioned to me in a note accompanying this photograph, "often ideograms appear in Chinese newspapers ... colored in red to orange to yellow manner by computer." The notion of digitized and stylized ideograms as symbols for poetic ideas recalls Ezra Pound's belief in the communicative superiority of Chinese ideograms, which was based on the theories of the American orientalist Ernest Fenollosa, whose study *The Chinese Written Character as a Medium for Poetry* was edited by Pound and published in 1920. Pound regarded images as "an intellectual and emotional *complex* in an instant of time ... which gives the sense of sudden liberation; that sense of freedom from time limits and space limits; that sense of sudden growth, which we experience in the greatest works of art."[13]

Perhaps Grosvenor's casual reference to ideograms carries more weight than he may realize. The theory (which Pound and Fenollosa followed) is that Chinese ideograms represent a stylized picture derived from actual historical experiences. Pound's idea of a poetry of "direct treatment," of presentation over description, experience over literacy, corresponds to Grosvenor's technique of sensuous immediacy. Reading Grosvenor's arrangements as ideograms that can only be experienced imagistically, his works may be understood, in their own idiosyncratic place, as abstracted archetypes of the American vernacular subconsciousness.

13 "A Retrospect," in *Literary Essays of Ezra Pound*, ed. T.S. Eliot (New York: New Directions, 1968), pp. 3–14.

PAINTING HEADS

Firstly, then, I perceived that I had a head, hands, feet and other members composing that body which I considered as part, or perhaps even as the whole, of myself. I perceived further, that that body was placed among many others, by which it was capable of being affected in diverse ways, both beneficial and hurtful; and what was beneficial I remarked by a certain sensation of pleasure, and what was hurtful by a sensation of pain . . . And although I may, or rather, as I will shortly say, although I certainly do possess a body with which I am very closely conjoined; nevertheless, because, on the one hand, I have a clear and distinct idea of myself, in as far as I am only a thinking and unextended thing, and as, on the other hand, I possess a distinct idea of body, in as far as it is only an extended and unthinking thing, it is certain that I (that is, my mind, by which I am what I am), is entirely and truly distinct from my body, and may exist without it.
— René Descartes, 1641

The Cartesian body/mind split as a schizophrenic condition was first described by the German judge Daniel Paul Schreber who began psychiatric treatment in 1884 and whose published account of his own illness was later used by Sigmund Freud in his *Psycho-Analytical Notes Upon an Autobiographical Case on Paranoia.* Schreber suffered from a distorted body image that made him believe, among other things, that his stomach and his intestines had disappeared. Later, Félix Guattari and Gilles Deleuze, in their critique of capitalism, *Anti-Oedipus,* speculated that the schizophrenic "body without organs" may be a product of capitalism.

The schizophrenic "body without organs" has a parallel in art history in the changes that emerged in the pictorial order at the beginning of the Renaissance. The pre-Renaissance Italo-Byzantine paintings of Duccio di Buoninsegna surpassed

This essay originally appeared in *Tony Bevan,* exhibition catalog (Valencia: IVAM, 2005).

Byzantine art in their illusionism and naturalism and were characterized by delicacy and fluidity of form. Duccio's overall compositions were visual dialogues between representation and void, figure and space, solid and fluid; between form — the silhouettes of the figures in the "foreground" — and formlessness: the shimmering gold plane, which the modern viewer perceives as the "background." Renaissance painting relegated the "formless" gold plane of Trecento painting to a background understood as secondary, and ultimately replaced the intuitive "lived" perspective of Trecento painting with invented landscapes constructed in linear *perspectiva artificialis*, devised by the architect Filippo Brunelleschi and first applied by the painter Masaccio.

But as the art historian Henri Focillon reminds us," the space of art is a plastic and changing material. We may find it difficult to admit this, so completely are we influenced by the rules of Albertian perspective. But many other perspectives exist as well."[1] The perspective of Renaissance art, in other words, is only one of an infinite number of symbolic constructions.

Consequently, beginning with Cézanne, modern art is filled with confusions of pictorial orders. According to Maurice Merleau-Ponty, the influential phenomenologist, Cézanne was the first to rediscover the "lived perspective" of pre-Renaissance art:

By remaining faithful to the phenomena in his investigations of perspective, Cézanne discovered what recent psychologists have come to formulate: the lived perspective, that which we actually perceive, is not a geometric or photographic one.[2]

1 Henri Focillon, *The Life of Forms in Art*, trans. George Kubler (New York: Zone Books, 1992), p. 69.
2 Maurice Merleau-Ponty, "Cézanne's Doubt," in *The Merleau-Ponty Aesthetics Reader: Philosophy and Painting*, ed. Galen A. Johnson (Evanston, Ill.: Northwestern University Press, 1993), p. 64.

Tony Bevan's "figurative" paintings share with Cézanne an "abstract" fascination with particularities, which finds its expression in the titles of his works — giving prominence to seemingly secondary elements of the composition, such as "Black Chair," "Exposed Arm," or simply "Horizon" — thus replacing one pictorial order with another.

Using his own body as a model, Bevan has been painting "exposed" structural portraits, not unlike Leonardo da Vinci's "mechanical" anatomical drawings, which oscillate between natural and abstract representation and not only endowed Leonardo's anatomical drawings from dissected corpses with an unprecedented living quality but reconstructed his "objects" in such a way as to manifest thereby the rules of their (physiological) functioning. Leonardo's *figura istrumentale dell' uomo* (man's instrumental figure) is reflected in both Bevan's paintings of heads, as well as his architectural studies of rafters and studio tableaus.

Tony Bevan is sometimes associated with a tradition of British figurative painting that begun in the 1940s with Francis Bacon and Lucian Freud. Now commonly known as the School of London (named so by R.B. Kitaj in 1976), it has been applied to painters as distinct as Frank Auerbach, Leon Kossoff, David Hockney, Jenny Saville, and Peter Doig.

But Bevan has little more in common with this group than an interest in the human body. He is a peculiarly singular figure amid that honorable tradition of British painting. Unlike his peers, Bevan paints himself almost exclusively; and most frequently, and rather persistently, his own head is the preferred subject.

But it is not a simple head, not the head we encounter on the figure of the modest man who greets visitors to his studio, nor the gentle face he himself sees in the mirror shaving each morning. Bevan's paintings feature the distorted facial features recorded in photographic studies he takes of himself, usually close-up shots taken from odd angles that overemphasize his nostrils or accentuate his neck and chin. Mainly, Bevan's heads are heads without bodies; heads balanced on abstract imagi-

nary horizon lines, sometimes leaning tenderly to one side, occasionally supported by ladders or other props.

Furthermore, Bevan does not paint faces. A face is an exterior structure, much like the facade of a building. Like Bevan's paintings of deconstructed roof spaces and, most recently, of stacked studio furniture and tableaus of aggregate objects in his studio, his heads are internal, architectural structures. Increasingly, the black or red scarlike lines that appear in his earlier self-portraits and reappear in his later architectural paintings as rafters have been moved inside his head. The most recent heads not only seem to incorporate the organic architecture of his body, but they appear to be completely autonomous, unlike Marc Quinn's remarkable frozen head, which is cast in several pints of his own blood and depends on an elaborate cooling system. More reminiscent of Kiki Smith, whose works seem to unite body and mind into one visceral structure, Bevan seems to have relocated his body inside his head. Some of his heads even resemble organs, particularly hearts.

In Thomas Mann's novel *The Magic Mountain*, which takes place at a lung sanatorium in Switzerland, patients converse through and with their deceased organs. In one episode, Mann describes a young woman who has learned to whistle with her pneumothorax from within a small incision on one side of her chest, which the doctors keep filled with nitrogen gas, a common procedure to relieve the ailing half of a lung:

They have formed a group, for of course a thing like the pneumo-thorax brings people together. They call themselves the Half-Lung Club; everybody knows them by that name. And Hermine Kleefeld is the pride of the club, because she can whistle with hers. Its a special gift, by no means everybody can do it. I can't tell you how it is done, and she herself can't exactly describe it. But when she has been walking rather fast, she can make it whistle . . . Also, I believe she uses up nitrogen when she does it, for she has to be refilled once a week.[3]

3 Thomas Mann, *The Magic Mountain*, trans. H.T. Lowe-Porter (New York: Vintage, 1969), pp. 50–51.

Another peculiarity of Bevan's art is the fact that he executes his paintings and drawings American style — on the floor, like Jackson Pollock, Larry Poons, or, more recently, Toba Khedoori. Bevan literally works inside his works, leaving traces of his knees and hands visible on the canvas or paper: "I need that physical contact with the painting. I'm actually in the painting. They are almost like body prints."[4] In another twist of the rules of traditional painting, Bevan confuses the symbolic order between the painted body and the body of the painter.

The performative character of this process is underscored by his excessive and forceful use of charcoal. Using various types and thicknesses and applying considerable pressure, he creates drawings and paintings that are strikingly sensual and tactile, material and physical. They are layered and constructed like an architectural object, with the lines having an almost three-dimensional presence: "I call that the debris in the making. The charcoal gets locked into that. There is no mystery [as to] how the material got in there. The process, the debris, is important to me." Bevan sees himself like an alchemist transforming pigment and charcoal into form.

Unlike Khedoori's architectural drawings, which also often feature her footprints in the white, unused areas, Bevan's paintings are much less calculated and controlled, closer to Richard Serra's "sculptural" drawings that are covered with thick layers of oil crayons.

Bevan grinds his own pigments and carefully considers their different weights and properties. He uses charcoal made from willow, poplar, or vine, each possessing a unique softness and "color." He devised a "canvas-folding" technique, which creates ghostly impressions from the charcoal and lends his drawings and paintings their characteristic transparency. Bevan translates the physical connection be-

4 All quotations by the artist are from a conversation with the author that took place in the artist's studio in Deptford on April 11, 2005.

tween interior and exterior space, which he has captured in his paintings of roof rafters in open spaces, into the process of painting itself: the threshold between pigment, charcoal, and empty canvas.

Cutting the bristles of his paint brushes extremely short, he is practically painting with the equivalent of a wooden stick. His frantic working method sometimes causes the pigments to spill over and charcoal to fracture. This messiness and unpredictability serves to emphasize the materiality of his works: "That physical quality is important to me . . . It's almost like looking at a bright sunlit room, when you see all the dust."

But even the most "nonfigurative" paintings, such as his architectural studies and the studio "still lifes" (the "things around me"), whose energetic execution belies their stillness, are, for Bevan, not without a human dimension: "For me they still have a human connection." Just as the lines of red pigment and black charcoal on the bodies and faces of his portraits can be read as architectural structures, so the red or black rafters and outlines of studio objects and furniture can be seen as scars or arteries carrying life-supporting blood.

The materiality of the pigments and charcoal in Bevan's painted lines bestows upon his works a self-revelatory quality that does not depend on outside references. It brings to mind the notion of "Firstness" of Charles Sanders Peirce, the American nineteenth-century philosopher who, with the French linguist Ferdinand de Saussure, was one of the fathers of semiotics. According to Peirce, there exists a logical category he named Firstness, which possesses an immediate, absolute quality that is independent of any other (any "Secondness"):

Firstness is that which is such as it is positively and regardless of anything else . . . For an example of Firstness, look at anything red. That redness is

positively what it is . . . it is absolute . . . We not only have an immediate acquaintance with Firstness in the qualities of feelings and sensations, but we attribute it to outward things.[5]

Bevan's particular process of working with pigment and charcoal also evokes Oriental ink painting, which is infused by the artist's own inner energy through the varying of speed and pressure of the brush. For the Oriental painter everything within this world has a spirit within itself, which in Chinese and Japanese painting is called "bone-structure,"[6] revealed only after years of close observation and by eliminating all Secondness, any subordinate elements and external factors.

In like manner, Bevan concentrates on exposing spiritual force or bone structure of his subjects. Bevan's self-portraits and studio tableaus possess a first order of presentness and intensity that transcends the schizophrenic split of the external world of objects and the internal world of the mind.

5 *The Essential Peirce: Selected Philosophical Writings*, vol. 2, ed. The Peirce Edition Project (Bloomington, Ind.: Indiana University Press, 1998), pp. 267–70.
6 See Toshihiko Izutsu, "The Elimination of Color in Far Eastern Art and Philosophy," in *Color Symbolism: The Eranos Lectures*, ed. Klaus Ottmann (Putnam, Conn.: Spring Publications, 2005).

EXHIBITION REVIEWS

WAKE UP, KYNASTON MCSHINE!

An International Survey of Recent Painting and Sculpture
The Museum of Modern Art, New York

There are many unimportant works by important artists and many works by unimportant artists in this exhibition: internationalism takes precedence over quality.

Some paintings (Rainer Fetting's *Selbstportrait als Indianer,* Helmut Middendorf's *Schwebender rot,* and Jiri Georg Dokoupil's *Geburtstag des gefangenen Fachmanns*) had a long way to go to get to MOMA — from West Germany, where they are part of the Metzger Collection, through Budapest, where they were exhibited earlier this year. Georg Baselitz's *Brückechor* had already been shown this May in the new Mary Boone/Michael Werner Gallery. Although it has been disassociated from the context of the Easter Passion in which it was originally presented, it remains one of the stronger works of this exhibition.

There is a unique insensitivity in the way the artworks are positioned so that the whole lacks visual continuity. Whereas the Berlin painters Fetting, Middendorf, and Salomé find themselves in one room together with Jean-Michel Basquiat and Bruce McLean, Karl Horst Hödicke's *Kusamba II* is far removed from his Berlin colleagues, surrounded by Robert Zakanitch's *Midnight Mornings of Glory* and zoological bird drawings by Elizabeth Butterworth.

Bernd Zimmer's *Brennende Fabrik* is hidden between Armando and Katherine Porter in yet another room.

The four paintings by Lüpertz from his "Alice in Wonderland" series are placed opposite the paintings of the Italian neoclassicist Carlo Maria Mariani on the ground floor

This review originally appeared in *Flash Art* 118 (Summer 1984).

whereas his colleagues Baselitz, Jörg Immendorff, and A.R. Penck are found on the lower level.

All the works representing the Berlin group, which once initiated the revival of painting, are, with the exception of Hödicke, of minor importance. There is none of Fetting's van Gogh's nor any of his shower paintings. Neither are there any of Zimmer's large cow heads or mountain paintings. Salomé's *Oscar Wilde Letter*, an early work from 1979, is certainly not one of his stronger works. This is disappointing particularly when one recalls his contribution to the *Zeitgeist* exhibition, and it is all the more unintelligible because both Fetting and Salomé live and work in New York with studios only minutes away from the museum. The Italians did not fare much better. Enzo Cucchi is represented solely by a large charcoal drawing, *Disegno Tonto*, and Francesco Clemente's *Priapea* from 1980 does not show this artist at his best either.

Furthermore, this show is characterized by absence. There is only one example of graffiti art (Basquiat). Keith Haring, James Brown, Donald Baechler, and Rammelzee are missing. Among the young French artists only Jean Charles Blais is included. Hervé di Rosa, Robert Combas, and Remy Blanchard are missing, as well as the most important young Austrian painter, Siegfried Anzinger. Although this exhibition claims to be a survey of recent painting and sculpture, there are no sculptures by Baselitz, Lüpertz, Immendorf, or Cucchi. There are only a few strong paintings in the show, among them Blinky Palermo's *Times of the Day I* (1974–75), Elizabeth Murray's *Sail Baby* (1983), Sigmar Polke's *Can You Always Believe Your Eyes?* (1976), Julian Schnabel's *Prehistory: Glory, Honor, Privilege and Poverty*, painted on pony hide with mounted antlers, which evokes the primitive power of Jackson Pollock, and Susan Rothenberg's horse painting *Pontiac* from 1979.

Sandro Chia's large painting of a sleeping shepherd in a war camp, *Malinconico Accampamento* (1982), placed at the entrance of the exhibition like an emblem, can be read as a metaphor for the whole exhibition: a sleepy show at MOMA.

The most exciting event at the opening was not the survey show but the never-before-exhibited sculpture of a bull. Made in 1958 by Pablo Picasso out of wood, nails, screws, and tree branches, it was given to MOMA by Jacqueline Picasso and can be seen on the new second floor of the museum.

FRANCIS BACON
Marlborough, New York

Oedipus:
 Ah! Unfortunate me! Where to am I carried, suffering me?
 Where is my voice bringing me?
 O! Demon! Where are you ravishing?
Chorus:
 To a powerful place, unheard, unseen.
— Hölderlin, 1803

Oedipus and the Sphinx: He who unlocks the riddle of the sphinx, the enemy of the state order and therewith unlocks the door to the blackness of the unconsciousness, — the realm of the repelled guarded by the sphinx — does not know that he kills part of himself for the sake of civilization, The wound on his foot is the wound he inflicted on the sphinx.

The blackness to which she returns is the same place to which Joyce's *Ulysses* leads: the black dot. It is the answer to the final question in the book, "Where?," the place of the unspeakable — *Finnegan's Wake*, the dark side of Odysseus, who is another hero of civilization.

It is also the place of the powers of the netherworld, of the matriarchal blood law, permanent threat to the logic of the patriarchal state. Their domestication is the foundation of the new Hellenistic law, which proceeds with the discharge of the matriarchate, as told in the *Oresteia* of Aeschylus.

In Bacon's *Triptych Inspired by the Oresteia of Aeschylus*, the two opposing powers are placed on the outer panels: the old matriarchal order, represented by the wounded sphinx, and the patriarchal claim, represented by the matricide Orest. The deceptive conciliation between the two, attained

This review originally appeared in *Flash Art* 119 (November 1984).

by the motherless-born goddess Athene by way of applying the new ability of (male) *discourse* to persuade the Furies to give away their right of vengeance to the state and take a place in a (powerless) state religion, is embodied in the center figure of the triptych: an amputated crossbreed that bears in itself the powers of the netherworld that are repelled into the forgotten depth of the unconsciousness only to return in the disorder of the dream, in the fantasies of madness, and in the language of hysteria.

JAMES VAN DER ZEE
Sharpe, New York

They calls me yellow
like yellow be my name
But if yellow is a name
Why ain't black the same
— Alice Walker, 1982

For almost a century, James Van Der Zee was the photographer of Harlem's middle-class African-American life. From the age of fourteen (in 1900) until his death at the age of ninety-seven, Van Der Zee produced more than 75,000 photographs of American negritude.

The black life depicted in these photographs — bridal couples, ballet classes, funerals, and portraits of celebrities and ordinary people — is not the black life that we see in the streets and welfare hotels of New York. Van Der Zee was a photographer of the African-American bourgeoisie, with its pride and beauty, its dreams and desires. He preferred the trompe-l'oeil backdrop to the streets of Harlem; the retouch to the realist portraiture. In his photographs, Van Der Zee superimposed a shade of purple on the color black.

This review originally appeared in *Flash Art 136* (October 1987).

EUROPE/EUROPE
documenta 8, Kassel

We pose the question: How is the spiritual shape of Europe to be charac-
terized? Thus we refer to Europe not as it is understood geographically, as
on a map, as if thereby the group of people who live together in this ter-
ritory would define European humanity. In the spiritual sense the English
Dominions, the United States, etc., clearly belong to Europe, whereas the
Eskimos or Indians presented as curiosities at fairs, or the Gypsies, who
constantly wander about Europe, do not. Here the title "Europe" clearly
refers to the unity of a spiritual life, activity, creativity, with all its ends,
interests, cares, and endeavors, with its products of purposeful activity,
institutions, organizations.
—Edmund Husserl, 1935

For more than a century the question of the spiritual state of our time has
been asked more and more pressingly; every generation has had its own
answers. It had been earlier a meditation of the few who felt our spiritual
world threatened; since the war it has become the question of many . . .
Man's nature is not only to be but to know that he is. Self-confidently he
explores his world and changes it according to his plans . . . Man is spirit,
the state of man proper is his spiritual state. An illumination of this state
as the current state of affairs will ask: How has this state been seen until
now? How has today's state come about? What does state mean at all? In
which aspects does it show itself? How is the question of humanity being
answered today? Which future are we heading for?
— Karl Jaspers, 1931

In Kassel, Europe is meeting Europe. Alluding to last year's
inaugural exhibition of the Ludwig Museum in Cologne
EUROPA/AMERIKA, *documenta 8* should have been subtitled
EUROPE/EUROPE. While the reversal of enlightenment into
myth on this side of the continent continues and American
art excels in self-reference and conformism, this *documenta*

This review originally appeared in *Flash Art* 136 (October 1987).

raises a fundamental European question, the question of the spiritual state of our time.

The discourse on consumerism and simulative media society is being articulated more cogently by Europeans like Ange Lecchia and Hans Haake than by their American counterparts. Lecchia, with his immaculate, blue Mercedes 300 CE, not only pulls up the pants of Haim Stainbach's adolescent consumer art but also refers to a human quality within or beyond the mere consumerist bricolage. In a similar manner, Haake, at a time when it has become unfashionable to assume an anticapitalist and antifascist position, manages to re-introduce into art a notion of integrity Jeff Koons would not even dream of.

Anselm Kiefer's monstrous canvases depicting the new gods of our age, the nuclear rod and the microchip, warn us (less pathetically than Beuys's *Blitzschlag*) of the threat to our spiritual world. His leaden books are like the tablets of Moses thrown down from Mount Sinai.

Olaf Metzel's egg boxes, poured in concrete, are bestowed with a painful, existential weight that becomes more intensified by their dull repetitiousness. Eberhard Boßlet's *Anmaßend* (Presumptuous), two constructions of found desks and building materials installed in the staircases of the Museum Fridericianum, unduly claim space (like so much of the art exhibited here) outside the conventional exhibition area and are presumptuous in title as well as, spanning from floor to ceiling, in dimension (to fit the space) and function (to support the building).

Albert Hien's fat, phallic *Wurstmaschine*, evocative of the German economic miracle, wriggles in pain and ecstasy like the dragon in Uccelo's *San Giorgio e il Drago* under the spear of the saint.

Rob Scholte's universe is composed, like Borges's Library, of an indefinite and perhaps infinite number of picture

galleries and raises questions of philosophical dimension. With Borges's narrator, he suggests but one solution:

The Library is unlimited and cyclical. If an eternal traveler were to cross it in any direction, after centuries he would see that the same volumes were repeated in the same disorder (which, thus repeated, would be an order: the Order).[1]

Hans Hollein's museum proposal, which reverses the order of representation of art with the exhibition label taking the place of the artwork, refers to a postmodern trend in which the gallery is replaced by the magazine; the art critic/curator, by the collector; and the artist, by the consumer.

1 Jorge Luis Borges, *Labyrinths: Selected Stories & Other Writings*, trans. James E. Irby (New York: Modern Library, 1983), p. 58 .

MODERN SLEEP
American Fine Arts, New York

We have killed the Modernist Father and we've entered (secretly, secretly, by the back door) the bourgeois home.
— Vito Acconci

Now that we have killed the modernist father and are taking refuge in the pleasures of suburban decor, Collins and Milazzo confront us with the Heideggerian silence of our (their) conscience or the Absolute Spectacle, celebrating the Hegelian murder of meaning.

Modern Sleep is itself less neo-/postmodern psychosis than the empty dream of the Sleeping Beauty on the bourgeois Freudian couch: Does modernism dream of Saint Clair Cemin, John Dogg, Ti Shan Hsu, Kevin Larmon, Jonathan Lasker, Annette Lemieux, Oliver Mosset, Joel Otterson, and Jeffrey Plate or do they dream of modernism? Should we guess who will be the prince to awaken the modern dream or should we ask, "Who is John Dogg?"

This review originally appeared in *Flash Art* 133 (April 1987).

JENNIFER BOLANDE/MOIRA DRYER/ANNETTE LEMIEUX
Lawrence Oliver, Philadelphia

While New York is still celebrating "boy-art" this year with retrospectives of David Salle and Julian Schnabel at the Whitney, a new generation of women artists is emerging who not only give a postconceptual and postfeminist commentary on the dialectic of art and mass media in the late 1989s, but are endowed with a new "feminine" sensibility and sensuality.

Among them are Jennifer Bolande, Moira Dryer, and Annette Lemieux, three of the youngest and currently, among critics, most talked about women artists, united here for the first time.

Unlike the older generation of artists, such as Julian Schnabel or Peter Halley, who approach history in a "male" gesture of subjugation within a still modernist frame, the works of these three women are characterized by cooperation rather than domination of time (Lemieux), by a radical redefinition of photography, even if the medium of photography is not used (Bolande), and by the emphasis on tactility of color and sound (Dryer).

Their attitude is comic rather than tragic; their work, multifaceted (mixing sculpture with painting or photography) rather than single-keyed. In the hands of Jennifer Bolande, Moira Dryer, and Annette Lemieux, art becomes a felicitous affair.

This review originally appeared in *Flash Art* 133 (April 1987).

VITO ACCONCI
International With Monument, New York

In contrast to Marxist orthodoxy I see the political potential of art in art itself, in the aesthetic form as such which is largely autonomous vis-à-vis the social relations. Art protests against these relations by transcending them.
— Herbert Marcuse, 1977

In the summer of 1787 Goethe wrote in a letter from Italy: "After what I have seen of plants and fishes at Naples and in Sicily I should be tempted, if I were ten years younger, to make a journey to India, not in order to discover something new, but to observe, in my own way, what has already been discovered."[1]

In his recent work, Vito Acconci makes such journeys, not to do something new but to look in his own way at what has already been done. The way he looks at things changes them forever: the modernist garden, the conceptual playground, postmodern leisure.

There are Freudian allusions to the interpretation of dreams and to femininity: "Ladies and gentlemen . . . People have pondered over the riddle of femininity for all time. . . Nor will you have escaped this pondering, inasmuch as you are men; it is not expected from the women among you, they are themselves the riddle."[2]

This review originally appeared in *Flash Art* 134 (May 1987).

1 In Rudolf Steiner, *Goethe's Conception of the World*, trans. H. Collison (London: Anthroposophical Publishing Co., 1928), p. 85.

2 Sigmund Freud, "Neue Folge der Vorlesungen zur Einführung in die Psychoanalyse, XXXIII. Vorlesung: Die Weiblichkeit," in *Gesammelte Werke*, vol. 15 (Frankfurt am Main: S. Fischer Verlag, 1979), p. 120 (my translation).

Then there are questions. What is nature? What is art? What is human? What is inhuman? Acconci once quoted Godard's statement (from La *Chinoise*): "Vague ideas in clear images." He delivers clear signs but, at the same time, deconstructs their meaning, replacing tragedy with comedy, art with nature, masculinity with femininity.

PETER HALLEY
Sonnabend, New York

"The Eternal Return." This is the most extreme form of nihilism: the eternal nothing ("meaninglessness").
— Friedrich Nietzsche, 1887

In this show of new paintings by Peter Halley, the artist appears as an adherent of the "Eternal Return of the Same." Just as Nietzsche's philosophy shows itself twofold, as affirmation and nihilism, so Halley's new paintings are new only insofar as they are readily available for the new gallery and its demands for sameness, while, at the same time, these paintings will go down in history as nothing.

This review originally appeared in *Flash Art* 138 (January–February 1988).

TONY TASSET/JAMES WELLING
Feature, Chicago

An anecdote told to every visitor to Frank Lloyd Wright's home and studio in Oak Park, Illinois, credits his architectural creativity to his childhood play with Froebel blocks given to him by his mother.

Tony Tasset's newest work that looks refreshingly unlike his previous Artschwageriana, reminds the onlooker of Froebel blocks and creates an aura of kindergarten innocence. These large cases containing painted wooden blocks, which allude in rather unserious manner to Sol LeWitt and Jennifer Bartlett, match James Welling's new polaroid photographs of silk draperies in their focus on the emptiness of display. Just as these works hint at a possible end of the current commodity discourse in art, so they also refer to the absence of art, suggesting perhaps the anticipation of the new in which both artists will most likely play an instrumental part.

This review originally appeared in *Flash Art* 141 (Summer 1988).

ANSELM KIEFER
The Museum of Modern Art, New York

More than four decades after the vast energy of the atom was unleashed on Japan, federal health investigators are preparing to search the high plains of eastern Washington State for American victims of the atomic bomb.

Thousands of people who live along the western boundaries of the Hanford Reservation, which made the plutonium for the bomb that destroyed Nagasaki, say that radioactive emissions from the plant over the years have caused an unusual number of rare cancers, miscarriages and other health problems.
— *The New York Times*, October 17, 1988

Government officials overseeing a nuclear power plant in Ohio knew for decades that they were releasing thousands of tons of radioactive uranium waste into the environment, exposing thousands of workers and residents in the region, a Congressional panel said today.

The Government decided not to spend the money to clean up three major sources of contamination, department officials said at a House Energy and Commerce subcommittee hearing. Runoff from the plant carried tons of the waste into the underground water supplies, drinking water wells in the area and the Great Miami River; leaky pits at the plant, storing waste water containing uranium emissions and other radioactive materials, leaked into the water supplies, and the plant emitted radioactive particles into the air.
— *The New York Times*, October 15, 1988

In the next 40 or 50 years the greenhouse gases in the atmosphere will double and the world will get warmer by between 1 and 4.5°C. Sea levels will rise by between 20 and 140 centimeters (unless the West Antarctic ice sheet becomes even more unstable, breaks off, floats north and melts, in which case the sea level will rise by 20 feet, but that's not thought likely). Even so, a rise in sea level of a meter will cause suffering, loss of life and severe economic damage in the deltas of the Nile, the Ganges, the

This review originally appeared in *Flash Art* 144 (January–February 1989).

Mekong, the Yangtse and the Mississippi. The Maldives will disappear. So will a lot of other coral islands . . . An extra one degree would make the world warmer than it had ever been for 120,000 years. A change of four degrees would represent the difference between now and the depths of the last Ice Age . . . If the mean temperature rises beyond 16° C wheat loses grain weight and yield drops; if it goes beyond 22° C rice will become sterile; the sexual capacity of trees will be affected . . . There are other, associated problems. One of them is acid rain. Sulphur dioxide and nitrous oxides are also being pumped into the atmosphere, dissolving in rain to form weak acids. Trees — indeed whole forests — are dying. Lakes becoming sterile. Cadmium is beginning to "migrate" into groundwater. Soil is becoming acidified to depths of 10 meters. The chlorofluorocarbons and other gases have stripped the ozone layer in the northern hemisphere by three percent. It could damage human immune systems, increase the incidences of skin cancer and exact unknown damage on plant and animal life.
— *The Manchester Guardian Weekly,* July 17, 1988

Chlorine. Phenol. Chromium. The icy love between the city and the river. Ammonia. Nitrate. Cyanide. The cracking that comes. Fungicide. Herbicide. Pesticide. Sweeteners. Foaming agents. Astringents. The laughter of deaf fish. Blind fish. Corroded fish. Fish without fins. Fish drifting with the current. Mutated fish. Bacteritic seaweed. Dioxin. Toxin. Weed killer. Clouds of death. Unknown sufferings. New diseases. Malformations. Mutilated lungs. Incurable lesions. Hiroshima in the obscurity of our bodies fallen prey to the new times.
— Jeanne Hyvrard, 1982

GERHARD HOEHME
Stux, New York

A well-known photograph taken in 1966 at the opening of an exhibition in Jörg Immendorff's flat in Düsseldorf shows, among others, the artists Joseph Beuys, Franz Erhard Walther, Immendorff, Nam June Paik, and Gerhard Hoehme. It provides a glimpse of the range of artistic talent, and the simultaneity of opposites, that made Düsseldorf a major art center in postwar Germany.

Gerhard Hoehme had been an important member of German Informel painting in the 1950s, an art movement that was born of the collective moral and physical breakdown of Germany after the war. The disintegration of ideals led to a withdrawal from the political and to an occupation with color and the process of painting. It soon became an empty, academic gesture, while the ZERO group, with its optimistic political vision and the capitalist realism of Gerhard Richter, Konrad Lueg (aka Konrad Fischer), and Sigmar Polke, was more in concordance with the German economic miracle of the 1960s.

This exhibition of Gerhard Hoehme, which is his first in the U.S., stresses his influence on Sigmar Polke (who was his student at the Düsseldorf academy) and on Eva Hesse (who spent one year in Germany during the sixties). Hesse's stay in Germany from 1964 to 1965 was critical to her artistic and personal development and she undoubtedly absorbed the work of Beuys, Walther, Günther Uecker, and Hoehme. In her diary, Hesse quotes a sentence from Simone de Bouvoir stating that "what woman essentially lacks today for doing great things is forgetfulness of herself; but to forget oneself it

This review originally appeared in *Flash Art* 148 (October 1989): 133.

is first of all necessary to be firmly assured that now and for the future one has found oneself."

Despite his premonition of an Arte Povera-related poetics of material, Hoehme has always remained essentially within the vocabulary of Informel, while Hesse was able, by way of a female mimesis of German art in the 1960s, to forget and find herself both as a German and a woman artist.

DREAMINGS:
THE ART OF ABORIGINAL AUSTRALIA
Asia Society, New York

Epama epam (Nothing is nothing)

The exhibition presents paintings and sculptures from Aboriginal societies across Australia, including both examples of traditional bark paintings and westernized versions of ceremonial sand paintings executed in acrylic on canvas. It is through these new materials, introduced to the Aboriginals only in 1971 by a former art student from Sydney, that this work can be seen here at a time when an increasing number of contemporary European and American artists as well as non-Aboriginal artists in Australia are becoming engaged with primitive or naive images, folk art, and religious spiritualism.

The paintings are about "dreamings," a timeless history of the Aboriginal world, a mapping of the land of the ancestors; and they are about the loss of this land. The Aboriginal world is a world of signs. Their aesthetic is a fundamentally social and ceremonial. The paintings are usually executed by two or three artists, by men as well as by women. The specific dreamings are owned by artists through their kin relationships and through inheritance and cannot be painted by others.

Viewing this works, it becomes clear that there is loss on both sides: loss of land on theirs, and loss of meaning on ours.

This review originally appeared in *Flash Art* 145 (March–April 1989).

BETSY KAUFMAN
Center for Contemporary Art, Chicago

The adjective, as a major predicate complement, is also the main path of desire; it is the statement of desire.
— Roland Barthes, 1973

Betsy Kaufman's new paintings are opening a path of desire. The black shapes placed on top of seductively iridescent backgrounds, which retain elements from her previous landscape-inspired work, obstruct the pleasure of viewing and form, like Barthes's adjectives, statements of desire. Kaufman's paintings are as much about desire as they are about a crisis of desire, which, as Barthes has noted, is perhaps a crisis of civilization.[1]

Kaufman confidently walks the thin line between totem and taboo of abstract painting, which many of her peers fail to master.

This review originally appeared in *Flash Art* 150 (January–February 1990).
1 See Roland Barthes's last interview, "The Crisis of Desire," in *The Grain of the Voice: Interviews, 1962–1980*, trans. Linda Coverdale (New York: Hill and Wang, 1985).

LARRY CLARK
Luhring Augustine, New York

A combination of conditions leads us to entertain a picture of mankind as it ought to be, and in that picture man appears at no less great a remove from extreme pleasure as from extreme pain: the most ordinary social restrictions and prohibitions are, with equal force, aimed some against sexual life, some against death, with the result that each has come to comprise a sanctified domain, a sacred area which lies under religious jurisdiction. The greater difficulties began when the prohibitions connected with the circumstances attending the disappearance of a person's life were alone allowed a serious character, whilst those touching the circumstances which surround the coming into being of life — the entirety of genital activity — tended to be taken unseriously.
— Georges Bataille, 1941

According to Alvin Toffler's new book *Powershift*, the social power of society is defined by knowledge, wealth, and violence, and the relationships among them.

The destructive discourse of these sources of power at the close of the twentieth century has become a main theme for a number of younger artists today, in particular, Cady Noland, Nayland Blake, and Nan Goldin. Earlier, Larry Clark focused, like them, on the social pathology of American society. His recent installation at Luhring Augustine is based on his two photo books *Tulsa* and *Teenage Lust* and made up of collages of photographs, magazine covers, and memorabilia, as well as a videotape. Closer, in its dangerously personal involvement, to Goldin's autobiographical *Ballad of Sexual Dependency* than to the disengaged forensic investigations of Noland and Blake, Clarke tells of the experience and attraction of death

This review originally appeared in *Flash Art* 156 (January–February 1991).

and violence through drugs, sex, and crime in his life as well
as in adolescent life in America in general — the "unbearable
transgression of Being" of which Georges Bataille speaks of
in the preface to his novel *Madame Edwards:*

The act whereby being — existence — is bestowed upon us is an *unbear-
able* surpassing of being, an act no less unbearable than that of dying. And
since, in death, being is taken away from us at the same time it is given us,
we must seek for it in the feeling of dying, in those unbearable moments
when it seems to us that we are dying because the existence in us, dur-
ing these interludes, exists through nothing but a sustaining and ruinous
excess, when the fullness of horror and that of joy coincide.[1]

1 In *The Bataille Reader,* eds. Fred Botting and Scott Wilson (Oxford:
Blackwell, 1997), p. 226.

GEORG BASELITZ
Pace, New York

Kant's skull obtains, through the regular formation of its individual parts and through its amount of greatly pronounced elevations, a curious form. The high, broad and square forehead, . . . the straight direction of the skullcap, the bilateral, greatly protruding elevations of the parietal bones, the gradually backwards arching temporal regions and the elevations located on them, the impression and flattening at the occipital region and the greatly backwards arching occipital bone, all give the skull peculiarities which one will hardly find in this combination again. The elevations of the skull increase through their identical height and proportion the regularity of its build, and from its diameter a considerable capacity of its cavity can be concluded.
— Wilhelm Gottlieb Kelch, 1804

This exhibition of Baselitz's recent cycles of paintings and sculpture, titled "45" and "The Women of Dresden," respectively, carries on the infatuation of postwar German art with the Teutonic cranium — from Markus Lüpertz's helmets and Rainer Fetting's heads to Thomas Ruff's portraits. In these works the expressionist empathy is replaced by mannerist decor and revisionist bathos riding the current wave of recidivism in Germany. It is a common revisionist practice to deny the singularity of the German crimes against the Jewish people by comparing them with the bombing of Dresden and similar consequences of the German belligerence.

This review originally appeared in *Flash Art* 156 (January–February 1991).

Yet it is more urgent than ever for every German to face the atrocities produced by the German mind, which constitute the central ethical myth of the twentieth century — and centuries to come — and to reflect on the following words from Kant's *Critique of Practical Reason:*

Morals began with the noblest property of human nature, the development and cultivation of which looked to infinite use, and it ended — in enthusiasm or in superstition . . . But after there had come into vogue, though late, the maxim of carefully reflecting beforehand on all the steps that reason proposed to take and not letting it proceed otherwise than on the track of a previously well-considered method, then appraisal of the structure of the universe obtained quite a different direction and along with it an incomparably happier outcome. The fall of a stone, the motion of a sling, resolved into their elements and the forces manifested in them and treated mathematically, produced at last that clear and henceforth unchangeable insight into the structure of the world which, with continued observation, one can hope will always be extended while one need never fear having to retreat.[1]

1 Immanuel Kant, *Critique of Practical Reason,* trans. Mary Gregor (Cambridge: Cambridge University Press, 1997), p. 134.

MICHAEL SCHMIDT
The Museum of Modern Art, New York

In 1920 the German photographer August Sander stopped retouching his works and proclaimed that he hated nothing more than "sugar-coated" photography full of "gimmicks, poses, and false effects." Michael Schmidt's compelling photographic installation *LJ-NI-TY* invokes Sander's words and his earlier historical undertaking of picturing German Being in its entirety; but it does so with the distanced intimacy that has become a trademark of contemporary German photography.

About half of the 160 black-and-white photographs are portraits of fellow Berliners and interior shots of German domesticity. They are interspersed with newspaper images from the 1930s to the 1960s, reminiscent of the rephotographic portraits by Gerhard Richter and Christian Boltanski. Schmidt's portraits of a lifeless and inexpressive German youth, taken between 1991 and 1994, eerily echo the inanimate subjects of the historical material.

For me, having grown up during the 1960s in Germany, the installation has an uncomfortable familiarity. Portraits of the Nazi leaders are paired with photographs of politicians of postwar Germany, both East and West: a lean Konrad Adenauer, an intense Willy Stoph, and an opulent Ludwig Erhard (who, more than any other political figure, personifies the *Wirtschaftswunder* — the German economic miracle).

But there is much that must surely remain obscure for the non-German viewer. One of the most haunting images is a collage of two pictures: one, a German schoolboy sitting on a desk; the other, a handwritten letter. The letter (dated April 29, 1955) was written by the young boy, or so we are to believe. In it, the boy declares that he used to deliver letters

This review originally appeared in *c magazine* (Summer 1996).

after school for his teacher to several people in Weimar but that he did not have any knowledge of their contents, as the letters were sealed. The image of this young boy, which closely resembles the look sanctioned by the *Führer*, alludes to unsaid crimes and the continuation of the totalitarian system of informers and spies in the East German postwar regime. This rather subtle message could easily be lost on those not familiar with the intricacies of the German psyche.

The exhibition is accompanied by a voluminous book containing the photographs published in the same order as the installation. Without added text, it resembles an artist's book more than an exhibitions catalogue. The layout of the book, which places most of the images on right-hand pages, enables the viewer to experience the pictures one at a time (with the exception of some that are placed side by side).

LJ-NI-TY reminds us that any historical discourse is always located between remembering and forgetting.

MARCEL BROODTHAERS
Marian Goodman, New York
David Zwirner, New York
John Gibson, New York

How should we explain to someone what a *game* is? I imagine that we should describe games to him, and we might add: This *and similar things* are called "games." And do we know any more about it ourselves? Is it only other people whom we cannot tell exactly what a game is? — But this is not ignorance. We do not know the boundaries because none have been drawn.
— Ludwig Wittgenstein, 1945-49

Like Wittgenstein, Marcel Broodthaers regarded language as a game, posing that same question regarding art throughout his work: How should we explain to someone what art is? And he might answer with Wittgenstein: This *and similar things* are called art. As the boundaries are not drawn, the game is open and the rules are not completely defined.

Broodthaers's own philosophical investigations, which seem to owe as much to Wittgenstein's questioning of language as to the art games of René Magritte and Marcel Duchamp, have continued to inspire younger artists for the last twenty years. These three simultaneous exhibitions are a fortuitous and long overdue event, which make up for the oversight of not bringing the retrospective of Broodthaers's work, organized by the Walker Art Center in 1989, to a museum in New York. Less than three months short of the twentieth anniversary of his death, which also happened to be his birthday (a macabre triumph of art over life), these exhibitions finally allow New Yorkers to see many aspects of Broodthaers's oeuvre firsthand.

This review originally appeared in *c magazine* (Winter 1996).

The exhibition at David Zwirner, entitled *Correspondences*, is an exceptionally beautiful show of significant works, ranging from *Panneau de Moules, Valise d'oeufs* (both 1968), and *Sculpture* (1974) to his later slide projections and the continuous 16mm film *Le Corbeau et le Renard* (1967–72). The accompanying catalogue contains responses by contemporary artists such as Carl Andre, Mike Kelley, and Raymond Pettibon to a questionnaire on Broodthaers. The choice of artists, however, seems rather arbitrary, with many younger artists with clear affinities to Broodthaers not being included, such as Andrei Roiter or Rirkrit Tiravanija, whose homage to Broodthaers was one of the few memorable events of this year's unfortunate Whitney Biennial.

The extensive *Section Publicité*, a segment from his *Musée d'Art Moderne: Départment des Aigles* (1968–72), an encyclopedic collection of objects, advertising ephemera, and slide projections of eagle imagery, is shown at Marian Goodman. It includes art crates from Broodthaers's original exhibition of the *Musée Moderne* in his apartment in Brussels in 1968, as well as Magritte-inspired labels bearing the statement, in English, French, or German, "This is not a work of art." This body of work has not been shown since 1972, when it was part of *documenta* 5.

The two exhibitions are supplemented by a selection of Broodthaers posters and books from the estate of the artist at John Gibson.

JACKSON POLLOCK
The Museum of Modern Art, New York

In the years between 1947 and 1950, a young painter whose work originated in a unique synthesis of Picasso's cubism, Miro's surrealism, Thomas Hart Benton's realism, and Native American art, forever changed the way paintings are made, viewed, and discussed. Jackson Pollock was thirty-five years old when he began to create his first drip paintings. Not since Duchamp's urinal had one stylistic event so radically defined American art.

This is the most complete and intelligently curated survey of Pollock's work that has ever been undertaken by any one individual or institution, if one disregards the exhibition's unconvincing replica of Pollock's Long Island studio. While the recent trend of museums to raise awareness of the process and production site of works of art is laudable, the practice of recreating artists' studios in the museum brings art dangerously close to Disney theme parks and Las Vegas–style spectacles.

That aside, the exhibition is a welcome change after the recent Johns and Rauschenberg retrospectives that were equally long-awaited but, for various reasons, disappointing. Having been fortunate to see the 1982 Pollock retrospective at the Centre Pompidou in Paris, which had a profound and lasting effect on this reviewer, it has been exhilarating nonetheless to visit the MOMA retrospective; to encounter major works never before included in any Pollock exhibition, such as *Blue Poles: Number 11, 1952*, on loan from the National Gallery of Australia, Canberra, and to discover a much more subtle, lyrical Pollock, in works such as *Untitled (Red Painting 1-7)* (c. 1950) — a series of small-scale "oil washes" on canvas,

This review originally appeared in *c magazine* (February–April 1999).

from a private collection in Berlin, surprising in their Zen-like simplicity and tender execution. Other discoveries were Pollock's cut-outs, in particular *Untitled (Cut-Out)* (c. 1948–50) and *Untitled (Cut-Out Figure)* (1948). The first is a drip painting with a crude silhouette of a human form cut from the center of the canvas; the cut-out form is collaged to the second painting, the blank white shape contrasting with the drip of the appliqué. These cut-outs bring to mind Alfonso Ossorio's 1950s expressionist paintings on paper, which prominently feature cut-outs. Ossorio, Pollock's first patron and close friend, is unfortunately only sparsely mentioned in the exhibition catalogue and not at all in the exhibition wall texts. While Pollock's cut-outs probably preceded Ossorio's, new scholarship suggests that Ossorio influenced Pollock's unexpected return to figurative imagery in the black enamel paintings of 1951. In the exhibition and catalogue, the reappearance of figurative imagery in Pollock's work is attributed to Picasso and Matisse. While Picasso undoubtedly played a significant role in Pollock's works preceding 1947, and Matisse may indeed have been on Pollock's mind, it was Ossorio's presence that defined Pollock's creative life in the years between 1948 and 1952. It is regrettable that the curators did not acknowledge the possibility of a mutual creative exchange between Ossorio and Pollock.

RENÉE GREEN
Pat Hearn, New York

Renée Green's installations are characterized by "flow" (the title of a previous installation and web project) — a fluid network of fragmented references to personal and political histories. Green is one of the most multifaceted artists working today. An artist without a studio who commutes between New York and Europe, she is a cultural tourist traveling through political history, critical theory, and popular culture in the guise of a conceptual artist.

Green transplants Smithson's notion of the site/nonsite into language, politics, and the mass media. As an African–American, she sees herself as a diasporic subject, having no affinity to linear history, which she perceives in fragments. Her complexly layered installations using photographs, video, and text (often in the form of citations drawing on sources ranging from Walter Benjamin and Michel Foucault to Seinfeld) demonstrate her interest in collecting, archiving, and assembling historical and cultural fragments.

Like most of her previous installations, the new works are self-reflexive, dealing with knowledge, history, identity, and notions of the Other and its absence. The exhibition features a DVD installation showing the video-films *Partially Buried Continued* and *Some Chance Operations*, a two-part audio installation with the same pairing of titles, and a video installation titled *WaveLinks*.

In *Partially Buried Continued* Green uses as historical backdrop the 1980 military coup in Korea during which hundreds of protesters were killed in what came to be known as the Gwangju Massacre. She links this to Robert Smithson's *Partially Buried Woodshed*, which he created in 1970 on the

This review originally appeared in *c magazine* (February–May 2000).

campus of Kent State University, and the concurrent shooting of four students by the Ohio National Guard during a student protest on May 4th, 1970. (Smithson's work became symbolically linked to the shooting by the simple fact that someone later painted "May 4 Kent 70" in bold white letters on the woodshed.) Green's film, made on the occasion of the 1997 Gwangju Biennial and part of the trilogy *Partially Buried in Three Parts*, interweaves personal and political history. (Her mother taught at Kent Ohio State in the 1970s).

This work is cross-referenced with a large installation of photographs in the back room of the gallery, most of them taken by Green during her visit to Korea. A number of these document the memories of the Gwangju massacre; others relate to the Korean war by way of three photographs originally taken by the artist's father during the war, which she reprinted and installed together with photographs taken in the war museum in Seoul.

Some Chance Operations explores the life and work of the Italian filmmaker Elvira Notari (1875–1946), who produced some sixty feature films, only three of which survive. Green uses Notari's hometown, Naples, as a starting point for a series of color photographs, taken in Vienna in 1998, which documents real and imaginary ideas of "Naples." This work, like the others in the exhibition, explores notions of translation and loss.

MARK TANSEY
Curt Marcus, New York

This surprising exhibition of works on paper by the painter Mark Tansey was far more than a simple group of studies. Rather, it constituted a major breakthrough in the career of this accomplished artist, known primarily for his highly controlled, monochrome tableaux that illustrate historical, aesthetic, and scientific concepts and theories.

The installation of 127 sheets was presented salon-style, yet the individual unframed drawings were attached to the wall with white pushpins and often labeled "in progress" (and therefore not for sale).

While these drawings reveal some of the techniques and methodology of Tansey's paintings, they also prove him to be more than merely an accomplished illustrator of ideas. They show him operating as a classical artist in the traditions of Rembrandt, Goya, and Cézanne. Combining chiaroscuro with surrealist-style collage, Tansey masterfully transfers sixteenth- and seventeenth-century techniques into contemporary drawing: he progressively and seamlessly integrates charcoal drawing and brushwork to create dark and light (physical and spatial) zones as well as unmarked, empty areas that seem to imply meaning.

Executed freely in graphite and oil on gessoed paper, many with added collages on acetate, the drawings' reduced narrative content is, as in his paintings, drawn from Tansey's extensive picture library. Yet here the images — such as *Fixing* (2000), showing two boys apparently trying to reassemble a giant egg, while a large, shadowy Old Master–style hand serves

This review originally appeared in *Artnews* (June 2000).

as a backdrop — are set against more ambiguous grounds full of emotional space.

While much of the irony and intellect that have come to be the trademarks of Tansey's paintings remain in these works, refreshingly, these qualities take second place to the act of drawing itself. In fact, the works' decidedly unfinished state is an added pleasure.

GWANGJU BIENNIAL
Gwangju, South Korea

The organizers of the third Kwangju Biennale, on view through the seventh of this month, have succeeded in creating a truly global event, offering fresh and engaging perspectives. Unlike the last Biennale, which was criticized for underrepresenting Asian art, this one is more balanced, divided as it is into five main sections: Eurafrica, North America, South America, Asia, Korea, and Oceania. The encompassing theme, "Man and Space," refers to the notion that humans and their social and political surroundings are inseparable.

The North American section is selected by Thomas Finkelpearl, program director at New York's P.S. 1 Contemporary Art Center. Focusing on the theme of individualism as a trait specific to North American culture, Finkelpearl presents a range of self-portraits by both emerging and established artists, among them, Amy Adler, Ellen Harvey, and Chuck Close. Large mirrors installed throughout the section effectively incorporate the viewer's own image into the exhibition.

By far the most successful sections are Eurafrica and South America. The first, curated by René Block, director of the Museum Fridericianum in Kassel, Germany, offers a multicultural perspective that focuses on areas historically considered peripheral to major European centers — Scandinavia, South and West Africa, and the Middle East (specifically Turkey, Iran, and Egypt). Here one can find provocative juxtapositions, such as photographer Esko Männikö's color portraits of people from his native Finland placed alongside Nigerian-born Fatimah Tuggar's installation of sculptures — consisting of small fans attached to feather dusters — and large-scale

This essay originally appeared in *Artnews* (June 2000).

digital montages that portray the Third World through the visual language of advertising.

The South American section, organized by the Korean American independent curator Yu Yeon Kim, features a chilling performance- and video-installation by the Cuban-based artist Tania Bruguera titled *El peso de la culpa IV* (The Burden of Guilt IV). For the performance, which took place during the first three days of the Biennale, Bruguera sat on the floor in the center of a room that was covered with lambskins. Naked, with her head shaven, her eyes and ears covered by pieces of lambskin, and a rope around her neck that held her left arm tied behind her back, the artist compulsively rubbed a sharp rock with her right hand. Visitors walked around her while periodically the lights in the room were turned off and the sound of bleating sheep was played on loudspeakers. In an adjoining room, the floor was covered with several inches of sugar, and a monitor suspended from a ceiling broadcast televised news clips of Fidel Castro. With these works, Bruguera focuses on words, or the lack of them, as a way to impose and resist power. The Cuban revolution, in the artist's view, has been particularly adept at using words to mythologize events and the bitter social conditions. More than any other work, Bruguera's performance signals the curatorial courage that prevails throughout this biennial.

DOUGLAS R. WEATHERSBY
Institute of Contemporary Art, Boston

Douglas R. Weathersby is the fifth recipient of the ICA's Artist Prize, awarded last year for his exhibition of site-specific installations, photographic documentation, and live-feed video from inaccessible areas like ducts and boiler rooms. Using both artificial and natural light sources, the artist creates mostly short-lived drawings by sweeping dust and debris into the shadows of objects like chairs or ladders.

Weathersby's conceptual/performative work is part of an ongoing interest by many contemporary artists in detritus and cleaning rituals dating back to Duchamp's 1920 dust-breeding experiment, including James Lee Byars's legendary street-washing performance of 1967 involving a water-soluble paper sculpture, Allan Kaprow's happenings involving old car tires, Marina Abramović's obsessive scrubbing of human bones, and Cornelia Parker's suspensions of the remains of guttered or razed buildings. In the 1960s and 1970s critical artists like Joseph Beuys, Allan Kaprow, and Robert Smithson blurred the distinction between art and life, stressing that meaning should not only be unfixed but invented. In Kaprow's words, artists were to become "conscious inventors of the life that also invents them."

Duchamp's 1920 dust experiment (a collaboration with Man Ray) involved not merely collecting and photographing dust but wiping it off in intervals of three to four months, except for certain areas where it was fixed with varnish. This experiment already presaged many of the elements of contemporary practice also found in Weathersby's work: performance, ritual, time, and the labor invested in the creative act.

8 This review originally appeared in *artUS* 2 (April–May 2004).

What sets Weathersby apart from others working with ephemeral site-specific installations is his practice of placing himself and his artistic modus operandi at the service of his clients. His company, a functioning business called Environmental Services, offers a variety of home cleaning and repair services, billed at reasonable hourly rates. At the core of these services is an agreement between the artist and his clients that permits Weathersby to document and collect the detritus remaining after the performance/service for use as temporary, site-specific installations.

Weathersby's sincere and unobtrusive approach, which invites participation and aims, according to the Environmental Services pamphlet, to "provide fresh perspectives on your living and working environments," is a welcome relief from the irony that has pervaded artistic practice in recent decades. He takes the existential questions of art and work beyond the usual political, psychological, ethical, and historical reductions but without pushing any agenda of his own. By quietly bringing to light that which usually remains hidden or unnoticed, the artist gives form to the abject and formless, something at once habitual and unknown.

Weathersby creates installations of haunting beauty that both comfort and disturb. Clearly, due to their intimate character, they function on a deeper level for those living or working in these spaces than for those of us who don't. Just the same, Weathersby's work will still evoke an eerie familiarity for most of us.

GLEXIS NOVOA
Worcester Art Museum

Murals have long been a means of describing and recording both social activity and historical or mythological events, from Paleolithic cave paintings and Pompeian mosaics to the Mexican murals of José Clemente Orozco, Diego Rivera, and David Alfaro Siqueiros. Three years ago, Cuban-born Glexis Novoa executed, on all four walls of the Miami Art Museum's project space, a landscape drawn in graphite and sparsely populated with utopian architectural elements, anchored by a thin horizon line. The new drawing at the Worcester Art Museum occupies a 166-foot-long wall of the museum's contemporary gallery and again features an anchoring horizon line, this time part graphite and part gold leaf. Like all his drawings on walls, it is a temporary work of art, to be painted over once the exhibition closes, making Novoa's installation more a performance than a traditional mural.

Novoa's Worcester wall drawing, conceived during an earlier visit there in 2003, incorporates the history of this old New England town. Its manufacturing past is reflected in the use of graphite to represent smoke and the gold leaf band symbolizing a society of affluence. The drawing combines postutopian architectural follies with particular reference to social realist artifacts, like the Mamayev statue commemorating the Russian soldiers who died in the Battle of Stalingrad. It is worth noting here that Soviet social realism, originally an expression of the proletariat responding to the utopian vision of the Russian Revolution's charismatic leaders, was reinterpreted by Cuba's pro-Soviet government during the 1970s, thus ending that country's hitherto relatively pluralistic forms of art and literature.

This review originally appeared in *artUS* 2 (April–May 2004).

Much of today's social art lies beyond mere "social realism," insofar as it follows a path from realism to abstraction and transcendental utopianism, initially trodden by artists like Mark Rothko and Barnett Newman. Novoa belongs among those artists, using his considerable skill to create images that circumvent mere realism by emphasizing extreme simplification of form and color and thereby encoding utopian ideology within its own vanishing act. White space is abundant in his work and gives it a minimalist appearance. Just as minimalism replaces essence in art with presence and place, relying on the void and the space around it, Novoa's wall drawings both transform and interact with the space they occupy, to the extent that the surrounding architectural space becomes an integral part of it.

The experience of exile is of particular significance in Novoa's work. The artist, who has been living and working in Miami since 1995, has suggested that the horizon line should be read as a metaphor for his immigrant existence, which demarcates both past and future. Novoa's iconography is less defined by originality than by acts of deterritorialization and dislocation, something expressed in a bricolage of references, not unlike Piranesi's frontispiece to his 1762 *Il Campo Marzio dell'Antica Roma*, an assembly of styles from all times put together to form one gigantic utopian folly. Like the Ethiopian-born painter Julie Mehretu, another exile artist who layers maps, urban grids, and architectural forms onto her canvases, Novoa draws landscapes and architectural structures that are aesthetically, politically, and emotionally charged while deeply imprinted by the artist's own personal history of displacement.

NONE OF THE ABOVE:
CONTEMPORARY WORK BY
PUERTO RICAN ARTISTS
Real Art Ways, Hartford

In his 1994 text "Traveling Theory Revisited," Edward Said analyzed an earlier essay of his, "Traveling Theory," which rejected the "portability" of theories and in which he since has detected traces of a common bias: that newer versions of a theoretical formulation not directly connected to or provoked by real historical circumstances are degraded and cannot replicate the power of the original idea; thus its potential for political change is subdued and made into an academic substitute for the real thing. In "Traveling Theory Revisited," Said had come to believe that a theory could after all become "transgressive," in the sense "that it can cross over from and challenge the notion of a theory that begins with fierce contradiction and ends up promising a form of redemption."[1]

None of the Above, an exhibition of contemporary Puerto Rican art is aimed at the same bias Said described. According to the curators, Deborah Cullen, Silvia Karman Cubiñá, and Steven Holmes, concept-based art, along with minimal and performative art, has been practiced in Puerto Rico since the 1960s. However, these practices have been underrecognized "due to the overriding problematic nature of Puerto Rico's — and Puerto Ricans' — status." The exhibition includes works by Manuel Acevedo, Jennifer Allora and Guillermo Calzadilla, Javier Cambre, Nayda Collazo-Llórens, Dzine (Carlos Rolón), Cari González-Casanova, Ivelisse Jiménez, Charles Juhász-Alvarado, Ignacio Lang, Malika, Arnaldo Morales, Enoc Pérez,

This review originally appeared in *artUS* 4 (September–October 2004).
1 In *Rethinking Fanon*, ed. Nigel C. Gibson (Amherst, N.Y.: Humanity Books, 1999), p. 200.

Chemi Rosado Seijo, and Carlos A. Rivera Villafañe. The title of the exhibition is derived from the result of a plebiscite held in 1998 in Puerto Rico. Given a choice between statehood, independence, and the current status of territorial commonwealth (of the United States), a majority of the votes were cast for "none of the above."

However, Puerto Rican contemporary art is not as dark a continent as the curators insinuate. One of the most successful conceptual artists of the 1990s was the Cuban-born Felix Gonzalez-Torres, who was raised and educated in Puerto Rico and who died in New York City in 1996. The artists in this exhibition are predominantly younger and much lesser known, and like their peers on the mainland United States and in Europe, not all are challenging their practices to new "redemptive" heights.

The Puerto Rican philosopher Nelson Maldonado Torres has written that,

since Puerto Rico has been Puerto Rico, the people of the island have always been in some form of subordination in relation to another people. Subordination becomes in this way for the Puerto Rican not some contingent result of their being but a constitutive factor of who they are. Their lives, culture, and history are marked by the trace of the colonial, a constant intervening factor that complicates the ordinary life, the ethics, and politics of the Puerto Rican. For this reason, the remarkable efforts to avoid the sudden emergence of an explicitly political consciousness fail, or perhaps succeed too well; in any case, politics becomes a daily business and an ordinary affair in the lives of Puerto Ricans.[2]

Torres warns of the danger in isolating Puerto Rico's philosophy (and art) from the issue of colonialism, which "might lead us very far from the radical critical and insurgent spirit

2 "Latin American Thought and the Decolonization of Western Philosophy," http://www.apa.udel.edu/apa/publications/newsletters/voon1/hispanic/05.asp

embodied in great philosophical ideas and in every great philosophical project."[3]

According to Torres, the political and personal are inseparable in Puerto Rican ethics and aesthetics. The exhibition's premise of shifting emphasis away from a popular conception of Latino art practices "whose agendas are decidedly more personal and nationalistic" is thus somewhat problematic. Making a distinction between personal and nationalistic practices on the one side; and conceptual, minimal, and performative practices, on the other, seems an unnecessary and artificial curatorial device. Fortunately, much of the art included in the exhibition does not follow the curators' distinctions.

What makes this exhibition interesting and successful, in addition to responding (as it should) to the ethnic diversity of Hartford (whose population, according to the 2000 U.S. Census, is made up of forty percent Latinos, of which thirty-five percent are Puerto Rican) is its demonstration of how a traveling idea (art as concept) can indeed become "transgressive" in the sense of Said's theory — revitalized and infused with new political and emotional content thirty years after Joseph Kosuth declared that all art after Duchamp is conceptual.

To the credit of most of the artists in the show, the political ambiguity or indecision of the voting populace that gave the exhibition its title, does not spill over into the practices of these young Puerto Rican artists. Manuel Acevedo's minimalist, utopian proposals for public places are drawn by the artist on top of photographs of abandoned urban landscapes. Nayda Collazo-Llórens's digital stream-of-consciousness-projections of alternating visuals and texts are structured in a non-linear manner by disjunctive narratives dealing with psychological and corporeal deterritorialization.

3 Ibid.

One work in particular distinguishes itself by the simplicity and lyricism with which it presents a politically charged subject: the video *Returning a Sound* (2004) by Jennifer Allora and Guillermo Calzadilla. It shows a young man riding on a moped, which has a trumpet attached to its exhaust pipe, around the island of Vieques. A U.S. Navy military zone from 1941 until 2003, when it was finally returned to Puerto Rico, Vieques has become a symbol for Puerto Rico's continued colonial status. The short moped ride (5:42 min.) along mostly empty roads, accompanied by the sad cries of the exhaust that recall the forlorn sounds of Miles Davis's trumpet, leads past abandoned army bunkers, munitions depots, and target areas through an obviously abused yet luscious vegetation. It is at once a gesture of reclaiming what had long been barred and a ritual of cleansing, an attempt at restoring the island to a state of innocence. At Real Art Ways the video is projected inside a roped-off utilities area adjacent to the gallery space, thus replicating the experience of exclusion and deterritorialization, although the visitors are encouraged to climb over the rope, therewith enacting their own small gestures of reterritorialization.

INTERVIEWS

JEFF KOONS
New York, 1986

What is the theme of your new work?
The basic story line is about art leaving the realm of the art-
ist, when the artist loses control of the work. It's defined ba-
sically by two ends. One would be *Louis XIV* — that if you
put art in the hands of an aristocracy or monarch, art will
become reflective of ego and decorative — and on the other
end of the scale would be *Bob Hope* — that if you give art to
the masses, art will become reflective of mass ego and also
decorative. The body of work is based around statuary rep-
resenting different periods of Western European art. Each
work in the show is coded to be more or less specific about
art being used as a symbol or representation of a certain
theme that takes place in art, such as *Doctor's Delight*, a sym-
bol of sexuality in art; *Two Kids*, of morality in art; *Rabbit*, of
fantasy in art. *Italian Woman* would be a symbol of the artist
going after beauty; *Flowers* would be art being used to show
elegance and the strength of money; *Louis XIV* is power, a
symbol of using art as an authoritarian means; *Trolls*, a sym-
bol of mythology.

What is your main interest as an artist?
I'm interested in the morality of what it means to be an artist,
with what art means to me, how it defines my life, etc. And
my next concern is my actions, the responsibility of my own
actions in art with regard to other artists, and then to a wider
range of the art audience, such as critics, museum people, col-
lectors, etc. Art to me is a humanitarian act, and I believe that
there is a responsibility that art should somehow be able to

This interview originally appeared in *Journal of Contemporary Art*, vol. 1,
no. 1 (1988).

affect mankind, to make the word a better place (this is not a cliche!).

Where do you get the ideas for your work?
It's a natural process. Generally I walk around and I see one object and it affects me. I can't just choose any object or any theme to work with. I can be confronted by an object and be interested in a specific thing about it, and the context develops simultaneously. I never try to create a context artificially. I think about my work every minute of the day.

How much are you involved in the actual production of your work?
I'm basically the idea person. I'm not physically involved in the production. I don't have the necessary abilities, so I go to the top people, whether I'm working with my foundry — Tallix — or in physics. I'm always trying to maintain the integrity of the work. I recently worked with Nobel prize winner Richard P. Feynman. I also worked with Wasserman at Dupont and Green at MIT. I worked with many of the top physicists and chemists in the country.

Could you elaborate on the term "integrity"?
To me, integrity means unaltered. When I'm working with an object I always have to give the greatest consideration not to alter the object physically or even psychologically. I try to reveal a certain aspect of the object's personality. To give you an example: if you place a shy person in a large crowd, his shyness will be revealed and enhanced. I work with the object in a very similar manner. I'm placing the object in a context or material that will enhance a specific personality trait within the object. The soul of the object must be maintained to have confidence in the arena.

How do you see the development of your work?
The early work is very important to my personal development, but I don't feel that it has the same social value as my work from the time of "The New." I feel basically that the core

of my work stays the same. I try to carry the best of my work with me through each body of work while enlarging its parameters.

What are the differences between your work and say someone like Richard Prince who rephotographs advertisement and media images?
Richard and I have been friends for many years. His work is more involved in the appropriation aspect, the aspect of theft, while my work comes from the history of the ready-made, which for me is position of optimism. Whether I'm casting my Jim Beam decanter or creating a painting from a liquor ad, I receive all the legal rights from everybody — a very optimistic situation.

How do you manage to get all the legal rights?
I come out of a background of, at one time, being the Senior Representative for the Museum of Modern Art. I was also a commodity broker on Wall Street for six years, so I have experience in dealing with people on a professional level. I had only one company in my last project that turned me down. And in each company I have to deal first with them, then with their lawyers, and in some cases with their advertising firms and their printers.

How do you see advertisement?
It's basically the medium that defines people's perceptions of the world, of life itself, how to interact with others. The media defines reality. Just yesterday we met some friends. We were celebrating and I said to them: "Here's to good friends!" It was like living in an ad. It was wonderful, a wonderful moment. We were right there living in the reality of our media.

What do you think about the fact that the owner of one of the largest advertising firms in the world is buying your art?
It's not negative toward advertisement. I believe in advertisement and media completely. My art and my personal life are

based in it. I think that the art world would probably be a tremendous reservoir for everybody involved in advertising.

What is the significance of the Nike ads?
The Nike ads were my great deceivers. The show was about equilibrium, and the ads defined personal and social equilibrium. There is also the deception of people acting as if they have accomplished their goals and they haven't: "Come on! Go for it! I have achieved equilibrium!" Equilibrium is unattainable, it can be sustained only for a moment. And here are these people in the role of saying, "Come on! I've done it! I'm a star! I'm Moses!" It's about artists using art for social mobility. Moses [Malone] is a symbol of the middle-class artist of our time who does the same act of deception, a front man: "I've done it! I'm a star!"

Would you be interested in doing an advertisement?
I would be extremely interested. I'm not interested in corporations having my work. Some corporations collect my work, that's fine. But let's say I use a specific product, like a Spalding basketball. I don't want Spalding to have my basketball. I don't do it for that reason. But if Spalding came to me and asked if I would like to work on an ad campaign, I'd love to do that.

Do you get money from companies for using their products?
Absolutely not. I would never accept it. Now, somebody like Jim Beam who has been so gracious to work with, I've given them a work of art, but if they would want to buy one I may feel uncomfortable because the work was not done for that reason. I've given them something out of appreciation of their being so tremendous to work with.

Do you consider the gallery the ideal space for your work?
I love the gallery, the arena of representation. It's a commercial world, and morality is based generally around economics, and that's taking place in the art gallery. I like the tension of accessibility and inaccessibility, and the morality in the art gallery. I believe that my art gets across the point that I'm in this morality theater trying to help the underdog, and I'm speaking socially here, showing concern and making psychological and philosophical statements for the underdog.

WOLFGANG LAIB
New York, 1986

You studied medicine. How did you get into art?
The more I knew about the natural sciences, the more I saw
that they were too narrow for me and it's just not what this
body, what all these things are all about.

Did you ever think of going into something like holistic medicine?
No, because that would have been too small a step, and I tried
to make a big step. It's not about homeopathy or anything
like that.

What kind of art did you start with?
I left university and half a year later I was already making my
milkstones.

Where did you get the idea for the milkstones?
The milkstones are the direct answer to what I left, to what I
found milk and stone are about. Because milk is not what is
told in hygiene. You can teach everything about this liquid
but have no idea of what it is.

When did you start working with pollen?
That came about two years later. This, of course, I would also
have never done without studying medicine and avoiding an
art college.

Tell me about your work process.
For years I had no studio at all. I collected my pollen from
early spring to August/September, and then, in the late fall,
I started to be very free, not being fixed to a space. So my stu-

This interview originally appeared in *Journal of Contemporary Art*, vol. 1,
no. 1 (1988).

dio was where I collected my pollen. Then, when I was doing more and more work, I bought a beautiful space, but it's less of a studio and more like a space where I want to see my work in and be with it.

How long does it take you to collect pollen for one single piece?
It's very different from one pollen to the next. Dandelion, for instance, has very little pollen and blossoms only for about four to six weeks. So I get only a small jar of dandelion pollen during one summer, and the piece is therefore very small. Pine has much more pollen, so I can make a large piece in the same time.

Do you collect pollen only around your home or do you collect also while you're traveling?
No, I always thought that would take away the concentration. It wouldn't become more, so I collect only around my studio and the village where I live.

Does the pollen change with the time?
You have to be very careful because of the humidity, but I have pollen that is fifteen years old. For instance, with dandelion you have to be more careful, because it is very coarse, very organic.

Could you say something about your recent work, the rice pieces and the houses?
The first piece is called *Rice Meals for the Nine Planets* and the second piece, *Sixty-Three Rice Meals for a Stone*. They're close to the milkstones. For me, it's the same, though visually they are very different. For me, it's the most beautiful sight — it opens up so much. It's just like the milkstones where the milk is no longer food for the body. It's something much more universal. The plates, for instance, are regular Indian eating plates, but the rice portions on each plate are not there to be eaten. It's more about things that are very different from what is common in our culture.

Your work is very much influenced by Eastern cultures and religions.
I like very different things from very different countries, like
from Africa or India, but also St. Francis of Assisi is for me
wonderful. I am never really fixed to something, not to a re-
ligion, not to a sect, because I think it's not the point to have
a new sect. That would be a big disappointment. I like things
which I feel are really different from our own situation be-
cause I feel it could be very radical for us if we apply those
things to our life, if we take them really seriously, not just as
an exotic adventure. If you bring these things into your own
daily life, they become the most radical and the most revolu-
tionary, whether they are from the Middle Ages or from other
cultures. I think that is the main point.

And that is also the main concern in your art?
I think so, yes. If I see other artists who feel that it is impor-
tant to reflect that which is, then of course that's not interest-
ing for me. I feel that it wouldn't even be necessary to make it,
because it's already there. For me that is not enough and that's
the reason why I became an artist.

*What is more important for you, collecting the pollen or spreading
it on the floor?*
I think it's both. It's the pollen piece as a whole. But it's not as
if I'm making an art out of the collecting. It's the pollen I'm
interested in. For me the jar of pollen is as good as the spread-
out piece.

So it's not important for you to put it on the floor?
No, of course not. It would be beautiful if I could get more
people involved in that, especially in living with it. For me
that's very important. Because if such a piece is in a space, it
changes the life around it. But of course most people are not
ready for that yet.

Your pollen pieces are for sale. If a collector wants to own one how exactly does that work?
He buys three jars of pollen and it's his choice of keeping it in the jar or to get rid of his furniture and spread it out on the floor.

Would you go to his home and do that?
Yes, but of course I would be even happier if he would do it himself.

Do you know people who own pieces of yours?
Yes, but each person is different. There are some very beautiful situations and some situations that make no sense at all.

Could you tell me more about the houses?
They have the shape of a house and they also have the shape of a Muslim tomb or a Medieval reliquary, but instead of the bones of saints, they contain food. For me that's very related, so I turn the bones into food.

What do the holes in the houses signify?
I can't explain the holes but they are very important. Just last night I saw a catalogue of an exhibition of Asian art from the Metropolitan Museum. There were two containers made of clay holding the bones of human beings. The containers were in the shape of sheep, with a big hole at one end. Of course I had to go and see that because it was so close to my work, and the sheep were incredible, very abstract, nearly like a house, but they had the head of sheep and the holes were much bigger than the one in my house. These are interesting similarities. They are like sealed houses. The food is really contained in the house.

You live very removed from the world. How do you feel about coming to a place like New York?
For me the choice is to live outside of a village. I really want to be independent from a situation, a city. I feel that living in a city makes you more or less dependent on what the actual situation and the actual thinking is, and I hope to be outside of that, to be more independent. Then when I come into the city, into different cities, nowhere really is my home. I can see and watch these things much better from the outside. I'm not really belonging anywhere and this gives me, I hope, an incredible freedom. Also, when you live in a place like New York, where you see all this art around you and you go to all these exhibitions, I think that's very bad. I can do that for two or three days but not all the time.

Some of your images, especially the houses, recall the works of artists like Jennifer Bartlett or Joel Shapiro.
Maybe visually they do. There are always some visual things that are similar to this and that. There are houses made by other artists, but I think that is not so much the point. I feel much closer to Joseph Beuys, for instance, than to the houses of Shapiro.

When you spread out the pollen, it doesn't look natural anymore. It seems very artificial and unnatural.
Of course. It's not about naturalism. Many people think that my work has a lot to do with nature. Yes, it has a lot do with the natural world, but not only that, it's much more complex. I would never agree to be part of a "nature show."

Doesn't art always reflect and carry with it the thinking of its time?
Yes, but I think the better the art is — you see this in his-
tory — the more it really makes a change to something else.
When I think of Giotto's painting of St. Francis of Assisi, even
though he is not an artist he is an important man — more so
than Giotto who made a painting about his life. St. Francis
really changed his life and his work. For me, he is interesting.
Giotto is an incredibly good painter, but St. Francis is for me
the more important man. He really made changes and had an
incredible vision.

MOIRA DRYER
New York, 1988

What are you working on right now?
Well, I'm still occupied with what I was working on before. I tend to do a lot of things concurrently, a lot of different bodies of work. What I'm doing now is a little hard to talk about because it's unfinished work, but it's no quantum leap from what I was doing earlier. I'm carrying on a series of things that I pursued before, and I'm only now starting to recognize that they fall into a pattern. I like to make a lot of different work at the same time and I don't really premeditate the format. I'm doing more diptychs with signature boxes and more fingerprint paintings, which are constantly transmuting into a new identity. They started out as something quite specific, the use of the finger print; it was a joke on artistic identity and authorship, and I didn't think I was going to take it this far. It was also a way of being able to make a lot of different kinds of paintings. It was an image I could group the work around. It developed away from that really, on its own will. It's been exciting.

A lot of new information has come in the work that I didn't anticipate, of a personal, emotional nature. I'm doing those and I'm doing free-standing sculptures. I don't see any big change. Some things have gotten a little larger; certain things have shifted. I've started a new body of work, "props," more work with the signature boxes. I recognize them now more as props to the paintings and how they make the whole piece a prop. They give it a quality, not of artificiality but of a theatrical situation. I'm beginning to see those paintings

This interview originally appeared in *Journal of Contemporary Art*, vol. 2, no. 1 (Spring/Summer 1989).

as performers. It is a theater, and the pieces are performing. I see them as animated entities, alive and performing.

You mentioned the theatrical quality of your work in your statement in Art in America *recently. Is that related to your interest in sculpture?*
Oh definitely, very much so. I liked Rebecca Horn's show at Marian Goodman, those circus metaphors. I never thought of the circus in relation to my own work, but I see an exhibition as a stage and my pieces are performing together, depending on the kind of installation. That's something I'm developing, definitely with the sculptures, particularly the freestanding ones. They are becoming, just by virtue of their physicality, figurative. It's almost a criteria for me to feel that a painting is somehow alive and animate. I don't know how else to describe that. Even in the case of a flat, straightforward painting, for it to feel finished, to be successful, I have to feel that it's alive. If it doesn't feel alive, then I know it's not working, and I need to work on it some more.

So if the paintings are the props, what's the play?
The play is put on by the paintings. The paintings are the performers. It's really up to the audience at that point to say what the specific production is. The pieces evolve from a very personal, emotional point, but then they become entities in themselves. I give them life and then they become their own. Once an installation is together, then the contrast of one piece to another brings in another element. I don't like to control that too much. I find it exciting how that evolves.

Can you talk more about your idea of the theater?
When I say theatrical or theater, I'm not necessarily referring to classical theater. I'm referring to an activated kind of viewing space. A painting that is just on the wall has one relationship to someone who looks at it. A painting that becomes more sculptural enters into its own physical arena. It estab-

lishes an arena. It draws the viewer into a more intimate relationship. I see the pieces performing, and that's what I mean by theatrical.

I used to work in the theater, on props and sets, and I was always very transfixed by the play before the actors came on or after they left the stage. That was my job and that was what I was focused on. The lighting would be there, and the tension and the audience would be there, but not the actors. Those props had an incredibly provocative effect. I've been recalling and using that lately. So the pieces are the performers themselves, and that's what I mean about them being animated. I see them as alive. I see them as walking away from the wall. It's a feeling I have that the work is active, active in our own world, not separate — that it has a sort of living quality of its own. I feel as if they have a figurative scale, a figurative quality. In some cases, it's less obvious, but there's a fake quality to it, and that's also why I use the word "prop." The box underneath, the signature or title box, evolved from looking at a lot of art in museums, where there's an explanation of the piece underneath or next to it.

When you hang an exhibition, are you consciously thinking about that idea of it being a theatrical performance?
Oh definitely. Even if they're paintings that don't have boxes. I see them very much as characters. I make the choice of how the work goes up, and that's definitely a part of the work, that certain pieces be placed next to others. There's resonance, one piece challenges another. It doesn't reaffirm the other piece. It has more of an anxious kind of relationship. It's quite charged.

Is it a comedy or a tragedy?
It's both. My paintings are about a lot of different emotions. They're as much about joy as they are about grief. Those are both combined. It's the electricity from experiencing one and

experiencing the other that makes them become stronger, just through the contrast.

What happens to the pieces when they're hung by themselves? Are they better as a group?
I don't think they're necessarily better. They can stand on their own. It will be a different reading of the work but it won't be a lesser reading of the work, or I would sell my work in groups. In the final analysis, the final moment, they're individual pieces. A show, an installation, is a forum where I have an opportunity to present my work, and that's the part that I get involved with. After the show is over, the pieces go off and live with another group of work, and the same thing will happen in a different way. I can't anticipate what painting might go next to it. I hear of a painting that went into somebody's home and it's next to such and such, and people would comment about those connections.

The theater continues.
Yes. It goes on, on its own. That's something I've not been aware of. But now that I've started to do more shows, patterns are starting to reveal themselves.

Then you would not be interested in working in the theater, doing stage design, for instance?
No. I'm taking the metaphor of theater and using it for my own ends, in gallery situations. You have to challenge people when you do a show. There are so many shows people see. I want it to be exciting.

Do you do any works on paper?
I do, but I don't show them. I do small gouaches. I have always done that, but I hide them. And I don't do them all the time. I tend to do them when I'm away from New York.

Do you feel they're private?
Yes, but eventually I may show them. At some time I'll get them all out. I showed some once a long time ago, but not lately. I'd like to, in the future.

Which artists do you feel closest to and which have had the greatest impact on your work?
I feel very close to what Elizabeth Murray does. I also feel very close to what Ross Bleckner does.

I love a lot of the Spanish painters. I adore Goya and Velazquez. I have incredible respect for them. I like a lot of fourteenth-century painting, pre- or very early Renaissance. I adore that work. It's incredibly seductive. I find it very moving — you sort of feel genuine religious feeling in them. I travelled to that part of Italy about six years ago. I was just so astonished. I'd like to go back and see it again. It's fantastic to see the work and where these people lived, like Piero della Francesco doing a fresco for his mother on her graveside, and the piece stays there, in some little barn. So part of liking that work is the work itself, and part is seeing it remain in the world that it evolved out of. I have great admiration for those painters.

I think Robert Smithson is a great artist. I find him incredibly exciting still. He seems so ahead of his time. And I like the fact that he wrote so well and that the writing was so creative. He's very special. Then there's René Magritte, and Paul Klee. I really like a lot of Klee's work, though I've sort of grown out of it. Let's see, a lot of Italian painters, Giotto, Fra Angelico, Piero della Francesco.

When you do sculptural works, do you look specifically for these mechanical parts, or do you collect a lot of things in advance and then think about what to do with them?
I do both. Sometimes I have a need for something really specific, and sometimes I will find an object that interests me and a work will come out of it. I like to have a bunch of things

around, just like I have paint around. The objects are usually quite specific. They come from somewhere specific, from somebody specific, and that becomes part of the piece. I don't just collect stuff. I find something or something falls into my hands from someone and a lot of who that person is will enter in that piece.

I'm really interested in wheels, in old industrial objects that are dysfunctional. I find that very provocative.

Is that a form of nostalgia?
No, it's not nostalgia. They're objects that don't operate, like a lamp that doesn't go on or a wheel that doesn't work. It's not about the past or nostalgia because the objects are placed in a context, and I paint and change them. I don't want them to look old. I want them to be part of the painting. I want the pieces to look modern, to use such a loaded word, meaning alive, of the moment. I usually do quite a bit to transform them. The fact that they have their own personal history interests me, but that's not nostalgia. I feel like I'm taking an old thing and bringing it back to life. I'm reassessing it. I take the pieces and I reassemble them.

When I was building props I had to do go around and find things and transform them into a new object. That got me into the oddest places, meeting the strangest people looking for things. I enjoyed that. And now I do it for myself, which is more fun because the objects aren't functioning for somebody's play, they're functioning for my own production.

RICHARD SERRA
New York, 1989

Who is your audience?
The first audience is the people involved in the process. That
would be the steel engineers, the steel mill workers, and the
riggers. I don't make the sculpture particularly for them, but
the riggers are the first audience. The people who put the
work together know more about it than anyone else.

The second audience is the interpretive audience, who-
ever happens upon the work, as with the Maillart piece in
Grandfey Viaduct in Switzerland. This particular work is ac-
cessible to anyone, whether you know anything about sculp-
ture or not. It cannot be misread as part of the function of
the bridge.

I think what has happened now is that instead of art deal-
ing with invention of form, we have the reverse. We have
art that is predicated on being the appropriate solution or
entertainment. It has to do with the exchange value of the
commodity — I'm not saying that site-specific works aren't
commodities — but as commodities they are nonstarters.
Their circulation is by definition limited. I think most of the
work being built right now is really predicated on secondary-
market sales.

How do you define site-specificity? Not all your work is site-specific.
No, Some pieces are just generic. Usually my commissioned
work is site-specific. I've just done two site specific installa-
tions, one in Munich — where I built seven pieces in seven
rooms and one in Eindhoven, ten pieces for ten rooms. Most
of the conical pieces I built are based on the relationship of
one part to another, and all that is required is an open space

This interview is previously unpublished.

and a flat floor. The problems that the cones present interest me in terms of the possibilities of invention. But if I had my druthers, my aspiration would be to build pieces for a given contexts — to try to open up a new way of seeing into those contexts. I don't believe in affirmation and I don't believe in complicity. That's what's wrong with prescripted or applied art...

You've talked about creating "anti-environments."
What I mean is any given place has a preexisting character and identity and when you intervene with a form, that form necessarily changes the character and description of the space and place giving it a new sculptural identity. Often this new identity is considered to be anti-environmental because it alters and changes the existing condition, whether it is urban, architectural or a landscape. It changes how one relates to those spaces and places both perceptually and conceptually. People become annoyed because they feel that they have a proprietary right over their environment. When it's altered by an interjection that is utilitarian, people don't mind. If you give them a nonworking fountain or a signboard or an advertisement, it is totally acceptable, but if it's a work of art, which is by definition useless, then they protest. I have never completely understood the logic of the protest. Calvinist logic of utilitarian purposefulness continues to be the subtext of most people's reluctance to deal with art in public places.

So you would always prefer site-specific works.
Yes, if I was given commissions, certainly. In this country my options are fairly limited although I have currently two interesting projects, one to build in Yale University's old Gothic library, and the other, in Des Moines, Iowa, where I have been asked to build a landscape work that fronts the museum. There are a few other possibilities to build here but

most of the work I've done in the last twenty years has been in Europe.

Now there were some relocations.
When people have taken pieces out and moved them? Yes.

There is a piece in Paris that I understand is not site-specific.
Most of the conical pieces I've built haven't been site-specific. What happened at the Beaubourg is that there was a possibility to build in the pit inside the Centre Pompidou and during the negotiations, the work was cancelled. Dominique Bozo chose a new location, in the Tuileries, and as it worked out, it was quite successful. Being on the main axis with the Champs Elyses, the sculpture brought people into an engagement with the entire scale of the larger urban context. Originally, this piece was never intended for the Tuileries. It was intended to be viewed in an open flat space. These pieces can go in various places as long as the ground remains flat and has a context that I find acceptable. Now that piece has been moved to the Parc de Choisy. I'm not sure it's as successful as it was in the Tuileries, but I never thought it was going to remain there. I only had a temporary permit.

Then there was the piece you designed for Wesleyan University in Middletown, Connecticut, Sight Point, *which was site-specific but was never placed there.*
Yes the work was cancelled in a preliminary phase. What happened was that the campus architect objected to the fact that the proposed sculpture was higher than the surrounding buildings. Later, when Eddy de Wilde asked me if I could build a piece for the garden of the Stedelijk, I thought that I could site the work in that space. Basically, the garden is a very flat generic space, and I thought that this piece could deal with the scale of the context as equally as well.

But the piece hadn't been built yet.
No.

So did you make any changes or adjustments to the work?
I think I may have made the interior space larger, but I didn't
make any significant changes.

You didn't try to make it more site-specific?
No, but I located the openings to connect to the surround-
ing paths that come into the park and the one that goes to-
ward the pool. The installation was difficult because of the
sub surface condition. There was water four feet below grade
and we had to build a pier with pylons. But I was happy that
de Wilde asked me to build *Site Point*. It was the first vertical
piece I installed and since then I have been able to build five
or six more, most recently in London, in the Stock Exchange,
55 feet high, with an interior space of about 20 feet across. Of
the vertical pieces, that one is the most successful because of
its context. It's called *Fulcrum*.

How do you see the role of American museums right now?
The collectors have a great deal of control over the muse-
ums, and there is collusion between the collectors, trustees,
and museum directors. Museums are becoming showcases
for collectors, in effect, museums not only collect collectors,
they collect collector's collections. In the sixties, there was an
acute critical awareness and dialogue that challenged the au-
thority and presumptions of museums which today has been
usurped by the market.

 Warhol had an enormous effect on the younger generation.
Some of it has been positive, but a lot of it has just turned the
younger generation into having the eye on the dollar. The art
world has become synonymous with a star system in terms of
monetary reward. You only find the equivalent in Hollywood
and athletics. That difference in monetary reward you don't

find in other serious professions such as writing, filmmaking and music. The marketing trend that is going on right now needs to be looked at with a great deal of reservation. It may be that America is in a mannerist decline. I'm not sure — let's say every generation gets what it needs.

Also, the art world is not isolated. It reflects a general climate in America that has changed from a social consciousness to mere greed. Do you think it has goose-stepped with the Reagan administration?

I think so.
I'm not inclined to make those correlations because it could be that such moments of strict repression spawn resistance. But I would say in this country there is no left and there is certainly no resistance.

Will the decision on the removal of Tilted Arc *create a precedent and encourage other individuals to attempt to remove public artworks?*
That may be but the other thing that may happen is that young artists who were looking for alternative ways of confronting a growing market will be inhibited from pursuing the character, nature, and direction of site-specific work for fear that it will be destroyed. Or the opposite will happen — that people who make work that will go hand in hand with the architects and city planners and designers who have a need to either advertise their "liberalism" or the commodities of the building, as you have on Sixth Avenue now; empty symbols representing corporate power.

I can think of a number of young artists who would have no problem doing that.
And then there is another kind of work going on that seems to engage what you would call the social benefit of the populace,

and you'll probably have more of those kinds of wholesome activities being carried out. You know art for the people.

You seem to be closer to architects and engineers than to other sculptors?
I'm interested in the clarity of building, in gravity, in the tendency to overturn, in the exactitude of measure, the addition and subtraction of weight, the rotation of weight. I'm interested in mass. I admire Mies and Corbusier for dealing with tectonics in a straight forward way. They extended their raw material whether concrete or steel to invent new forms. Most building doesn't deal with invention in the engineering. It's just cladding, putting a new physiognomy, a new face, on a building. Basically, Maillart and Sharoun still interest me. The history of sculpture has been limited by either modeling and casting or cutting and welding. From Gonzalez, Picasso, Smith, and Calder up to the present, sculpture has still dealt with a pictorial relation to the plane that may be of interest, but not to me. It seems a dead end. I am much more interested in the fundamentals of building, than in three dimensional pictoralism as sculpture

Didn't classical sculptors like Michelangelo also experience that struggle with the material.
One of the things that are evident with sculptors is how they deal with weight, mass, and gravity. These are givens that you have to deal with. The question of gravity applies and defines the individual work no matter who the sculptor is. Consider Brancusi, Picasso, Giacometti, Calder, Smithson, or Judd. You can immediately see whether gravity/balance is an issue in their work or not, and whether or not it defines the content of their work. I tend to isolate particular aspects of weight, mass, and gravity.

Do you feel your work has an existential character?
I majored in English at the University of California at Santa
Barbara and wrote my senior thesis on Camus, but I don't
consider myself part of the existential tradition. That was a
movement that occurred after the war when there was a need
for people to define themselves continuously in the absurdity
of a given moment. Giacometti epitomized that moment.

JESSICA STOCKHOLDER
New York, 1990

What are the most important issues in your work?
My work developed through the process of making site-specific installations — site-specific sometimes in very specific ways but also just by virtue of being "art" in a room; there's at least that much going on between the work and its context; after all, paintings don't hang on trees. In all of the work I place something I make in relationship to what's already there. With installations it's the building, the architecture, or you might say it's the place that I work on top of; with the smaller pieces I work on top of or in relation to stuff that I collect.

I don't see a dichotomy between formalism and something else. Form and formal relations are important because they mean something; their meaning grows out of our experiences as physical mortal beings of a particular scale in relationship to the world as we find it and make it. I don't buy that formalism is meaningless.

Is there a particular aesthetic involved when you look for materials?
It doesn't matter what I use. It can be anything. What's interesting is how what I'm doing combines with the stuff I use, but then it's not entirely true to say that. I also choose things for particular reasons, though not according to a particular aesthetic. More often I avoid the development of a cohesive look that will too powerfully direct the work in only one direction. A lot of people have written about my work in terms of junk. That I sometimes use junk doesn't seem of central im-

This interview originally appeared in *Journal of Contemporary Art*, vol. 4, no. 1 (1991).

portance to me. I use all kinds of things, old and new. Much of the stuff I use could be found in your living room.

There is that danger of junk becoming "art" by itself, without the artist adding meaning.
I rely on that tendency to aestheticize as I do on chance and happenstance. What's exciting is how the more clearly structured, more formal, more pictorial side of the work meets the more chaotic — sometimes very clearly and logically, then bleeding off in all kinds of directions.

I see it as a mesh of Kaprow, Tinguely, and the surrealists on the one hand, using chaos and chance and making systems out of happenings; and on the other hand, meshing that kind of thinking with formal painting and minimalism. John Cage's thinking also had a lot of influence.

Are there other influences that you would like to mention?
I studied with Mowry Baden in Victoria [British Columbia]. He's a sculptor with a large appreciation for painting; he addressed my work from both points of view. That's part of how I got where I am.

How did painting come to the work?
I started as a painter and I never stopped making paintings. And still, part of what interests me is a pictorial way of looking at things. Viewing through pictures is part of our experience of the world, an experience that happens to be often associated with art.

Standing in front of one of my pieces, its size is important in relationship to your size, you feel how heavy it is or what the light is like in the room, and all that kind of information is seen in relation to the pictorial structure in the work. The thing cues you to measure one side against the other, trying to balance it as you would a picture, and for me, looking at things in a pictorial way includes a distancing where the thing that's pictured is far away and a little static, unchanging, without time. This distancing is exaggerated by the "art"

status of the work, which brings with it a feeling of precious-
ness and the feeling that the work is somehow removed from
or above human life. These qualities are seductive and they
make me angry. So I place the pictorial in a context where it's
always being poked at. The picture never stands — it's always
getting the rug pulled out from under it.

I also love color; and color hasn't been dealt with much in
sculpture.

*Do you relate more closely to an American or European painting
tradition?*
I relate more to an American tradition, though probably to
both. Matisse, Cézanne, and the cubists certainly are impor-
tant to me. I also feel a strong affinity to Clifford Still, Frank
Stella, the hard-edge New York School painting, and minimal-
ism, as well as Richard Serra.

When did you decide to make smaller, site-independent objects?
When I moved here I had no studio. I was working in my
apartment. It didn't make sense to build installations there,
and I didn't want to have to find a show in order to be able
to make my work. So I started to make objects. The first one
I made had a light pointed at the wall making a circle of
color. The light uses electricity, which is happening in time;
although the work is static, the light gives it a sense of hap-
pening. Also, there's color on the piece and color on the wall
from the light; the color on the wall from the light is kind of
ephemeral, and it's not physically attached to the piece, but
the two things, the piece and the wall need each other to be
a complete thing. So though I was making an object, it broke
down a little bit. It wasn't isolated unto itself.

I also like that the smaller pieces are physically easier,
more in my control. And I can work out ideas that I later use
in installations.

Could you say something about how meaning is generated in your work?

My work often arrives in the world like an idea arrives in your mind. You don't quite know where it came from or when it got put together, nevertheless, it's possible to take it apart and see that it has an internal logic. I'm trying to get closer to thinking processes as they exist before the idea is fully formed. The various parts of my work are multivalent as are the various parts of dreams. At best, there are many ways to put the pieces together.

MIMMO ROTELLA
New York, 1991

When did you begin working with torn posters?
I was living in Rome in the 1950s and 1960s, and I used to paint in a neogeometrical style. In fact, the first show I had in Rome was neogeometrical. In 1951, I received a Fulbright Fellowship to come to the United States to be an artist-in-residence at the University of Kansas City, Missouri, where I painted a huge mural. I spent one year there. When I went back to Rome, I didn't want to paint anymore because I thought everything was already done in painting, that painting was finished.

I continued to write phonetic poetry and, at the same time, was working as a teacher. For about three years I didn't do any painting. One day I saw in the streets of Rome these fantastic, big posters, very alive, very colorful. I reflected upon that and I said, "This is the art I should be making!" So at night I went out to steal these posters, but I didn't have the courage to show them to anybody. I took them to my studio and put them under my bed. And one night a critic from Rome, Emilio Villa, came to see me in my studio. He wanted to see the posters, and he told me that I was discovering a new way of expression that goes beyond painting, and a space that was no longer a cubist space but a new space. He was preparing an exhibition at the end of the month of six Roman artists on a boat on the Tiber. He told me that he wanted me to be the seventh artist. When the exhibition opened, there were many people, among them, an American critic, [Milton] Gendel, who used to write for *Artnews*. He later wrote that the only artist who had a new message was Rotella, and he called it "New Dada."

This interview originally appeared in *Journal of Contemporary Art*, vol. 4, no. 1 (Spring/Summer 1991).

Did you manipulate these posters at all?
Sometimes yes, sometimes no. Sometimes they were really ready-mades. They were very pure then.

When did you become aware of the French affichistes*?*
I heard about them in Rome and met them later in Paris through Pierre Restany.

What would you say is the main difference between your work and that of the French affichistes*?*
First, the ink in French posters is different from Italian posters. Italian posters have more vivid colors. Also, they used to show letters while, in 1959–60, I started to show images of the cinema because at that time in Rome there were many Italian films made at Cinecittà, which was the equivalent of Hollywood. The French *affichistes* also did not come from painting but from photography.

I was the first to exhibit torn posters in public. The French *affichistes* claim that they started in 1949, but I know through a friend of theirs that they exhibited in public three years after me at Galerie Colette Allendy. At that time, I used to show the front and the backs of posters, something [François] Dufrêne did years later. I'm telling you that because they don't tell you this in the catalogues.

After 1964, I discovered "mec art," which is short for Mechanical Art. I used to expose images of cinema posters directly onto photo-sensitized canvases that were first shown in 1965 in Paris. My first exhibition in Paris was in 1962. It was called *Cinecittà* and consisted of torn cinema posters — Sophia Loren, Marilyn Monroe, Elvis Presley. It was a fantastic success.

Why were you so fascinated by the cinema?
Because ever since I was five or six years old I have been fascinated by the cinema. I used to go with my parents to the cinema to see films.

In 1960 I also started to appropriate posters that were proofs of typography with superimposed images. I called it *Art Typo*. First I showed them pasted onto canvas; later, in Paris, I coated them with plastic. So I had these brilliant surfaces that had the effect of a technological product. I understand there are young artists who do that today. I continued to experiment with these different techniques, and in 1980 I discovered the "Blanks." In Italy, when the advertising is finished, they cover it with monochrome paper until a new poster is pasted up. I called these works, which were shown in 1981, *Coperture* (Blanks). They were very strong images, very mysterious, but the public didn't understand them. It was always fixed on my posters.

In 1984 I started to paint again, cinema images on canvas. I wanted people to know that painting had changed in regard to technique and images. I wanted them to understand that traditional painting was finished. So I painted in this *sauvage* technique — wild, very, very fast —in order to have this kind of effect.

When I first saw these paintings, they reminded me of the neo-expressionist painting going on in Germany and Italy at that time. Were they influenced by that?
I think so, yes. But it was a different spirit. Because what interested me was the lettering, the titles of films, the names of the actors. The lettering was very important. And again I limited myself to images of the cinema.

You were never interested in other images?
No, never.

Were you interested in the fictional character of the movies?
No, I was fascinated by the kissing scenes.

In 1987 I started to appropriate big panels in metal. These panels were covered with torn posters, on which I then

painted. I called them *Soprapinture* (Overpaintings), and that is what I am doing now. In my last show in Paris you could see sculptures for the first time; finally, the torn posters became sculptures — architecture.

How exactly did you become involved with the manifesto of the Nouveau Réalistes?
Pierre Restany came to Rome in 1956 and saw one of my exhibitions. When he met me, he told me about the French *affichistes*. So when I went to Paris in 1960, he introduced me to them. Later, they sent a telegram from Paris to Rome, asking me if I wanted to join their group.

Were there ever any bad feelings because you were all doing similar things.
No. Maybe it was hidden. Anyhow, each of us had his own expression.

Are you familiar with what younger artists are doing?
I see the exhibitions. I know, for instance, the work of Jeff Koons, Jenny Holzer, and Peter Halley.

How would you describe the difference between Nouveau Réalisme and Pop art?
While we were doing Nouveau Réalisme in Europe, Pop art was born in America, which is completely different, spiritually. Nouveau Réalisme is a European phenomenon and comes from the tradition of Marcel Duchamp and the ready-made. American Pop art is an American phenomenon where everything is done by hand. I think our art was more conceptual, based on the ready-made.

Do you see a continuation of Nouveau Réalisme in Europe today?
Well, not really because the new generation is influenced more by arte povera.

Do you think the arrival of Pop art was responsible for the failure of Nouveau Réalisme *in the U.S.? Yves Klein's first exhibition here was a disaster.*

Even Fontana's exhibition was unsold. Yes, I think it was for reasons of nationality.

ALAIN KIRILI
New York, 1993

Let's begin by talking about the new sculpture in Dijon.[1]
It began with a visit from Xavier Douroux, who is with the consortium in Dijon. He visited the studio I had at the Villa Arson in the summer of 1992 and, after seeing some of my marble pieces, said, "If you like to work in stone, Alain, please come to Dijon and try the quarry there." This idea was very appealing to me because Dijon is a town of the French eighteenth century and thus has great meaning for me personally. It's the town of Premeaux, the town of Klaus Sluter and thus a kind of capital of sculpture. The *pleurants* or "mourners" of Dijon have been studied by Ariane [Lopez Huici] in her photography and by myself as well.

So I accepted Douroux's invitation and went to Dijon to visit the stone quarries. When I got there and saw those buildings, the beautiful *hôtel particuliers* of Dijon, all done in that same pink-violet stone, I was so surprised that I asked about the quarries for that particular stone and they took me to the little village of Premeaux, which is right in the vineyard of Nuits-Saint-Georges. Of course, as it turns out, the change of flavor in the wine is related to the change in the soil but, more fundamentally, to the change in the stone. And so I ended up in this quarry directly adjacent to Nuits-Saint-George, and there, in the midst of the Côte de Nuits, saw that beautiful pink stone.

This interview is previously unpublished.
1 *Hommage à Max Roach* (1992). This work was later accidentally destroyed. It was redone by the artist in 2000 as *Improvisations Tellem* and is now permanently installed in the Esplanade Erasme on the campus of the University of Dijon.

The owner of the quarry invited me to consider it as my studio; and let me tell you, it was the biggest studio I've ever had. I asked him what sort of precedents there were for sculpture in this quarry, what history it had regarding other sculptors, and he explained to me that this quarry was the source for the stone used in building the Abbaye de Cîteaux. On the other hand, he said, it had never been used for sculpture. Later, I realized that the reason for this was that figurative sculpture would obviously require a more neutral type of stone. Since the stone had no sculptural history, the situation was very open and I was free to develop the stone's abstract possibilities. I was free to develop a kind of fleshy abstract possibility. That's a good start to answering your first question.[2]

What you describe seems to present a kind of contradiction, and indeed your work seems to be concerned with contradictions in that you talk simultaneously about flesh and about abstraction. According to a traditional understanding, sculpture is something very rigid, very heavy, very conceptual. But you talk about sculpture much more as an extension of yourself and particularly as an extension of the body; you relate it to sensuality and sexuality. How would you describe the abstract possibilities of that stone?

For me, that stone has no connection with granite, for example. One associates granite with something rigid and austere, or even something radically connected with death. Ones sees a lot of granite in cemeteries, in urns. In this stone, on the other hand, there is a genuinely fleshy aspect. Its reddish color is like wine or blood, as if they were solidified there. This stone has a lightness of being, and consequently it was natural for me to work with it in much the same way that I work with and shape clay. It was done by direct attack using stone carv-

2 See also the remarks on this project in "Alain Kirili at Nuits-Saint-Georges," in *Alain Kirili* (Saint-Etienne: Musée d'Art Moderne, 1992), pp. 139–43.

ing and electrical saws. Thus for me the creation of this piece involved both selecting and shaping, as well as a kind of accumulation through the superimposition of horizontal and perpendicular elements. But all these processes were applied to what I would call an almost eroticized material.

And as I mentioned to you earlier, this happened at about the same time as the Rodney King verdict and the insurgence in South Central Los Angeles. The night all that happened I saw Max Roach at the Village Vanguard in New York and had a sudden flash. What I realized was that there's a relationship between what Matisse did in his great book of cut-outs called *Jazz* and cutting in stone. Matisse would say that cutting into color is like sculpting. He thought of himself as a sculptor when he did the cut-outs. He connected that sort of cut-out with the rhythms of jazz, the sexuality that jazz evokes, and the truly nonpuritanical use of stone. Now this is the sort of thing I dreamed of doing and something I could achieve in Burgundy because of the beautiful color of that particular stone. This may be an answer to your question, for the reason the work is not merely conceptual and has no rigidity is related to all these considerations.

When you work in clay or in iron, you work very fast, very spontaneously. How are you able to work this way with stone?
First of all, I worked this stone with very good assistants. When you're dealing with weight you have to think it through because once anything goes over, say, fifty pounds, you have to devise a means of moving the piece quickly. So, with a very good team, and using four lifts, I was able to work on that piece extremely quickly, just as I would in forging iron or shaping clay. In fact, the piece was done so quickly that I hardly knew what was happening to me. I suddenly became comfortable with a major event in my life; that is, with undertaking monumental sculpture. To create a monumental sculpture that could be done as rapidly as a small sculpture was an amazingly stimulating process. I worked almost in the

manner of Jackson Pollock: I displayed the piece with a fork-lift. I created the disposition and distribution in space of the elements very spontaneously, instinctively, with no sketch or other preparation. And so I kept that sense of speed.

You mentioned to me earlier that you have learned that Pollock was one of the first to use clay in abstraction.
Pollock is indeed one of the first to do abstract modeling. And this is a major event in twentieth-century art because abstraction tends to be understood in very different terms, let us say in a constructivist manner. Abstraction in modeling, in *modelé*, and even in direct carving has been rejected for a long time now, primarily, I think, because these techniques were associated with traditional art. But the emergence in the last few years of abstraction in modeling is a major event to close out the twentieth century,

I did my first piece of this sort in 1972. And one day when Ileana Sonnabend visited my Crosby Street studio, she said to me, "Alain, those clay pieces remind me that Jackson Pollock did some abstract clay pieces." What I want to say, though, is that monumental sculpture can be done with the same quickness as abstract modeling. You can do direct carving quickly, you can saw into a piece quickly; today ease and spontaneity are also possible in monumentality. I would even say that this piece is a *monument to spontaneity.*

Is this your first monumental piece?
I think so, but I would say that *Grand Commandement Blanc* [1986] in the Jardin des Tuileries is a monumental sculpture. It exceeds human dimensions. *Commandement I* [1979], which is in the Ludwig collection, my first piece in that series, is also larger than human scale. The Dijon sculpture, how-ever, is monumental not only in horizontality (like these earlier works) but also vertically. So between its verticality, which is above human height, and its weight, which is more

than sixty tons altogether, it's my first complete monumental sculpture.

Would you say that your way of working is primarily intuitive?
Well, yes and no. No, because I don't consider myself an expressionist artist. I'm much more connected to Abstract Expressionism in the sense that the expression and intuition in question are based on a very strong memory of history. My work is not amnesic. It's not primitivist or automatic. It is really connected to a tradition of art and to a knowledge of art similar to what one finds in David Smith, Noguchi, Pollock, de Kooning, and so on. So intuition, yes. "I am nature" in the sense that Pollock says "I am nature," which means I relate to the unconscious, to an impulse of sexuality that involves my own history, but also to a great deal of art history. And in this sense I am delighted to have made this piece in Burgundy because Burgundy connects me with a certain aspect of French tradition and the eighteenth century. This means a certain lightness, a certain . . . what André Masson would call *sexualité solaire,* a solar sexuality — a sexuality in art that is antipathetic to morbidity, ugliness, and abjection. This is something I like to connect with and that I was, in a sense, lucky to do it there.

How would you see yourself in relation to minimalist sculpture?
The difference between myself and Richard Serra, for example, is immense because my sculpture is monumental but not frightening. Mine is a welcoming sculpture; it doesn't reject you. You don't get a sense of weight here, or if you get a sense of weight, it is balanced by the color, which gives you a sense of excitement, levitation, *pleasure.* These sculptures involve incarnate pleasure. They are not concerned, as in Serra, with the fact that there is rusting going on, in the sense of self-destruction. In that case, in my view, there is much more of a connection to death than a celebration of life. So we're involved with two very different powers here.

In a way, isn't all abstract art closing itself off from the viewer because of the difficulties of understanding the work?
To a certain degree, I think you're right. Obviously, some people find it easy to enjoy the Free Jazz improvisations of Ornette Coleman. Just as you may like those rhythms, you can enjoy the sensual rhythms of this sculpture without having to think about the concept. But the impulse that's there is not so far from conceptual abstraction. It's an incarnate abstraction, a fleshy abstraction of the sort you find in jazz or in Stravinsky, for example. It's not a conceptual abstraction.

It seems to me that your work has as strong an affinity with music as with other forms of plastic art.
It has a strong affinity with anything that produces a sense of pleasure. It has an affinity with Steve Lacy, Max Roach, or Roy Haynes; less so with minimalist music. There is, in fact, a relation between the gestures of the drummer (like Roach or Haynes), in particular, and the gestures I invented for my modeling. Recently, Jean-Paul Fargier did a magnificent video in which Roy Haynes is drumming while I do modeling in clay in my New York studio.

What do you think about the idea of site-specific sculpture?
Well, certainly there has always been great "site-specific" sculpture by different civilizations over the centuries.

Your work is, in a way, very "site-specific" because it deals with a particular stone, in a particular area, and was done almost on the site. On the other hand, the work isn't designed for a particular place.
That's right. The piece is absolutely site-specific here for all the reasons you've just mentioned: it's done in the stone of the area, in the spirit of the area, and, in addition, the distribution and interaction of the elements was created for that specific site. But I'm not at all implying that the piece should not be moved. It's a French tradition that pieces can be moved, and I basically feel that that's fine. I respect that.

I'm fascinated by the duality between the feminine and the masculine in your work.

For me to be a good sculptor, I need first of all to have a sense of celebration of verticality: verticality with multiple points of view that invite the viewer to circumambulate, to turn around a piece. I can't tell you why, but verticality for me involves a sense of my own personal dignity; it is uplifting for me. When sculpture is crushed or flattened on the floor, it strikes me as depressing. So verticality is connected to a crucial instinct of my own dignity.

I erect a sculpture and thus establish a relation to sexuality and the phallus. In this connection, by the way, I tip my hat to Louise Bourgeois, who is one of our major French artists but who, alas, has not been adequately recognized in France. This is very regrettable, so let me say that she is the most important French sculptor today. Her sculpture *The Blind Leading the Blind* [1949] is crucial for me. And being a woman, on top of everything else, she has been a real pioneer.

One of Louise's great contributions was having the courage, in a minimalist conceptual period, to insist that sculpture has something to do with sexuality. And very often in her work one sees a relation between verticality and the phallus. For a sculptor, then, I think that the other aspect of the duality consists in giving complexity to verticality by investing it with a certain femininity. One needs to bring a feminine quality to that verticality. I think it's very important that the vertical, which is already related to the phallus, not over-fetishize the phallus. So one should let go, in the archaic sense of acknowledging that which is feminine in oneself. It seems to me that a certain longevity, a certain age, is necessary if one is to release what is within each man, which is to say femininity, and to release it into that verticality. I have always dreamed about putting that duality into volume.

When you speak of sensuality and sexuality in the creation of your sculpture, would you say that working the clay, in some sense, is connected to the sexual act itself?
Yes, I really believe it corresponds to the way Freud spoke of art as another form of sublimation. It's like another form of sexuality.

Returning to the Dijon sculpture, how would you see the duality we were talking about in this work?
The duality in these pieces is something I feel but something that is difficult to verbalize. I think the fleshy, almost trembling surface of the stone has a quality very similar to that of a "sanguine" Watteau or Fragonard. It has a sanguine quality and thus a gracefulness in color that makes the piece more welcoming than rejecting; it has a sense of positive creativity, a sense of female expression in abstraction. That, I think, is where a feminine element comes into that sculpture and makes it monumental, yet not violently imposing. Not to be violent or imposing is extremely important for me because I don't want to threaten with my work but, rather, produce a stimulating, inviting sense of monumentality — a monumentality that welcomes you.

You and Louise Bourgeois come out of a tradition that is quite different from the one that underlies most of the sculpture being done today.
Louise and I had a conversation that was published some time ago.[3] Her work is connected to sexuality in a way that is quite the opposite of my own. Louise is into what is almost a violent repulsion from sexuality. She will say, for example,

3 Alain Kirili, "The Passion for Sculpture: A Conversation with Louise Bourgeois," *Arts Magazine* (March 1989): 69–75.

"Puritanism is sexy." And I am the opposite of that. This is to say that we do come, although in opposite ways, from the same tradition, a tradition that involves connecting sexuality to creation in a nonmorbid way. That's why she became isolated during the 1960s. It's only recently that artists who refer to the body have begun to see her as a major historical reference. My relationship with Louise is not about the representation of the body but, once again, about a certain notion of sexuality and creation that connects her to the Abstract Expressionists — among whom she had many friends. I came to New York because of Pollock and David Smith, whom I could not see in France. Abstract Expressionism is thus one of my sources as well.

IDA APPLEBROOG
New York, 1997

How has your work changed in the last ten years?
I had primarily been using Rhoplex, but this was taken off
the market about 1984 because it was found to be carcino-
genic. At that point, I started to use oils and resin gel, and
with a palette knife I simulated the Rhoplex effects. Simul-
taneously, I found myself in the middle of something very
different and more complicated. The cartoon images were
reduced; to "storyboard" panels, a form of Renaissance pre-
della. The paintings then escalated in scale and content to a
more complex set of multipaneled, multilayered works.

How do you view your artists' books in relation to your paintings?
The artists' books acted as a conduit into the paintings. In
1974, I had moved from California to New York. In Califor-
nia, I had been working on very large modular sculptures.
Not knowing anyone in New York gave me the time to sit
quietly and draw story after story. These narratives turned
into 3-D stagings that were installed on the wall. They were
then photographed and made into a series of booklets titled
Performances. The booklets were mass produced for mass
consumption. For me, it was a way of decentralizing the art
system. Subsequently, the themes from the booklets were re-
flected in the paintings.

This interview is previously unpublished.

How did the idea of creating freestanding panels come about?
It actually began with one particular painting, *Camp Compa-zine*. In that painting, I felt that a large side panel should be swung off the wall so that it almost faced the panel next to it. It was very important for me to do that at that point. It was like letting the genie out of the bottle: once I did that, every-thing else followed. Suddenly, those paintings no longer had to hang flat on the wall — the panels could move. It involved a more complex way of seeing. And once the panels started to come away from the wall, the next logical step was to bring some of them right onto the floor.

What do you think the next ten years will bring to your work?
I don't think any artist can really say what the future is go-ing to be like. I think what happens is just built into who you are and what you do. I expect to keep on working, and if things go well, then the paintings sort of make themselves through you.

INDEX

ABOUT THE AUTHOR

Klaus Ottmann was born in Nuremberg, Germany, and lives in New York as an independent scholar and curator. He received a M.A. in philosophy from the Freie Universität Berlin, Germany, and a Ph.D. in philosophy from the Division of Media and Communications at the European Graduate School in Saas-Fee, Switzerland. He is the author of *The Genius Decision: The Extraordinary and the Postmodern Condition*, *The Essential Michelangelo*, *The Essential Mark Rothko*, *Wolfgang Laib: A Retrospective*, and *James Lee Byars: Life, Love, and Death*.

Ottmann has curated over forty exhibitions, including the SITE Santa Fe Sixth International Biennial (2006); *Life, Love, and Death: The Work of James Lee Byars* (Schirn Kunsthalle, Frankfurt am Main and Musée d'Art Moderne et Contemporain, Strasbourg, 2004–05); *Wolfgang Laib: A Retrospective* (which originated at the Hirshhorn Museum and Sculpture Garden, Washington, D.C. in 2000 and traveled to five additional museums); and *Extreme Existence*, a group show focusing on performances and video works by, among others, Tania Bruguera, Patty Chang, Bill Viola, and Chantal Akerman (Pratt Manhattan Gallery, New York, 2002).